Photography and
Anthropology

exposures

Photography and Anthropology

Christopher Pinney

reaktion books

For Roslyn Poignant – with belated thanks

Published by Reaktion Books Ltd
33 Great Sutton Street
London EC1V ODX
www.reaktionbooks.co.uk

First published 2011, reprinted 2012, 2014

Some illustrations were supplied with the support of the following institutions:

Printed and bound in China by 1010 Printing International Ltd

A catalogue record for this book is available from the British Library

ISBN 978 1 86189 804 3

Contents

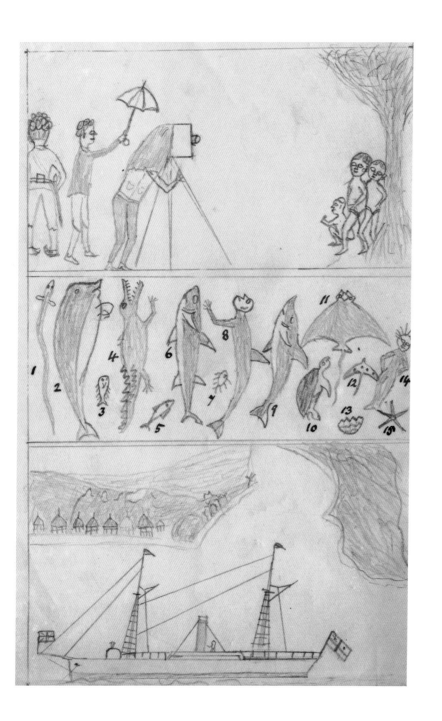

Prologue: Images of a Counterscience

Consider four moments, and four images, that catapult us along a trajectory of transformation into the history of anthropology's relationship with photography. The first of these images (illus. 1) is a line drawing of an anthropologist at work in the mid-1880s.[1] Drawn by a Nicobarese artist whose name is unknown to us, it shows a police orderly and a servant who holds an umbrella, assisting Edward Horace Man in his photographic endeavours. Man's face is hidden in the cloak of his camera, which points at three children posed at the base of a tree. All this occurs in the top of three horizontal registers. In the middle register, and subsequently numbered by Man, is a range of Nicobarese sea life including a dugong, crocodile, turtle and ray. In the lower register is the steamer *Nancowry* with a Malacca village, Spiteful Bay and Leda Point visible in the background.

This drawing, pasted in at the beginning of one of E. H. Man's remarkable photographic albums of late nineteenth-century life in the Nicobar Islands, in the Bay of Bengal, mixes several genres. Most obviously it is a drawing that engages photography. Less obviously it juxtaposes the 'screen' imposed by the camera with the rigid frames of an enduring Nicobarese representational tradition, the *henta-koi*. The three frames transfer onto paper the horizontal frames that characterize the wooden shields installed by shamans in Nicobarese homes afflicted with sickness and designed to ward off evil spirits. *Henta-koi* usually incorporated depictions of aquatic life-forms (crabs, male mermaids, squid) and symptoms of the Nicobar Islands' long history of cultural contact with Burmese, Malay and Ceylonese traders, Jesuit missionaries

1 Unknown Nicobarese artist, drawing of E. H. Man at work, c. 1880s.

and the detritus of sundry shipwrecks. These include sailing ships, ship's compasses, pocket-watches, telescopes, envelopes and mirrors whose very exotic hybridity seemed to be a source of strength to preserve the Nicobarese.[2]

The protective potential of photography, its apotropaic qualities that enabled it to ward off evil, lies at the heart of Queensland aboriginal people's engagement with it in the early part of the twentieth century. Aborigines who commissioned bourgeois portraits of themselves and their families, the Aboriginal curator Michael Aird notes, 'felt a very real need to state their successes in the European community to ensure protection from oppressive "protection" policies'.[3] The Aboriginals Protection and Restriction of the Sale of Opium Act of 1897 was one element of a colonial legal apparatus that endured through to the 1960s and which made it possible for Aboriginal children deemed 'neglected' to be forcibly removed from their parents and their communities. Adults who requested assistance from the state could be forcibly relocated to Aboriginal stations.[4] Photographs, Aird notes, indexed success according to European norms, and staged displays of middle-class white respectability were used to distance the Aboriginal subjects from the possibility of punitive state action. William Williams's family, from the Upper Logan River, for instance, 'lived and worked on their own land' and Aird's suggestion is that they managed to continue to do this is in part because they were able to mobilize photography in their defence. Their children were stockmen, drovers, axmen and housekeepers. Their descendants continue to live in Queensland and 'proudly identify themselves as Munanjahli'.[5] In a hand-coloured photograph dating from about 1910 William Williams stands next to his seated wife, Emily Jackey: he faces the world, staring down its threat, Emily regarding him anxiously.

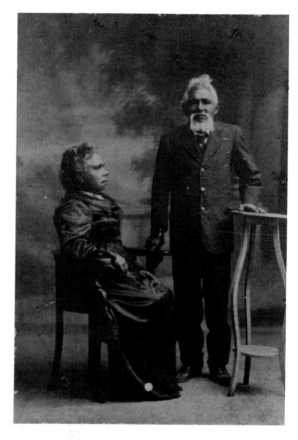

2 Peter Hyllested, *Emily and William Williams photographed at Beaudesert*, c. 1910, hand-coloured photograph.

Twenty-five years later, in Cologne, Germany, hybrid images collected by an anthropologist were deemed the source of danger. The images had been collected by Julius Lips, ethnographer of Cameroon and curator of the Rautenstrauch-Joest anthropological museum. Part of a vibrant Cologne radical primitivism where 'everyone talked primitive art' and 'popular songs took up the theme; posters advertised it',[6] Lips started to accumulate a vast archive of photographs from museum collections of images and objects in which colonized peoples recorded their 'censure, buffoonery, astonishment, misunderstanding'. This was, as he later wrote in exile in the United States, the opportunity for the colonized to 'take vengeance upon his colonizer'.[7]

One of the images also originated from the Nicobars and was a photograph of a carving in the Rautenstrauch-Joest Museum's own collection. In his book about the collection, published after Lips had fled Germany, he juxtaposed it with a photograph of the person to whom the carving referred: Edward VII 'as he actually was'. The Nicobar double strove for some of the protective effect of the *henta-koi* for it was a 'scare-figure', a portrait of a high-status person intended to make 'evil spirits' 'flee in terror and impotence' before it. This was possible through the deformation of the photographic referent – 'the figure's gaping mouth contrasts strangely with the king's genial smile' – and Lips stresses the 'considerable difference in attitude between a King who is thanking inspired citizens for their cheers, and the same King scaring devils'.[8]

Hitler's capture of the German Chancellorship in 1933 would soon lead, as Lips put it, to the 'annihilation of all German science' and its supersession by what the new rector of Frankfurt University praised as the 'the militant, the warlike, the heroic'. The African head in the ancient Coburg coat of arms was replaced by a sword and swastika. In March 1933 one of Lips's students – a 'vest-pocket Hitler' who had helped him mount his photographic archive – arrived at his office accompanied by the State Secret Police. They announced that Lips's project was 'contrary to the racial theories

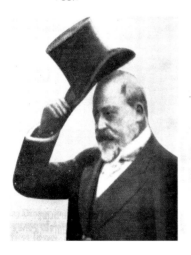 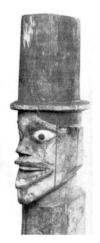

3 Julius Lips, figs 209–10 from *The Savage Hits Back* (1937).

9

of the *Führer*, and the cardboards on which the pictures had been mounted came from the museum and therefore belònged to it'.[9] Lips's photographs included portraits of German military and government officials, produced by 'blacks', and 'the mere possession of the pictures' was deemed to be a 'crime against the State'. Lips fled to Paris, narrowly escaping arrest, and from there travelled to the United States, where he would found the anthropology department at the historically black Howard University. The leading anthropologist Bronislaw Malinowski, writing in 1937 in the introduction to Lips's *The Savage Hits Back*, celebrated a writer who 'is frankly the native's spokesman, not only of the native point of view, but also of native interests and grievances'.[10]

One hundred and twenty-five years after E. H. Man photographed in the Andamans and Nicobars, and 500 miles north across the Bay of Bengal, the camera was called upon as a kind of amulet. It was September 2007 and Buddhist monks in Burma were leading a popular revolution. 'Those of you who are not afraid to die, come to front' we hear an organizer shout to a crowd of monks and students as troops from the Burmese

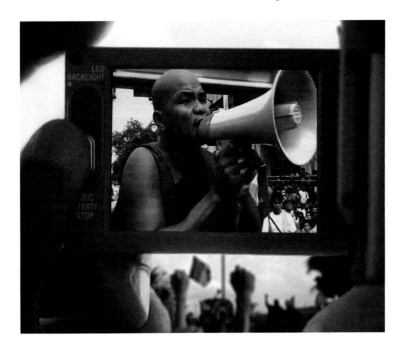

4 *Burma VJ* (Anders Østergaard, 2009), still.

Army start to 'contain' a large protest march. It is clear that the sense of a global photographic witness reassures these brave protestors. Clandestine video journalists allied with The Democratic Voice of Burma film the ensuing chaos and the deaths, including that of a Japanese photojournalist whose killing is repeatedly shown in Anders Østergaard's film *Burma vj*. The film provides a chilling insurrectional point of view, reusing film shot with a new mobile technology from the point of view of the protestor on the street (illus. 4), and smuggled out beneath the coercive surveillance of the generals. The events in Burma in 2007 mark a kind of limit point for anthropology and photography: this is cultural struggle and the struggle for political and representational autonomy in a seemingly post-anthropological world. If everyone has a camera, is there any role, any longer, for the anthropologist with a camera?[11]

Picture Anthropology

There are many anthropologies. However, one version of anthropology has closely, and critically, scrutinized its colonial past, and one version of anthropology has subjected itself to ethico-political self-critique more trenchantly, perhaps, than any other practice in the social sciences and humanities. Because of this, anthropology (or at least one version of it) occupies a good place – perhaps a uniquely privileged place – from which to consider the relationship between images and culture, and images and power. Anthropology's engagement with cross-cultural questions of causation, evidence, personhood and monumentality (among many other concerns) demands that a history of its engagement with a technical practice (photography) so inextricably linked to all those themes itself becomes anthropological.

Michel Foucault suggested that anthropology (in his usage 'ethnology'), along with psychoanalysis, was one of the modern age's 'countersciences'.[12] Both formed a 'treasure-hoard of experiences and concepts, and above all a perpetual principle of dissatisfaction, of calling into question, of criticism and contestation of what may seem, in other respects, to be established'.[13] Consequently, this is no tame history of an emergent

discipline's exploitation of photography. It tries to ask, instead, what an anthropological destabilization of the relationship between anthropology and photography might look like.

Among the most anthropologically charged insights into photography, the origins of what would later come to be called *Bild-Anthropologie* by the art historian Hans Belting,[14] were developed by the cultural critic Walter Benjamin in the 1930s. In an account that is decidedly anthropological in its sensibility, Benjamin described how early photography deposited aura in its 'ultimate point of retrenchment' – the face. The technology for the production of these faces created a new time-space: 'The procedure itself caused the subject to focus his life in the moment rather than hurrying on past it; during the considerable period of the exposure, the subject . . . grew in to the picture, in the sharpest contrast with appearances in a snapshot'.[15] In consequence, daguerreotypes transcribed peculiarly powerful individualized physiognomies. Benjamin cites Karl Dauthendey's anxiety about the facial presence in these early images: 'We were abashed by the distinctness of these human images, and believed that the tiny little faces in the picture could see *us*'.[16] In a retort that leaps across the years like a vein of silver in a dark passageway,[17] recent anthropology reports that the Banyankole of south-western Uganda scratch out the eyes from photographs of the deceased 'to stop the dead "looking back" at the living'.[18]

While much photographic self-publicity stressed its astonishing newness, its radical dissimilarity to what had gone before, Benjamin seeks out affinities with archaic and universal practice. Photographers are revealed as the descendants of 'augurs and haruspices', photography opens up an 'optical unconscious', and 'make[s] the difference between technology and magic visible as *a thoroughly historical variable*'.[19] Benjamin suggests here that technology and magic do not belong to entirely separate worlds. Technology suggests the apparatus of the camera and its chemical way of referring to the world. Magic suggests a contagion of qualities and the ability to produce effects beyond the range of ordinary bodies (illus. 5). The augurs (Roman priests who studied the flight of birds as symptoms of future events) and the haruspices (who prospected in bones and entrails) remain with us in the form of the photographer whose magical

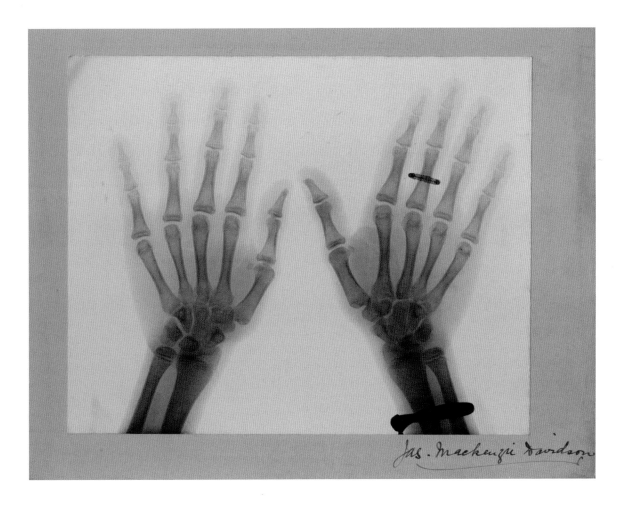

Jas. Mackenzie Davidson

5 James Mackenzie Davidson, x-ray photography, the subject of experiments by various physicists from the late 1880s onwards, provides a visual metaphor of photography's 'divinatory' potential.

images offer diagnoses of past and future events. Benjamin wants to place magic and technology on the same spectrum, the one fading into the other, and each having the potential to erupt into each other's time.

This Benjaminian perspective would only be explicitly acknowledged by anthropologists (such as, for example Alfred Gell[20] and Michael Taussig[21]) at the close of the twentieth century, and yet I will suggest that it can inform our understanding of much about the relationship between anthropology and photography throughout the nineteenth century. The parallels between technology and magic and the questions of a bigger

Bild-Anthropologie were, to draw again on Benjamin: 'meaningful yet covert enough to find a hiding place in waking dreams'.[22]

Photography as a Kind of Writing

An early anxiety about native speech was part of the background against which the anthropological potentiality of photography was defined. This was one aspect of its doubly de-Platonizing agenda: for Plato, writing was a lifeless and dangerously disseminatory technical system, just as the shadows and external forms it preserved were degraded copies of the truth of the mind. For early anthropologists, external forms offered stability and reassurance through what E. B. Tylor would later call 'object lessons'. Anthropologists wanted raw data about the incredible diversity of the world's peoples. By 1922 Sir James Frazer – author of *The Golden Bough* – was able to praise the new ethnography that resulted from very lengthy residence in the 'field'. Introducing Bronislaw Malinowski's paradigm-changing *Argonauts of the Western Pacific*, Frazer noted that the author had 'lived as a native . . . conversing with them in their own tongue, and deriving all his information from the surest sources – personal observation and statements made to him directly by the natives in their own language without the intervention of an interpreter'.[23]

It would have been very difficult to make such an assertion in the nineteenth century. Anthropologists were suspicious of verbal data and 'personal observation' lacked the methodological rigour that it would later acquire. There was a twofold problem with 'native testimony': anthropologists were quite likely not to understand it because most lacked the necessary linguistic competence, but they were also sceptical of the transparency of 'natives', assuming that irrelevance, deviation and untruth were likely to predominate. W. H. Flower's observation that 'physical characters are the best, in fact the only tests . . . language, customs, etc. may help or give indications, but they are often misleading'[24] articulated a widespread distrust of linguistically culled information. Later, even E. H. Man (who was skilled in the languages of the Andamans and Nicobars where he worked) would argue that 'more correct

information [can] be obtained from photography than from any verbal description'.[25] We might add to this a profound uncertainty about *what kind* of statement would be deemed relevant to an anthropology in the making. As with any new intellectual practice and disciplinary formation, it is important to retain a sense of the incoherence and contradiction that attended its historical articulation. It is important not to endow it retrospectively and anachronistically with a purpose and unity it lacked.

In this respect it is crucial to underline how uninterested many nineteenth-century anthropologists were in 'culture'. For much of that century it was the human body that constituted the proper terrain for study and for many, anthropology was little more than a form of comparative anatomy. An anthropological definition of 'culture' did not emerge until 1871, in Edward Burnett Tylor's *Primitive Culture*. Further, there was no single methodology. Much of what would be called 'anthropology' was the product of a division of labour between 'men on the spot' and theorists and synthesizers based in the colonial metropole (Oxford, Paris, Berlin and elsewhere). The men on the spot might be missionaries, traders or colonial administrators. And some of those did their own work of theorizing and publishing without resorting to a Tylor or a Frazer to mediate their observations.

Photography was quickly recognized as a vital tool in the transmission of data, and what was thought to be reliable data at that. Photography's chemical connection to what it depicted, the fact that, as Benjamin wrote, it was 'seared with reality',[26] suggested that it might be capable of capturing and conveying 'facts about which there is no question'.[27] While the anthropologist was sundered from the 'man on the spot', photography was recognized as a crucial mediator. The emergence of fieldwork towards the end of the nineteenth century as a methodology central to anthropology's new vision of itself (through the work of men such as James Mooney, Franz Boas and Alfred Cort Haddon) collapsed the earlier separation of labour: the anthropologist was now to do all their own research. Many figures associated with Haddon, particularly W.H.R. Rivers and Charles Gabriel Seligman, were pioneers of this new sacred protocol, but it was the self-mythologization by Bronislaw

Malinowski that would enshrine him, in the early twentieth century, as the founder of a new discipline. The chapter that now follows traces photography's centrality to this emergent anthropology.

one

The Doubled History of Photography and Anthropology

The coincidence of the establishment of the Aborigines' Protection Society in 1837 and the founding of the Ethnological Society of London in 1843 with François Arago's announcement in 1839 of Daguerre's photographic process, and Fox Talbot's declaration of his 'photogenic drawing' in the same year, draws our attention to the curious echo between the history of photography and that of anthropology.

Like photography, anthropology also has a 'long history' that would extend its significant moments further back than 1839 or 1837. In the case of photography, as Geoffrey Batchen has shown,[1] there were numerous attempts in the early decades of the nineteenth century by enthusiasts 'burning with desire' to produce photographs. It is clear with hindsight that in 1827 Joseph Nicéphore Niépce did in fact produce an image in Varennes using bitumen of Judea that has all the formal characteristics of what would later be understood as a photograph. In a similar manner, anthropology has a prehistory littered with names like Peter Camper and Johann Friedrich Blumenbach, comparative anatomists who were struggling empirically and conceptually with the diversity of humankind. Edward Burnett Tylor was probably the first individual who consistently called himself and thought of himself as an 'anthropologist': in the mid-nineteenth century numerous figures who have been subsequently claimed for the proto-history of anthropology 'would not . . . have defined themselves as "anthropologists"'.[2]

Philanthropy, Observation and Science

The history of anthropology, like the history of photography, involves many decades of enquiry punctuated by occasional memorable dates. The establishment in 1837 of the Aborigines' Protection Society (APS) was largely the result of the Quaker pathologist Dr Thomas Hodgkin's commitment and energy. Hodgkin founded the British African Colonization Society to promote the colonization of Liberia by freed African-Americans and was in part motivated to found the Aborigines' Protection Society by his concern about the plight of Native Americans. In the year the APS was launched his promotion at Guy's Hospital was blocked by the hospital's treasurer, Benjamin Harrison, who was also deputy chairman of the Hudson's Bay Company and had been angered by Hodgkin's interventions.[3] The APS set about '"correcting" false assumptions about aboriginal peoples – especially the belief that they were naturally inferior or devoid of physical or intellectual capabilities'.[4] This, as Ronald Rainger suggests, was the 'scientific' means to an ethical end – the more humane treatment of colonial subjects.

The Société Ethnologique de Paris was founded in 1839 – photography's *annus mirabilis* – as a direct result of Hodgkin's visit to Paris on behalf of the APS. Because France was deemed to lack 'colonial aborigines' requiring protection, the Société would take a very different – more 'scientific' and less humanistic – direction.[5] France would, however, lead the way in joining the practice of a nascent anthropology with that of early photography. The anatomist E.R.A Serres would display daguerreotypes by Adolf Thiesson of a Botocudo man and woman to the French Academy of Sciences in 1844 (illus. 6),[6] and publish short observations concerning the usefulness of photography in the study of race in the same year[7] and on anthropological photography in 1852.[8] In 1856 Ernest Lacan would enthuse about the possibilities of photographic portraits of Indians, Africans and Russians for the study of mankind.[9] Among the earliest photographs to be found in British collections are a pair of photographs of skulls, captioned 'Gallerie d'Anthropologie du Museum' and dated 1854, which found their way into a large album compiled by J. Barnard Davis[10] alongside early photographs of a skull from the Andamans, and Assamese studies by E. H. Higgs dating from 1861 (illus. 7). The Royal

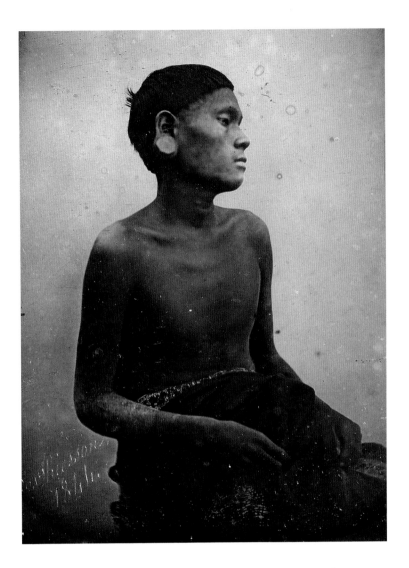

Anthropological Institute Photographic Collection possesses a large
album of photographs from the US Geological Survey of 1877 that
contains an 1868 albumen copy of Thomas M. Easterly's haunting
daguerreotype of the Sauk chief, Keokuk, Watchful Fox. The original
daguerreotype was made in 1847, the year before Keokuk's death on a
reservation in Kansas (illus. 8).

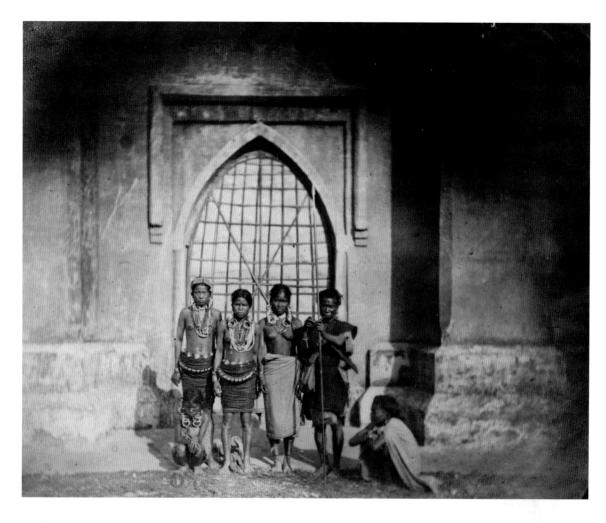

In England, in 1839, a paper by James Cowles Prichard, the leading ethnologist of his day, on 'The Extinction of Native Races', read at a meeting of the British Association for the Advancement of Science, resulted in the formation of a sub-committee (among whose members were Hodgkin and Charles Darwin – recently returned from the *Beagle* voyage) to draw up a questionnaire 'for all who came into contact with native races'.[11] Published as *A Manual of Ethnological Inquiry*, this was the forerunner to *Notes and Queries on Anthropology*, a methodological handbook that would

7 E. H. Higgs, *Abors*, 1861, from the album compiled by J. Barnard Davis in the mid- to late 1860s, which included some of the earliest examples of anthropological photography.

foreground the potentiality of photography for anthropologists in the late nineteenth century.

The *Manual*'s engagement with historical transformation is striking ('recent observation may differ from the older in consequence of changes that may have taken place in the people') and Hodgkin's concerns are evident in the advice that 'when colonization is contemplated, the facts contained in the replies to these queries will point out the mutual advantages which might be obtained by preserving, instead of annihilating, the aboriginal population'. A lengthy section on 'Physical Characters' enquires about 'the prevailing complexion' and wonders whether it is impossible to 'describe colour by words', recommending that the colour be imitated on paper. Hair specimens can be collected and the character of eyes should be fully and accurately described. Further, 'it is very desirable to obtain individual likenesses by means of some photographic process'.[12]

In 1843 Hodgkin, together with Richard King, helped found the Ethnological Society of London. After a separation from the Anthropological Society led by James Hunt in the 1860s (a split precipitated by the latter's explicitly racist programme), this would further evolve into the Anthropological Institute in 1871.[13] Recognizing the political failure of the Aborigines' Protection Society, a memo by King stressed the need for the study of the 'natural history of man . . . the collection and classification of materials on the races of man . . . and the establishment of a correspondence with similar societies with persons residing in remote, predominantly non-European countries'.[14] The emergence of institutional practices that claimed the name of ethnology and anthropology coincided, in Britain and in France, with the appearance of photography, and as these practices of anthropology started to formalize their interests in new forms and possibilities of data, photography would emerge as an increasingly vital mode of data capture and transmission.

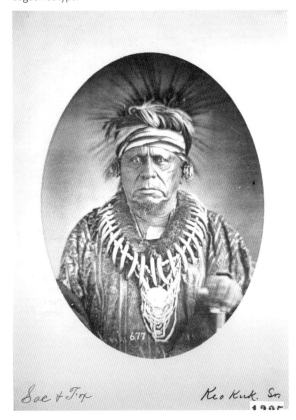

8 Thomas M. Easterly, *Keokuk, Watchful Fox, Head of the Combined Sauk and Fox*, 1868, albumen print, copy of an 1847 daguerreotype.

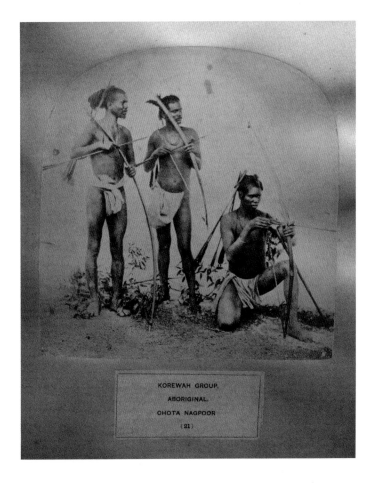

KOREWAH GROUP,
ABORIGINAL.
CHOTA NAGPOOR
(21)

9 Benjamin Simpson, *Korewah Group: Aboriginal Chota Nagpoor*, plate 21 in J. Forbes Watson's and John William Kaye's *People of India* (1868) albumen print.

The earliest photographs came to the attention of the Ethnological Society through a variety of routes. Commercial, missionary and official photographs of 'anthropological interest' were occasionally shown and discussed at the Society's Ordinary Meetings and some records of these survive in printed proceedings. Official photography took various forms. One of the earliest and most ambitious projects, *The People of India*, was displayed at a meeting chaired by Thomas Henry Huxley on 9 March 1869 alongside a wealth of other Indian artefacts (including twelve quartzite implements from Madras and twenty almond-shaped implements from the Bundlecund[15]). Huxley in his address noted that:

The Indian Museum has been good enough to place its wonderful collection of photographs at our disposal; and by Dr Forbes Watson's kindness, they are disposed around this theatre [in the Museum of Practical Geology, in Jermyn Street] in a manner which makes them accessible to everyone.[16]

Huxley's account suggests that loose sheets were exhibited rather than a single bound volume, and it is easy to imagine a small audience fascinated by images such as Benjamin Simpson's photograph of three Korewah hunters from Chota Nagpur (illus. 9), which appeared in the first volume of *The People of India*, published in 1868, and engrossed in the accompanying letterpress' account of how the brother of 'their chief' had persuaded them to be photographed:

They had never been so far from their homes and never been seen by a European. As Dr Simpson had not arrived, it was found necessary to detain them for some days, and their alarm at this was excessive. It is possible that they regarded the good feeding they were indulged in as but the preparation for the sacrifice they were destined to be the victims of.[17]

Indian photographs were also shown by individuals such as Dr A. Campbell, the former Superintendent of Darjeeling, who exhibited images of Limboos, Lepchas and others alongside 'articles of clothing, arms, and other objects illustrative of the tribes.[18]

Commercially produced images were also avidly collected and displayed, testimony to the power of the photograph itself rather than the authority of the person who had made it. From Australia, images of the 'Last of the Tasmanians' by the Hobart photographer Charles A. Woolley, commissioned for the Intercolonial Exhibition in Melbourne in 1866, potently evoked the mournful sense of a world transformed by colonialism (illus. 12). J. W. Lindt's Grafton River studio in New South Wales produced elaborately staged tableaux of local Aboriginal people in the mid-1870s (illus. 10) which are to be found in all the major British anthropological photographic collections alongside images by

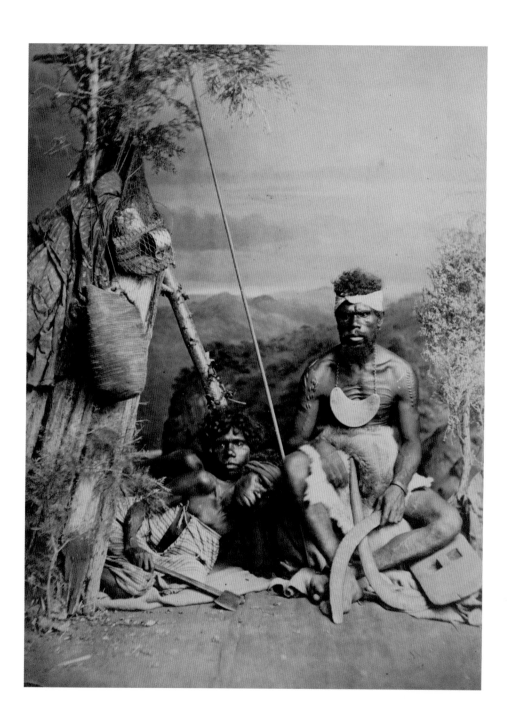

11 'Kerry's Series of Photographs', a printed list of Charles Kerry's albumen prints of Australian Aboriginal subjects, 1890s.

10 J. W. Lindt, Aboriginal group posing in Lindt's Grafton River studio, c. 1870s, albumen print.

Charles Kerry, whose lists of photographs of Corroborees and 'Aboriginal warriors' were eagerly studied by early scholars for whom a properly 'anthropological' photographic practice had yet to emerge.

In its early usage photography's ability to generate what C. H. Read would later term 'facts about which there can be no question'[19] was the balm for a widespread discomfort about the foundations of the new science. In due course, as we shall see, the certainty that photography seemed to offer would generate further anxieties peculiar to itself.

The ethical dimension of the APS clearly ruffled many feathers (as Hodgkin found out to his cost), but it was easy to justify conceptually: a monogenetic theory of human origins underpinned by liberal Christian sentiment produced a single human community in whose interests it was imperative to act. But the transformation from morals to science was harder: how was one to observe other members of one's own species? The anthropologist and founder of the Folklore Society, Andrew Lang, put it this way: 'Man cannot be secluded from disturbing influences, and watched, like the materials of a chemical experiment in a laboratory.'[20] Haddon, who quotes this in his *History of Anthropology*, and who will himself star in a leading role later in this narrative, considered the difficulty of establishing 'a firm scientific basis' to be the major 'stumbling-block' in the ascendancy of 'comparative ethnology', and goes on to detail common accusations concerning the reliability of anthropological observation: 'How can you pretend to raise a science on such foundations, especially as the savage informants wish to please or to mystify inquirers, or they answer at random, or deliberately conceal their most sacred institutions?'[21]

Lang and Haddon here dramatize a divide that will resonate for many decades through anthropological engagements with photography: between on the one hand culture as a lived practice caught up in the rhythms and idioms of speech, and on the other culture as objectified in visual and material representation, culture in other words as a form of 'writing'. Culture itself as a lived complex of practices was inherently problematic, subject to the vagaries of linguistic practices with which most anthropologists felt uncomfortable (and whose 'translatability' would continue to be questioned, via Clifford Geertz's 'interpretive anthropology' right through to the present day). Culture

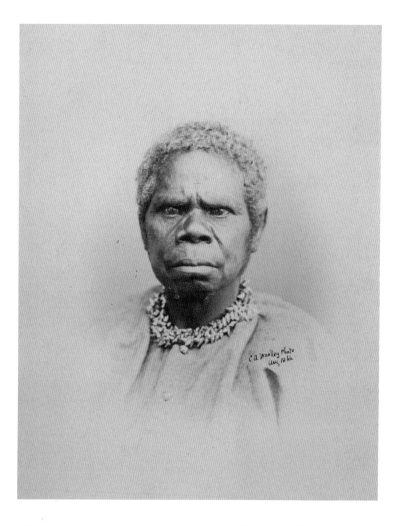

12 Charles A. Woolley, *Portrait of Trucanini*, 1866.

as lived practice was mercurial, and potentially inscrutable. Material objectifications (what Tylor would call 'object lessons'), and even better the incontrovertibility of the photograph, appeared to offer a more solid resting-point, but this stability and stasis was itself – it was increasingly recognized – a corruption of that fragile object that anthropologists anxiously sought.

 This was inherent in what Martin Heidegger would term the 'world as picture', that way of viewing the world as something fundamentally

13 Unknown photographer, 'The Dialect of the Academy Figure', Madagascan man photographed against a 'Lamprey grid', *c.* 1870s, albumen print.

14 Unknown photographer, *Boxall No. 1. East India*, man photographed against a 'Lamprey grid', c. 1870s, albumen print.

separated from the observer. Knowability in advance and substitutability were proofs of the power of one's system of viewing but they also involved a destructive power over what is observed. J. H. Lamprey's 1869 proposal that anthropologists photograph their subjects against a background grid of 5-cm (2-inch) squares formed by hanging silk thread on a large wooden frame (illus. 13) was designed to surmount difficulties in the 'questions

of comparison' that anthropologists had to confront when uniquely embodied individuals were represented in diverse ways: 'By means of such photographs the anatomical structure of a good academy figure or model of six feet can be compared with a Malay of four feet eight in height'.[22] Lamprey's system (which via Huxley and the Colonial Office became globally distributed) strove for a homogeneity predicated on the destruction of singularity and embodiment. The grid, created by the suspension of silk threads, sought to transform the presence of unique bodies into what we might think of as somatic prototypes within 'the realm of man's knowing and of his having disposal'.[23] For Lamprey, individual variation was an obstacle in the way of his desire for a complete visual knowledge that would assimilate bodies as data in a vast system of comparison. But it is striking how individuals still emerge in these gridded images: one bearded man who appears in a photograph in the British Museum's collection is captioned 'East India[n], has been in this country some years, sat as a model at the Kensington Museum, late years kept a Turkish bath' (illus. 14).[24] Elizabeth Edwards perceptively notes how many of these images are infected by the 'dialect of the academy figure'.[25] Other images in the same collection reveal two men – one white and one black (labelled 'Europe' and 'Africa') – in a series of homoerotic poses invoking the imagery of St Sebastian that are utterly disruptive of the *eidos* of the grid.

Magic and Technology as Historical Variables

For Haddon, as for many others, E. B. Tylor was the 'master-mind . . . guiding the destinies of the nascent science'.[26] Anthropology would come to be widely referred to as 'Mr Tylor's science'.[27] Tylor would also famously declare that 'The science of anthropology owes not a little to the art of photography.'[28] Tylor was the driving force behind the establishment of *Notes and Queries on Anthropology*, whose first edition was published in 1872.[29] It was intended for the use of 'travellers and residents in uncivilized lands', and the manual's table of contents announced a section concerned with 'instructions for the use and transport of the photographic

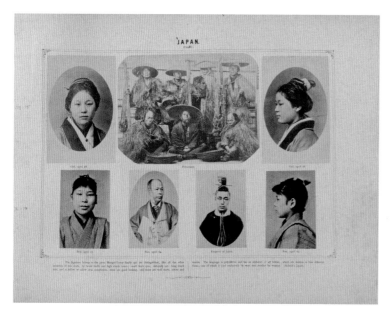

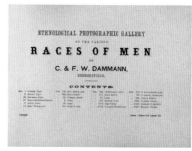

15 Title page from Carl and F. W. Dammann's *Ethnological Photographic Gallery of the Various Races of Men* (1876) the smaller and cheaper version of their *Anthropologisch-Ethnologisches* album of the same year.

16 Carl and F. W. Dammann, 'Japan', plate XI from *Various Races of Men* (1876) albumen prints.

apparatus', but its realization would have to wait until the second edition in 1892. In 1876 Tylor would write enthusiastically in *Nature* about Carl Dammann's album, praising it as 'one of the most important contributions ever made to the science of man' and noting anthropology's dependence on photography and the superiority of its indexical traces: 'most engravings of race-types to be found in books [are] worthless . . . Now-a-days little ethnographical value is attached to any but photographic portraits'.[30] The Berliner *Gessellschaft für Anthropologie* had commissioned Dammann, in Hamburg, to make copy negatives of photographs that the Berlin Society had collected from expatriate Germans. This resulted in an *Anthropologisch-Ethnologisches Album*, and a subsequent cheaper English edition which, following Carl Dammann's death in 1874, was continued by his half-brother Frederick Dammann, who, improbably enough, taught the zither in Huddersfield.[31] The cheaper edition, Tylor noted, 'will make new anthropologists wherever it goes'.[32]

He expands this sentiment in his introduction to the English translation of Friedrich Ratzel's *The History of Mankind*, published in 1896 in three magnificently illustrated volumes. There are over a dozen chromo-

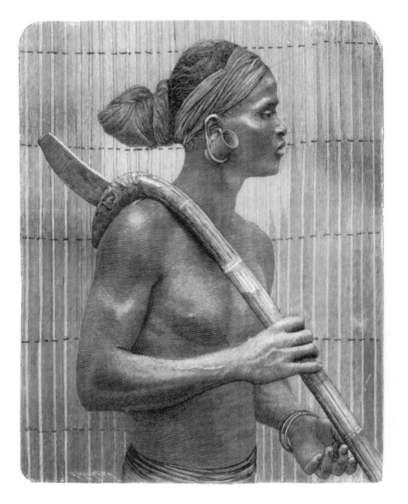

17 'A Moi, from the hills of South-West Annam', 1890s, steel engraving based on a photograph by Rosset.

lithographic plates but the bulk of the many hundreds of illustrations are engravings, mostly derived from photographs. Tylor draws immediate attention to the wealth of visuals, praising the 'illustrations, 1160 in number, which in excellence surpass those which had hitherto come within the range of any work on Man intended for general circulation'.[33] These illustrations, Tylor argues, are no 'mere book decorations' but 'object lessons'. He celebrates a broad regime of visual and material knowledge, of which photography occupies one part of the spectrum. This visual evidence offers a guide that 'no verbal description can attain to':

The habit of constant recourse to actual objects is of inestimable use to us in the more abstract investigation of ideas . . . the sight of material things . . . gives a reality and sharpness of appreciation which add much to the meaning of words.[34]

Warming to his theme, Tylor ends his introduction with a crescendo of examples demonstrating the incisive illumination offered by material representations and their superiority over the vagaries of language. The simple huts of Tierra del Fuego, the huge village-houses of the Malays, the decorated roof posts of British Columbia and the 'rude human figures' in which 'spirits take their embodiment' are all examples where 'a more positive knowledge' can be gained than from 'vague though not unmeaning language'.[35]

Tylor expresses a wider sentiment of his time: a very particular kind of enthusiasm for knowledge generated by surface appearance. It is an enthusiasm, we should be clear, that is born out of a disparagement of anthropologists' slightly earlier enthusiasm for knowledge generated by the surface of bodies. Tylor – famously the inventor of the earliest anthro-pological concept of culture – marks the move from bodies to cultures as the site of knowledge. In *Primitive Culture* he had written of culture as 'that complex whole which includes knowledge, belief, art, morals, law, custom, and any other capabilities and habits acquired by man as a member of society'.[36] Tylor here attempted to remove the physiological and 'racial' from the ambit of anthropology, and reconstituted man as the primary bearer not of a genetic inheritance but of one that was fashioned by society.

Some years earlier, in 1866, Tylor, who throughout his career was openly hostile to religion, published 'The Religion of Savages' in the famously liberal reformist periodical *The Fortnightly Review*. Here he first outlined his ideas about animism, arguing that the origin of religion lay in dreams and hallucinations in which spirits appeared to inhabit trees and stones.[37] In retrospect, it is possible to trace a symmetry between this central theoretical concern of his work and his enthusiasm for photography, but the evolutionary disparagement of 'primitive' thought ('pernicious delusions that [vex] mankind'[38]) blinded him at the time to the homology

between photography and the life to be found in shadows and doubles. Tylor's writing and actions can be seen as caught in this contradiction and the desire to suppress an incipient insight about the way in which his own time was increasingly configured by the presence of magical images whose time – in theory – ought to have passed.

This historical contradiction is an issue he confronts directly at various points with respect to 'modern spiritualism'. In 'The Religion of Savages' he had insisted that 'every ethnographer' knows that spiritualism 'is pure and simple savagery both in its theory and the tricks by which it is supported'.[39] One consequence of spiritualism, he complains, in his masterwork, *Primitive Culture*, is that 'Apparitions have regained the place and meaning which they held from the level of the lower races to that of medieval Europe'[40] and he then imagines a 'wild North American Indian looking on at a spirit-séance in London' and feeling 'perfectly at home'.[41] At the heart of animism – the attribution of living qualities to inanimate objects – was the 'apparitional-soul' or 'ghost-soul', which he described as 'a thin unsubstantial human image, in its nature a sort of vapour, film, or shadow . . . capable of leaving the body to flash swiftly from place to place'.[42]

This theoretical antipathy was much more ambivalent in practice. In 1872 Tylor conducted a month's ethnographic fieldwork among leading London spiritualists, knowledge of which we owe to George Stocking's discovery of Tylor's diary in the attic of the Pitt Rivers Museum in Oxford.[43] The diary contains several photographs – one of the Fox Sisters of Rochester, an image showing 'William Howitt (in the flesh) and [his] granddaughter (in the spirit)' (illus. 18)[44] and a final photograph whose inscription by Tylor declared that he had bought it at 'Burn's 15 Southampton Row, for 1/s[hilling] under the distinct assertion that it was a real spirit photograph' (illus. 19).[45] Tylor records a fascinating discussion with the leading spiritualist the Revd William Stainton Moses on 24 November 1872. Smoking together, and walking around the grounds of a house in Hendon at which a seance had been held the previous evening, Moses showed photographs 'taken with blurs of white, behind'. Tylor conjures a sense of his own potential willingness to be convinced and of Moses's ambivalent responses: the white blur, Moses suggested, 'might have been made by waving a white

Spirit-photograph of William Howitt
(in the flesh) and granddaughter (in the spirit)

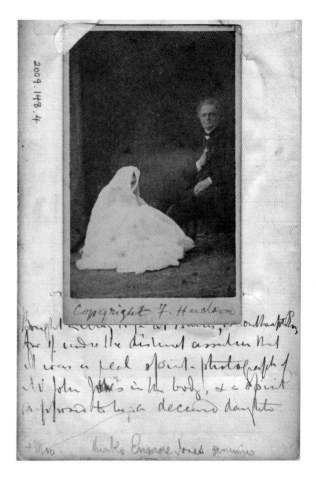

2009.148.4

Copyright T. Hudson

handkerchief'. Moses's general observations 'on the question of the spirit photographs though professing scepticism', Tylor concludes, 'tended to confirm [their] reality . . . in certain circumstances'.[46]

In his 1881 *Anthropology*, the first anthropology textbook, Tylor wrote of a 'natural explanation' that 'every man's living self or soul is his phantom or image, which can go out of his body and see and be seen itself in dreams. Even waking men in broad daylight sometimes see these human phantoms, in what are called visions or hallucinations'.[47] Tylor does not explicitly link these observations to the increasing saturation of his own society with photographic images, and there is certainly no reference to his own ambivalence in that London garden with the Revd Moses, although his text is scattered with engravings based on photographs,

18 'Spirit Photograph of William Howitt (in the Flesh) and Granddaughter (in the Spirit)', 1872, annotated *carte-de-visite* from Edward Burnett Tylor's 'spiritualism' fieldwork diary.

19 'Bought at Burn's, 15 Southampton Row, for 1/s under the distinct assertion that it was a real spirit photograph of Mr John Jones in the body and the spirit supposed to be a deceased daughter', 1872, *carte-de-visite* from Edward Burnett Tylor's 'spiritualism' fieldwork diary.

the originals of which he credits to 'Messrs Dammann of Huddersfield from their valuable Albums of Ethnological Photographs'.[48]

In that same book Tylor noted the 'curious contrast' between the phonograph and a South Sea Islander's amazement with a 'talking chip'. The chip was a piece of wood upon which the missionary John Williams wrote a request in charcoal for a woodworking tool he had forgotten. He asked a 'native chief' to take this to Williams's wife and, Tylor records, the Islander was 'amazed to find that the chip could talk without a mouth [and] for long afterwards carried it hung by a string round his neck, and told his wondering countrymen what he saw it do'.[49] The recently invented phonograph,[50] with its strip of foil whose indentations replayed the sound previously inscribed upon it, made the South Sea Islander's understanding of the technology of reproduction 'hardly unreasonable'.[51] This allusion to the phonograph is the nearest that Tylor comes to envisioning the parallel between animist practices and photography. His commitment to an evolutionary theory of survivals and partisanship in the 'warfare of science and theology'[52] prevented him from understanding photography's power except in rationalist and progressive terms. If, as I have suggested, Benjamin's intuition that photographers were the descendants of the 'augurs and haruspices' is the basis for a truly anthropological theory of photography, it is ironic – although also undoubtedly inevitable – that anthropology's founding father was unable to see this.

Living Beings and Fuzzygraphs

Anthropometric photography – of the kind that Lamprey's grid was designed to systematize – was vulnerable to complaints concerning (to use a phrase from Roland Barthes) its 'mortiferous edios'. The most eloquent complainant was the remarkable, and remarkably named, Sir Everard im Thurn, who in an illustrated talk at the Anthropological Institute in 1893 outlined his vision for 'Anthropological Uses of the Camera'. Im Thurn pursued an astonishing career as a museum curator, botanist, anthropologist and colonial administrator successively in Guiana, Ceylon and Fiji, finally working as High Commissioner of the

Western Pacific from 1904 to 1910. He was known to E. B. Tylor, and was elected President of the (by then 'Royal') Anthropological Institute in 1919.[53] Outside anthropology he is perhaps best remembered as the author of travel narratives that were the inspiration for Conan Doyle's *The Lost World*.[54]

Im Thurn argued that anthropologists had been preoccupied with the camera as a tool to record the lifeless bodies of 'primitive folk'. These might indeed 'be more accurately measured and photographed for such purposes dead than alive, could they be conveniently obtained when in that state'. Im Thurn urged the rejection of such practices:

> Just as the purely physiological photographs of the anthropometrists are merely pictures of lifeless bodies, so the ordinary photographs of uncharacteristically miserable natives . . . seem comparable to the photographs which one occasionally sees of badly stuffed and distorted birds and animals.

His alternative was that the anthropological camera should be used to depict their subjects as 'living beings'.[55]

Im Thurn narrates his first attempt to photograph a Carib 'red man' at the mouth of the Barima river. Posed high up on a mangrove root,

20 Everard im Thurn, *A Macusi Lad in Full Dancing Dress*, c. 1883.

21 Everard im Thurn, *Arawak Whip Game*, c. 1884.

Im Thurn's subject 'sat quite still while I focussed and drew the shutter. Then, as I took off the cap, with a moan he fell backward off his perch on to the soft sand below him'. Equally frustrating was the common habit of subjects suddenly concealing their faces at the moment of exposure, through fear of 'having their features put on paper'.[56] The photographs he displayed during his talk (illus. 20, 21) were sensual and empathetic images of Caribs and Warrau among whom he lived 'as they do'[57] for prolonged periods. Other colonial administrators during this period used photography empathetically to produce very extensive documentation of the societies in which they worked. E. H. Man, who appeared in the Nicobarese drawing opening this account, would be a fine example. Resident in the Andamans and Nicobars for almost 30 years from 1869 onwards, he was an exceptionally skilled and industrious photographer

whose work was an attempt to come to terms with the 'insoluble dilemma' presented by his work as Officer in Charge of the Andaman Homes, contributing to the destruction of a life-world with which he clearly identified.[58]

22 E. H. Man, two-plate panorama of Dring, Comorta Island, Nicobars, c. 1880s.

Im Thurn's aesthetic agenda seems, however, not to have impacted on Maurice Vidal Portman (1861–1935), an eccentric and cantankerous 'Officer in Charge of the Andamanese' who would frequently come into conflict with Man. Ten years after taking his first appointment in the Andamans in 1879, he would offer the British Museum 'a series of photographs of the Andamanese aborigines, in their different occupations and modes of life'. Portman's object, he continued, was 'to show every step in the making of a weapon, etc., so clearly, that with the assistance of the finished articles now in the British Museum, it would be possible for a European workman to imitate the work'.[59]

The final – unfinished – project is probably the largest and most ambitious of its kind in the history of British colonialism and comprised eleven large volumes (of anthropometric and 'process' studies; illus. 23) and four smaller volumes of physiological data and photographs. These latter volumes presented 54 categories of data from schedules titled 'Observations on External Characters', such as height, rates of abdominal breathing, temperature and weight. The original schedules also included

23 Maurice Vidal Portman, *Andamanese Adze Production*, 1893.

tracings of the outlines of hands and feet, recalling the advice at the end of the section on 'paper squeezes' in *Notes and Queries on Anthropology* on the useful supplementary value of tracings: all served as associated indexes, vehicles of data transmission.[60]

In 1896 Portman would publish – with the encouragement of Charles Hercules Read – a paper on 'Photography for Anthropologists' that provides

insights into his huge work in progress (he refers to his 'partly finished' 'Record of the Andamanese' executed for the British Museum) a project which, in its archaic coloniality, establishes a backdrop against which Haddon's innovative expeditional-fieldwork practices (to be described shortly) acquire a great clarity. Portman announces the inadequacy of the existing *Notes and Queries* chapter on photography for it did not 'answer all the questions which an explorer who intended to photograph for anthropological purposes would be likely to ask'.[61] Portman approvingly cites Read's earlier *Notes and Queries* eulogy concerning the 'facts about which there can be no question' that photography was capable of delivering and then argues for photography's importance to all anthropology, pointing out that Parts I and II of *Notes and Queries*, which dealt with physical anthropology and technology, respectively, demanded photographic responses. 'Physiognomy' required photographs taken of subjects at different ages: 'These should be stark naked, a full face and profile view should be taken of each, and the subject should touch a background painted in black and white chequers, each exactly 2 inches square.' Photography would likewise 'be found of the greatest use' in answering questions about technology 'correctly'. 'The manufacture of different implements, weapons, &c. (each stage from the rough material to the finished article being shown), indeed almost every act of the life of a primitive people may be photographed.'[62]

Portman's language is littered with demands for clarity: native bodies must be *stark* naked, and all 'aesthetics' are to be avoided:

> For ethnology, accuracy is what is required. Delicate lighting and picturesque photography are not wanted; all you have to see to is, that the general lighting is correct, and that no awkward placing of weapons or limbs hide important objects.[63]

Similarly, 'Do not retouch or add clouds &c. to scientific photographs'.[64] Portman's anthropology emerges in its starkness and accuracy through its avoidance of a dangerous aesthetic: 'A good *focussing glass*, as kept by any good firm, is required, and should always be used as our object is to get great and accurate detail, not to make pictures. "Fuzzygraphs" are quite out of place in anthropological work.'[65]

This powerful sense of the anxious discipline at work in the construction of anthropology's disciplinarity is further reinforced by his insistence on an austere colonial sensibility. There was a logistical and a psychic dimension to this. Logistically, 'native servants and savages' could be entrusted with the 'mere manual work of cleaning',[66] but expensive equipment had to be protected: 'Lock up all apparatus from savages and others.'[67] He notes the necessity of patience when dealing with sitters, but this is not a mark of geniality or ease but of discomfort with the potential blurring of colonizer/colonized identities:

> If a subject is a bad sitter . . . send him away and get another, but never lose your temper, and never show a savage that you think he is stupid, or, on the other hand, allow him to think that, by playing the fool, he can annoy you, put you off your work, or that to stop him you will be willing to bribe him into silence.[68]

Finally, one is struck by Portman's desire to abstract and extract: bodies require dislocation from a context infected with the aesthetic corruption of the picturesque. If subjects are not to be photographed against his chequered-flag version of the Lamprey grid, 'A dull grey or drab background, being unobtrusive, is the best.' If foliage is the only option 'it should be as much out of focus as possible'. If a fire can be arranged then the 'smoke of a damp leaf fire makes a good background, and is of use in blotting out foliage, &c., which are not required in the photograph'.[69] The negatives that result should be filed systematically, and 'as soon as you can' a print should be made that can be pasted in a notebook together with 'detailed description[s] of the facts illustrated'.[70]

Being There

Portman was writing at a time when the implosion of the scholar and 'man on the spot' was spreading fast. The year 1888 was a signal one in the history of 'being there'. In North America, James Mooney was working under the auspices of the Bureau of American Ethnology. He first

24 James Mooney, Arapaho followers of the Ghost Dance religion, Cheyenne/ Arapaho Reservation, Darlington, Oklahoma, 1891.

took a camera to the field in 1888, and in 1890 became aware of the growing Ghost Dance cult, a messianic resistance movement among Plains Indians that would eventually culminate in the brutal massacre of Sioux at Wounded Knee. Mooney produced resonant images of Arapaho followers of the cult, the imprecision of images produced on a Kodak with 'the campfire smoke and the pallor of winter light reflected on the snow-filled dancing grounds'[71] adding to their plangent quality.

The year 1888 was also the one in which Franz Boas – who would define the course of anthropology in the USA – first met his Kwakiutl (Kwakwaka'wakw) collaborator George Hunt.[72] Boas would return for five brief field trips to the Northwest Coast between 1888 and 1895 and subsequently direct the Jesup North Pacific Expedition between 1897 and 1902.

25 Franz Boas and O. C. Hastings,
Jesup North Pacific Expedition,
British Columbia, 1897–1902.

26 Waldemar Jochelson, Reindeer Koryak offerings on the Jesup North Pacific Expedition, 1897–1902. Koryak initially refused to pose this sacrifice for Jochelson's camera but relented following the offer of two bricks of tea and two bundles of tobacco.

Boas foregrounded new technologies of data collection including the camera and worked closely with a professional photographer, O. C. Hastings, overseeing the composition of his images (illus. 25).[73] Members of the expedition generated more than three thousand photographs, mostly of body types intended to resolve the question of Native American origins, but including some powerful studies of the shamanistic landscape of northern Kamchatka (illus. 26).

Finally, we might note that 1888 was also the year during which Alfred Cort Haddon departed for his first expedition to the Torres Strait, a culturally rich area between Northern Australia and New Guinea. During this first expedition, Haddon pursued the interests of a marine biologist, investigating coral reefs, but his detailed journals reveal his growing interests in what he would later understand to be the subject-matter of anthropology. His biographer Hingston Quiggin records how Haddon's long days collecting on the reef were increasingly followed by 'evenings surrounded by natives "yarning", and, as he gained their confidence, relating what happened "before white man he come"'.[74] Haddon also collected 'curios' for museums as a means of recouping some of the expenses of the expedition and soon found himself absorbed in the 'salvage' concerns of the evolutionist anthropology of his day.

27 Dinner invitation to celebrate the return of Alfred Cort Haddon from the first Torres Strait expedition, 1890.

Haddon returned to Dublin in 1889 and enjoyed (in 1890) an elaborate nine-course celebratory dinner hosted by 24 of his friends and colleagues. The hors d'oeuvre was served with Chablis, the Filet de Boeuf aux Olives with extra-dry 1884 vintage G. H. Mumm. The invitation card was adorned with an albumen print of a negative exposed during his expedition of the kind whose 'repatriation' during his second expedition of 1898–9 would preoccupy so much of his time. Papers on topics like 'Manners and Customs of the Torres Straits' appeared in *Nature* and *Folk Lore* and attracted the attention of the leading Cambridge-based anthropologist J. G. Frazer, who wrote to Haddon urging further publications.

Encouraged to convert from zoology to anthropology and to relocate from Dublin to Cambridge, Haddon then set about organizing a properly anthropological expedition to the Torres Strait. W.H.R. Rivers (at that time lecturing in Cambridge on the physiology of the senses but later to become known to the wider world through his work on shell-shock with the poets Siegfried Sassoon and Wilfred Owen), whom Haddon approached first of

28 Invoice from Newman and Guardia for Alfred Cort Haddon's equipment for the second Torres Strait expedition, 1897. Haddon bought a quarter-plate 'Special Pattern B' N&G camera.

29 Advertisement in the Royal Geographical Society's *Hints to Travellers* for Newman and Guardia's N&G camera, 1901. The 'N&G' range used by Alfred Cort Haddon is advertised at the top and a cheaper, popular, quarter-plate model is shown in the middle.

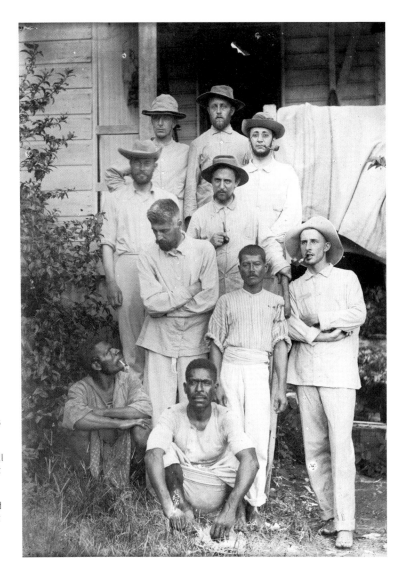

30 Members of the second Torres Straits expedition, 1888–9. Alfred Cort Haddon is on the left, looking down, and then above him, proceeding clockwise: William H. R. Rivers, Charles Myers, William MacDougall and Charles Gabriel Seligman. The linguist Sydney Ray is in the centre and the expedition's photographer, Anthony Wilkin, on the far right. The Torres Strait man seated at left front is Jimmy Rice and to the right of him is Debe Wali. The man in the lower centre is probably the expedition's cook, Charlie Ontong.

all, initially refused, but after discovering that two of his best students – C. S. Myers and W. McDougall – were also going, decided to accept. This group was then augmented by Sidney H. Ray, an elementary schoolteacher, and the only Melanesian linguist of the day, Anthony Wilkin, a Cambridge undergraduate who joined as a supplementary photographer, and finally by Charles Gabriel Seligman. During the course of the expedition Haddon, Rivers and Seligman would all begin to make the transition from the natural

and medical sciences towards a new practice of fieldwork-based anthropology of which they would become the leading exponents. And for all three photography would play a hugely important role (illus. 28, 29, 30).[75]

It is very apparent – from the space that Haddon devotes to this in his journal – that photographs became a crucial pivot of interaction between Haddon and Torres Strait Islanders throughout the second expedition. Within a few days of his arrival he arranged for acquaintances from the first expedition to view photographs: they 'sometimes cried when they saw photos of their deceased friends, but most were in a state of wild delight! I can assure you that it was a steamy and somewhat smelly performance.'[76] This use of photographs as vehicles of conviviality and a means of eroding barriers between anthropologists and locals, as much as a research tool, stands in strong contrast to Portman's insistence on the act of photography, and the subsequent use of photographs, as a theatre for the staging and reinforcement of colonial asymmetry.

Haddon's photography is also distinctive for the way in which it intervenes in the world that it attempts to describe. At many points in his journal and in his subsequent published account, *Head-Hunters: Black, White and Brown* (1901), Haddon notes a necessary manipulation of the scene in front of the camera:

> Very rarely have I turned a carved stone around so as to bring out its carving more effectively – occasionally I shift shells a little, so as to make them show better . . . Attention to small details such as these are necessary to produce intelligible photographs; but care must be taken not to overdo it.[77]

We will return to Haddon's 'performative' photographic practice in chapter Two.

Haddon had applied for the professorship in zoology at Melbourne University in 1886, but lost out to another zoologist who would convert to anthropology, Walter Baldwin Spencer,[78] who, like Haddon, would become a pioneer field photographer.[79] While a student at Oxford, Spencer had attended lectures by Tylor. During his early years in Melbourne he

31 Baldwin Spencer and Frank J. Gillen, Two Arrernte men, decorated for the *Illionpa* corroboree, Alice Springs, c. 1896.

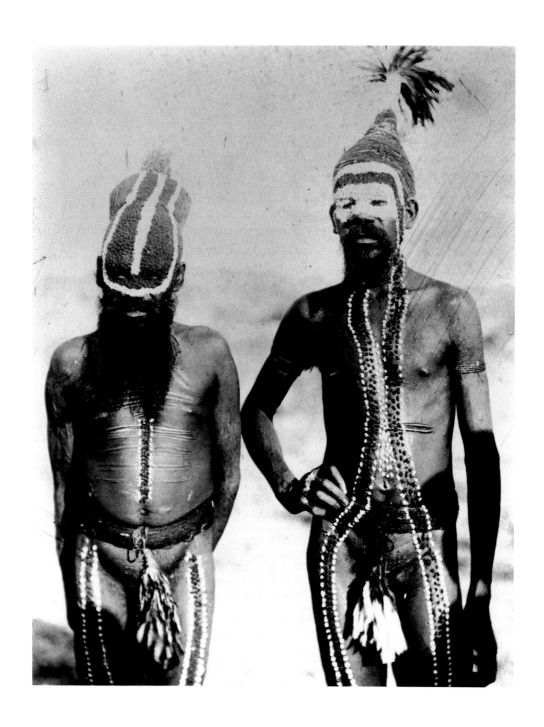

tried (unsuccessfully) to secure a post for Lorimer Fison, one of Tylor's 'men on the spot', and then joined the Horn Expedition to Central Australia in 1894, where he met his long-term collaborator Frank J. Gillen, an anthropologically enthused telegraph operator in Alice Springs who facilitated Spencer's access to the indigenous Arrernte (Aranda) people. Intially, Gillen was Spencer's 'man on the spot' but later field-work projects in 1896 and 1901 allowed them to work together on a long-term basis.[80] The 1896 research involved an elaborate ceremonial – the *Angkerre* (*engwura*) – staged for Gillen in Alice Springs to coincide with Spencer's summer holidays, and extensively photographed by Gillen and Spencer (illus. 31).[81] Chapter Three discusses the 'changing contract' of Aboriginal photography, which has made it no longer appropriate to reproduce the images of sacred ceremonies that were central to Gillen's and Spencer's work. In 1913 Bronislaw Malinowski – the ego who hovers over the rest of this chapter – would estimate that half of the theoretical work since the publication of Spencer's and Gillen's *Native Tribes of Central Australia* in 1899 – a text structured around the culminating drama of the *Angkerre*[82] – had been based on that book and that 'nine-tenths had been "affected or modified by it"'.[83]

Photography Internalized

Haddon's advice on the anthropological use of photography in the 1899 edition of *Notes and Queries* would be revised by J. L. Myers for the 1912 edition, although its substance remained largely Haddon's. It was in this form that it found its way to the Trobriand Islands in the possession of Malinowski.[84] Malinowski, a student of Seligman and founding father of modern British anthropology, brings the first part of this narrative about photography and anthropology full circle. Following the publica-tion of a library-based thesis, *The Family Among the Australian Aborigines*, Malinowski joined other anthropologists travelling – just before the out-break of the First World War – to the British Association meetings in Australia. The myth about Malinowski suggests that when interned for the four years of the war as a enemy alien he was forced to invent modern

anthropological fieldwork. The historical record shows that following initial fieldwork in Mailu, Malinowski would spend two periods of ten months working on the island of Kiriwina in Milne Bay (off the east coast of New Guinea, north of Australia), ethnographic research that would be published, to great acclaim, in 1922 as *Argonauts of the Western Pacific*. One of the nicknames he acquired during his Trobriand research was *Topwegigila*, 'the man with loose shorts', a reference, Michael Young notes, to 'his habit of hitching his trousers while trying to focus his camera'.[85]

Malinowski embodies the collapse of what might be called the 'negative-positive' journey of an earlier anthropology in which photographs were transmitted from the 'field' to the study. This is poetically evoked in those of his diary entries that dwell on an implosion and internalization of experience. Rather than the detached observing subject, separated from a clear world of objects or external forms, Malinowski is

32 'Imagine yourself suddenly set down surrounded by all your gear, alone on a tropical beach close to a native village, while the launch or dinghy which has brought you sails away out of sight'. Bronislaw Malinowski, 'The Ethnographer's Tent on the Beach of Nu'aasi', plate 1 from *Argonauts of the Western Pacific* (1922).

continually on the verge of a dissolution into the material worlds of
vibrations and impressions:

> Lay in euthanasian concentration on the ship. Loss of subjectivism and
> deprivation of will (blood flowing away from the brain?), living only by
> the five senses and the body (through impressions) causes direct merg-
> ing with surroundings. Had the feeling that the rattling of the ship's
> engine was myself; felt the motion of the ship as my own – it was *I* who
> was bumping against the waves and cutting through them.[86]

Malinowski's internalization and annulment of the antinomies that
structured the relationship between the armchair anthropologist and
the 'man on the spot' takes its most remarkable and intimate form in his
observation of a dream on 20 September 1914:

> A strange dream: homosex., with my own double as partner. Strangely
> autoerotic feelings; the impression that I'd like to have a mouth
> just like mine to kiss, a neck that curves just like mine, a forehead
> just like mine.[87]

Malinowski – the self-mythologizing perfector of 'participant-observa-
tion' – took onto his own body and his own presence the functions that
photography had previously mediated. Consequently, although he was a
keen and prolific photographer he would find himself latterly regretfully
confessing that he had 'treated photography as a secondary occupation'.[88]
Malinowski was 'at home' in Massim. His controversial private diary –
published in 1967, many decades after his death – communicates his
'placed-ness' in Kiriwina. He is a 'man on the spot' but one generating
observations and processing these theoretically in the same location.
The polarity between data gatherer and analyst that in previous generations
was frequently distended over thousands of miles was in Malinowski
compressed into a singular complex space. The consequence of this for
his photographic practice is clear: although he is sending photographs back
to his supervisor Seligman,[89] he ceases to be the point of image generation
whose final destination lies elsewhere. The final destination is now the

same as its point of origin, and this no doubt accounted for some of his confusion and anxiety about what he should be photographing ('Oh yes, I . . . failed to mention the large amount of time I have wasted dabbling in photography',[90] 'If the picture looked nice in the camera and fitted well, I snapped it.'[91]).

A sign of the new vector of photography within the participant observational paradigm is the striking reversal of image flow to which the *Diary* testifies. Whereas earlier, photographs flowed from the 'field' back to Europe (for instance, figures such as Lorimer Fison and R. H. Coddrington sending images to Tylor), Malinowski recounts how photographs from Europe flow out to the 'field'. He narrates what seems to have been an accident in the darkroom:

> Developed and fixed photos. Discovered that *T.* had been developed on *self-toning* paper and made a print. The sight of her sad face – perhaps still in love? – dejected me. I recalled the mood in the black-papered room, that dark afternoon, when the husband found us.[92]

This memento mori of happier (or at least more amorously dramatic) times continues as a thread through the *Diary* and leads Malinowski to compare *T.* with other past lovers:

> I am still in love with *T* . . . but I realize that psychically we have nothing in common, not like with *Z.*, for instance. But I am no longer in love erotically with *Z*. If I could choose one of them as a companion at present, purely impulsively, I would without hesitation choose *T.* A great part in this is played by the marvellous photos I have taken along.[93]

George Stocking has written perceptively about what he terms the 'narrative technology' of Malinowski's 'I-witnessing', noting the manner in which Malinowski places the reader 'imaginatively within the actual physical setting of the events'.[94] 'Imagine yourself suddenly set down', *Argonauts* begins, 'surrounded by all your gear, alone on a tropical beach close to a native village'. Perhaps the most beautiful passage by this most

accomplished of prose stylists appears at the beginning of his 1935 masterpiece *Coral Gardens and their Magic*, which romantically extols the Trobriand cultivator, the 'real peasant':

> He experiences a mysterious joy in delving into the earth, in turn-
> ing it up, planting the seed, watching the plant grow, mature, and
> yield the desired harvest. If you want to know him, you must meet
> him in his yam gardens, among his palm groves or on his taro
> fields. You must see him, digging his black or brown soil among
> the white outcrops of dead coral . . . You must follow him when,
> in the cool of the day, he watches the seed rise and develop within
> the precincts of the 'magical wall', which at first gleams like gold
> among the green of the new growth and then shows bronzed or
> grey under the rich garlands of yam foliage.[95]

This is the literary ethnographic equivalent of 'feeling the motion of the ship as [one's] own': it is the reader who is urged cinematically towards the Trobriands – *you must meet him* – the reader who participates in Trobriand space – *you must follow him*. Malinowski annuls the earlier suspicion of local speech. Recall those earlier anxieties about whether 'natives' could be trusted to tell the truth and whether anthropologists could be trusted to understand them. Photographs' utopian promise was of facts 'about which there could be no doubt'. The revolutionary nature of Malinowski's transformation lay in the collapse of that space between 'us' and 'them' along which photographs had previously shuttled. Through an extended, lived practice of 'being-there', and a literary panache that allowed the reader to inhabit the space of the Trobriands as if it were some slightly unusual English village, Malinowski eroded anthropological photography's alibi.

The anthropologist Michael Young, who has written extensively on Malinowski and on his photography, finds in his images a visual index of Malinowski's chief theoretical contribution to anthropology (albeit one that has been subsequently disavowed): 'functionalism', with its stress on context and coherence. Young notes that Malinowski's images are overwhelmingly shot in landscape format (that is, horizontally framed). 'Portrait' format

(vertically framed) photographs constitute a very small percentage of the one thousand or so images he produced in the Trobriands, and many of these can be attributed to Billy Hancock, a Trobriand resident pearl trader with whom Malinowski exchanged photographs.

The more encompassing space of landscape format allowed Malinowski, Young suggests, to place Trobriand persons, practices and objects in what he would later come to term a 'context of situation'. Malinowskian functionalism insisted on this broad framing, stressing the wider panorama of 'a setting, a situation, a social context'.[96] Pictorially, this is reflected in Malinowski's situation of his subjects against natural backdrops. He wholly spurns M. V. Portman's suggestion that distracting backgrounds be focused out or even obscured with smoke from a damp leaf fire. Indeed, in *Coral Gardens*, in which he provides a series of self-lacerating methodological introspections, he notes the aesthetic problems inherent in this situational photography:

> The cutting of scrub [was] distinctly ungrateful to photography [*sic*]. The men do not detach themselves neatly from the tangled back-ground, and *takaywa* [early clearing] on the mat-glass of a reflex camera looks very much like men loitering about on the outskirts of the jungle.[97]

The contextualizing background, which Malinowski evidently desired, presented formal compositional difficulties.

For Young the photographs serve as mirrors of the theoretical agenda of *Argonauts* and other paradigm-creating publications. As a theorist Malinowski stressed the need for what metaphorically we might think of as a 'wide-angled lens' and consequently shot the Trobianders in landscape format in order to include more contextual data. Such a correspondence is perhaps reasonable if we permit the consideration of only the public 'conscious' face that Malinowski presented to the world. However, as the extracts from his *Diary* suggest, there was more to Malinowski than this, and I would also like to suggest, more to photography. Such a 'common-sense' approach to Malinowski's pho-tography might be 'sensible', but does it grant access to the complexity

of his practice? We might start by separating the bluster of *Argonauts* from the Conradian self-doubt of the *Diary*. The instinctual *id* (uncoordinated and instinctual) of the *Diary* is as much part of Malinowski as the *ego* (controlled) of *Argonauts*. Further, while Malinowski was reading Haddon on photography in *Notes and Queries* and receiving photographic advice from Seligman, he was also intimately close to the modernist photographer (and subsequent Polish national hero) Stanislaw Witkiewicz, who had accompanied Malinowski to Australia with the intention of serving as his fieldwork photographer. Finally, we should ask how we should position photography in relation to the world it engages.

Is it to be understood as a transparent objectification of a photographer's intentions, a mere device for the capture of surface evidence? Or, following Walter Benjamin, might it be understood as giving access to the 'optical unconscious'? Just as psychoanalysis permits us access to the instinctual unconscious,[98] so photography – when it follows what is truly 'native' to it, Benjamin proposed, allows us to discover the optical unconscious. Benjamin describes Karl Blossfeldt's plant photography, in which are revealed 'the forms of ancient columns in horse willow, a bishop's crosier in the ostrich fern, totem poles in tenfold enlargements of chestnut and maple shoots'.[99] Here technology reveals itself as a magical process, a mode of diagnosis. Photography, as Benjamin continues in a crucial and justly oft-cited phrase,

> reveals in this material physiognomic aspects, image worlds, which dwell in the smallest things – meaningful yet covert enough to find a hiding place in waking dreams, but which, enlarged and capable of formulation, make the difference between technology and magic visible as a thoroughly historical variable.[100]

Perhaps this sense of photography as a route to the optical unconscious can help make sense of Malinowski's closeness to Witkiewicz. They shared two decades of intimacy – intellectual, photographic and, on one occasion, sexual.[101] Following Witkiewicz' fiancée's suicide in 1914, he sought redemption as Malinowski's 'photographer and draftsman' in

33 Stanislaw Ignacy Witkiewicz, *Self-portrait*, c. 1910.

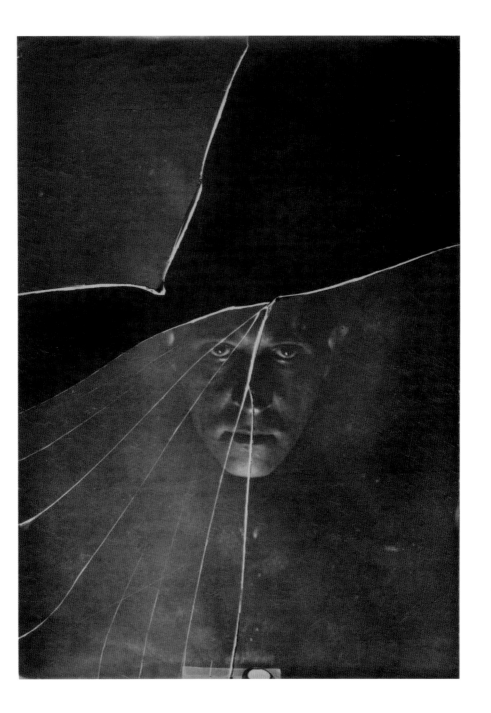

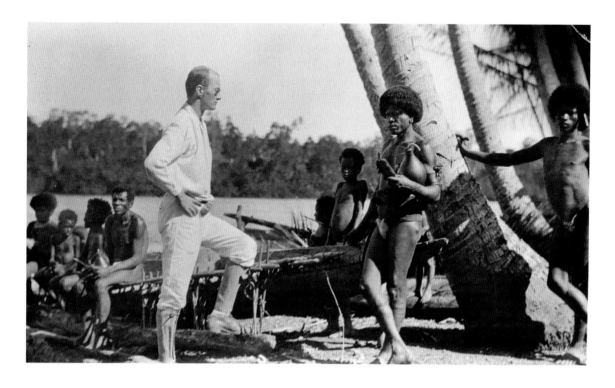

34 Bronislaw Malinowski and Billy Hancock, 'Ethnographer with a man in a wig', plate 68 in *The Sexual Life of Savages in Northwestern Melanesia* (1929).

'some savage country'.[102] En route to Australia they photographed together in Ceylon, but Witkiewicz spent most of the journey in agonized suicidal despair. The outbreak of war shortly after their arrival gave Witkiewicz new purpose, but the friends quarrelled dramatically and when Malinowski headed north to Papua, Witkiewicz headed back to fight for the tsar, survive the Revolution and subsequently find fame as a painter and playwright. Following the German and Soviet invasions of Poland in September 1939, he committed suicide.

Young is keen to stress Malinowski's and Witkiewicz's irreconcilable 'metaphysical' differences about the relationship between life and art. This is reflected in their photography, he suggests. Whereas Witkiewicz 'photographed himself in grotesque, misshapen postures, caricaturing his multiple masks' (illus. 33) there are 'no modernist tricks, no metaphysics in Malinowski's photography'.[103] But is there, we might ask, an 'optical unconscious'?

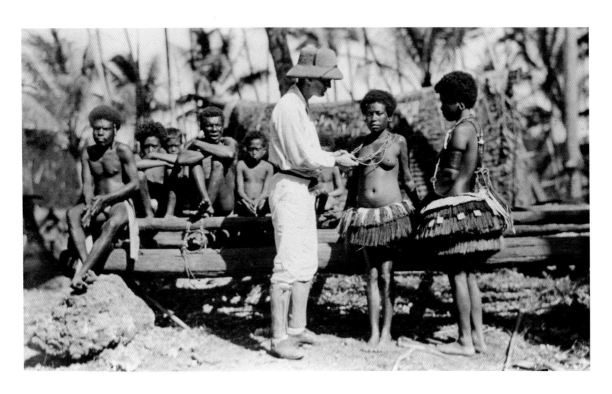

35 Bronislaw Malinowski and Billy Hancock, Malinowksi inspecting the *solava* of a Tukwauku girl, c. 1918.

Consider, for instance, a series of photographs of Malinowski with Trobriand informants, probably taken by Billy Hancock but clearly staged by Malinowski himself. Among this series is a celebrated image, *Ethnographer with a Man with a Wig*, which has recently been subjected to an illuminating reading by Michael Taussig. The image reveals a stately luminous ethnographer standing to the left of the image, his left foot resting on a log, his hands on his waist. Malinowski stares at the 'man in a wig', Tongugu'a, a sorcerer of repute whose 'skin fading as it does into the dark, blurred background, suggests mystery and concealment'. Taussig is struck by the 'spectral dizziness' of Malinowski's whiteness, and notes the picture's celebration of 'the aura of the man in white, glowing like a star in the depths of the darkness of the sorcerer, whose enchantment ignites a flame, erotic and magical, that is the fabulous whiteness of the man in white'.[104]

In another image in this series, Malinowski inspects a Tukwaukwa girl's *solava*. Young records that a note on the reverse of the print in the

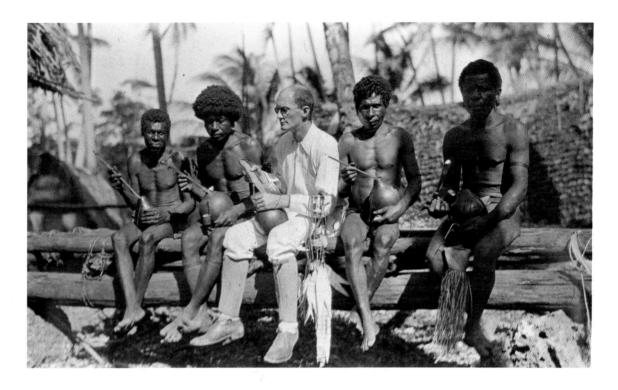

36 Bronislaw Malinowski and Billy
Hancock, '. . . the ethnographer's phallus',
c. 1918.

London School of Economics indicates that he intended to use the image
as the frontispiece to *The Sexual Life of Savages in North-West Melanesia*,
which would be published in 1929. He stands in the centre of the image,
holding a *solava* shell necklace worn by a rather discomfited young
woman, his hands precisely aligned with her breasts. Elsewhere in the
series Malinowski sits at the centre of a group of male Trobrianders,
cradling – absurdly and comically – a massive gourd. Used to store
lime (which is mixed with betel nut prior to chewing), this is, as Taussig
notes, 'the ethnographer's phallus'.[105]

Is this Malinowskian photographic realism? Is this Malinowski as
the single, stable, subject of portraiture? Or does this series of images –
produced in collaboration with Hancock – stage a complex fragmenta-
tion and series of masks as inventive and disturbing as anything
produced by Witkiewicz? And what if we juxtapose this series – as a
Gedankenexperiment – with Man Ray's famous image from 1926, *Noire et*

Blanche?[106] That image stages a similar collision of identities and of desire: a recumbent white Parisian dreamer (Kiki) maps a horizontal space of longing for a black mask that vertically transects the picture space. Malinowski's early draft for a Kiriwina monograph included an appendix on cultural contact titled 'black and white'.[107] This might also have served as a title for the series of images that spectrally stages Malinowski's luminosity among the darkness of Trobriand bodies.

Man Ray's *Noire et Blanche* exists in two forms, negative and positive. 'Reversing the black/white binarism' renders Kiki's white flesh 'electrically dark and the African wood mask eerily bright', reinforcing, Jane Livingston notes, 'the formal as well as the anthropological tension'.[108] Malinowski's images seem to stage a similar tension, one that not only investigates the position of the ethnographer in the Trobriands but also stages the internalization of the negative and positive stages of the photographic process itself.

The suturing of the theorist with the 'man on the spot' in the new figure of the fieldworking anthropologist problematized photography's role as a messenger between the 'field' and the study. Some sense of photography's ambivalent position in a post-Malinowskian anthropology was conveyed in 1962 by the French ethnographer Luc de Heusch, who noted the relative absence of photographs in monographs. Sometimes, he observed, 'an ethnographer goes so far as to publish pictures of men he has known and liked, but does so with considerable reluctance as if the emotive power of the picture, being foreign to his purpose, embarrasses him'.[109]

Photography in post-Malinowskian practice was not especially visible, but had it disappeared? Was it still present, but in a new structural form, so intimately tied to the new practice of anthropology that it was hidden in plain sight? David Tomas's work on the parallel rituals of photography and fieldwork can help us explore the plausibility of this proposition.[110] He has suggested that both photography and fieldwork have the formal tripartite features of a *rite de passage* as theorized by Arnold van Gennep, which describes steady states punctuated by heightened transformative moments of inversion according to the logic of preliminary separation, liminality and postliminal re-incorporation. A photograph begins as a

negative and through the heightened moment of exposure (placed in the camera and subject to liminal magical procedures under the black cloak) is transformed into an object capable of producing a positive in the form of a print. The new heroic ethnographer located 'the field' as a liminal place of transformation. Since Rousseau this had been conceptualized as necessarily geographically or psychically distant ('remote'[111]), an assumption that much recent ethnography has attempted to negate. Fieldwork in this liminal place and state was expected (indeed was required to be) physically and psychologically difficult, and ideally transformative. Seligman described this form of fieldwork as to anthropology what 'the blood of martyrs is to the Roman Catholic Church'[112]). Fieldwork necessarily involved the presence of the fieldworker in the field, 'exposed' to new experiences, as though his or her body were a glass negative or strip of film.[113] During this prolonged and arduous period of exposure to local light the ethnographer accumulates data, usually in the liminal form of 'fieldnotes', which will, following their return and re-incorporation 'at home', be processed into a 'positive' form as a published monograph. This 'internalization' of photography into the protocols of the new anthropology perhaps explains why Luc de Heusch was confronted by all those ethnographies lacking pictures. So fully had photography infiltrated anthropology's codes of authority that it was invisible, like a drop of oil expanding over the surface of clear water.[114]

two

The Trouble with Photography

Roland Barthes, so often celebrated for his enthusiasm for a perfumed nostalgia associated with photography, was also keen to stress the 'disturbance' that this new invention brought to modern life. 'Odd', Barthes wrote, 'that no one has thought of the *disturbance* (to civilisation) which this new action causes'.[1] I've suggested – prompted by Walter Benjamin's insights – that anthropologists committed to evolutionary distinctions between early practices of animism and its later manifestation in the form of religion were able to enthuse about photography in its technical and progressive dimension but were 'troubled' by its archaic and magical qualities. Photography's reinvention of 'homeopathic' and 'contagious' magic (magic based on likeness and contact, respectively) brought with it all kinds of difficulties that required complex detours, avoidances and ellipses. But if, to recall Benjamin, we look not at 'what the neon sign says, but the fiery pool reflected in the asphalt below',[2] we can grasp the 'smoky second nature'[3] of discourses about animism and magic.

Photography, Witchcraft and Magic

It is worth recapturing some sense of early responses to photography. The most powerful account of the ambivalent attitudes generated is provided by the Parisian photographer Gaspard Felix Tournachon, a.k.a. Felix Nadar, who noted how the discovery of 1839 'smelled strongly of witchcraft' and of 'sympathetic magic [and] the conjuring of spirits, ghosts'.[4] 'Awesome Night', he continued, 'dear to all sorcerers and wizards

– reigned supreme in the dark recesses of the camera'. Consequently, the 'lowliest to the most high' trembled before the daguerreotype, so 'worried and frightened' were they. Nadar's comments resonate intimately with Benjamin's view of photographers as descendants of the augurs and haruspices. Balzac was the most famous of those anxious sitters described by Nadar, who devotes considerable space to Balzac's theory that 'all physical bodies are made up entirely of layers of ghostlike images, an infinite number of leaf-like skins laid one on top of the other'. Since Balzac believed that something could not be made from nothing, a material photograph incapable of production from impalpable apparition, 'he concluded that every time someone had his photograph taken, one of the spectral layers was removed from the body and transferred to the photograph'. Nadar then asks whether this fear was sincere, concluding that it was, 'although Balzac had only to gain from his loss, his ample proportions allowing him to squander his layers without a thought'.[5]

The strong evolutionary direction of Tylorian and Frazerian anthropology was built upon a sense of civilizational relief that the enchantments and delusions (the 'mistaken association of ideas'[6]) of earlier practices had been surpassed. 'Magic', Tylor had written, was 'one of the most pernicious delusions that ever vexed mankind'[7] and Frazer trumped this with his assertion that 'every single profession and claim put forward by the magician as such is false'.[8] And yet, like Frazer – whose detailed elaboration of the protocols of magic lay at the core of *The Golden Bough* – Tylor proceeds to pay a form of homage to these delusions in the form of a prolonged catalogue of primitive practices. These ambivalent tactics might be seen as part of what Bruno Latour would subsequently locate as a longing for escape from the 'despair' and 'self-punishment' of disenchantment.[9] Wittgenstein would memorably capture this paradox in his 1931 observation that Frazer 'was more savage' than the 'savages' whose practices he describes.[10]

Frazer's *The Golden Bough* (first edition in two volumes, 1890, and third definitive edition in twelve volumes, 1906–15) makes only fleeting mention of photography. In Part 2 of the third edition, *Taboo and the Perils of the Soul*, Frazer explains that people who believe that portraits contain the soul of the person portrayed are reluctant to have their likenesses

37 Contagious magic. Frazer highlighted the 'magical sympathy' that is suppose to exist between a person and their severed hair or nails. Wilhelm Burger, *carte-de-viste* depicting Chinese nails. Austrian Expedition to East Asia, 1868–70.

taken, 'for if the portrait is the soul or at least a vital part of the person portrayed, whoever possesses the portrait will be able to exercise a fatal influence over the original of it'.[11] However, questions of images and causality lie at the very heart of Frazer's *magnum opus*. He devotes a great deal of space to the two major 'principles of magic': homeopathic and contagious. Homeopathic magic involved 'like produc[ing] like' by the Law of Similarity, whereas contagious magic involved the Law of Contact.[12] Homeopathic magic's most familiar incarnation was in the 'injuring or destroying of an image' of a person 'in the belief that, just as the image suffers, so does the man'.[13] Frazer provides examples from the Ojibwe, from central Australia, India and from the contemporary Scottish Highlands where his own 'ignorant countrymen' were sticking pins into rude clay images.[14] Contagious magic by contrast entails 'a material medium of some sort . . . assumed to unite distant objects and to convey impressions from one to the other'. Frazer proffers as the most familiar example the 'magical sympathy that is supposed to exist between a man and any severed portion of his person, as his hair or nails'.[15] A global compendium then follows of practices involving nails, teeth and other *exuviae*. The body appears as an endless source of dangerous leakage: Papuans travelling through thick forest will stop to 'scrape from any bough any clot of red pomade' that, having dropped from their heads, is infused with contagious possibilities, and similarly seek to recuperate any lost fragments of clothing.[16] The Law of Contact extends also to impressions left by bodies in sand and earth, footprints in particular being a popular vehicle for malicious attack. Here Frazer juxtaposes reports on Australian practice by A. W. Howitt, the son of William Howitt who appeared in one of the spirit photographs collected by Tylor, with observations about those Pythagaoreans who urged that on 'rising from bed you should smooth away the impression left by your body on the bed-clothes'.

Frazer delineates a theory of signs and causation. It is an exercise in what would later come to be called 'semiology'. The swirling penumbra of ethnographic and classical footnotes in *The Golden Bough* seems to have convinced generations that this was merely a literary exploration of myth and blinded them from seeing its parallel to the 'iconic' and 'indexical' in Peircean semiotics. For Peirce, an American logician active in the early twentieth century, an icon was characterized by a resemblance that was not dependent on any physical causation: this is akin to the Law of Similarity. An index, however, was a sign that was 'really affected' by the object it signifies through a contiguity, or as Frazer would have put it, contagion.[17] He gives the examples of weathercocks (physically moved by the wind it signifies), but also photographs (which he says are 'very instructive'), which have a resemblance to the objects they represent because they 'were physically forced to correspond point by point to nature'.[18]

Peircean iconicity is central to photography's appeal: resemblance and iconicity mark the success of most photographs, for they 'look like' their referents. When they don't that is usually because of some technical mishap (slow shutter speed, overexposure and so on). The result will be the 'fuzzygraph' against the production of which M. V. Portman inveighed. A blurred image of an Australian Aboriginal woman (illus. 38) dating from *circa* 1880 would certainly have been deemed a partial failure of iconicity but it was no less 'indexical' for that:[19] Peircean iconicity parallels Frazer's Law of Similarity in which 'like produces like', the effect resembles its cause. But photography's particular claim to our attention is usually vested in its indexicality. This is the rather off-putting term, derived from Peirce for that quality of contiguity observed by many theorists of photography. Susan Sontag, for instance, writes of photographs as 'a trace, something directly stencilled off the real; like a footprint or a death mask . . . material vestiges of their subject'.[20] In a similar idiom the art historian and champion of the 'index' Rosalind Krauss writes of photo-chemically processed traces

parallel . . . to fingerprints or footprints or the rings of water that cold glasses leave on tables. The photograph is . . . genetically distinct from

38 Unknown photographer, an Australian Aboriginal woman, date unknown.

painting or sculpture or drawing . . . it is closer to palm prints, death masks, cast shadows.[21]

Sontag and Krauss describe phenomena that Peirce called the 'index', but these are also phenomena that could happily inhabit Frazer's account of the idiom of thought that informs the Law of Contact. Footprints, fingerprints, death masks: all bear the contagious imprint of their subjects and, like the photographs of which they are analogues, convey evidence that can lead back to the body that created the imprint.[22]

Part of Wittgenstein's observations on Frazer that were deleted from the material later published as *Philosophical Investigations* included his decision that he should begin his book with 'remarks about metaphysics as a kind of magic'. In doing this, he continued, he must 'neither speak in defense of magic nor ridicule it'. There then follows a powerful commentary on the paradox that is Frazer's *The Golden Bough*: 'What is deep about magic would be kept. In this context, in fact, *keeping magic out has the character of magic*'.[23] Wittgenstein's conclusion after reading Frazer that metaphysics might also be a form of magic, and the immense impact that Frazer's supposedly evolutionist rationalism had on figures such as Eliot, Pound and Joyce, are powerful signs of what was reflected in the 'fiery pool' below *The Golden Bough*'s neon sign.

39 'Keeping magic out has the character of magic.' James Frazer's *The Golden Bough* took its title from J.M.W. Turner's painting of the same name, an engraving of which served as a frontispiece in most editions. Turner's image depicts Aeneas holding a golden bough cut from a sacred tree that the prophetess Sybil had declared would grant him access to the underworld to see the ghost of his father. This version is from the 1911 edition.

40 In most editions, James Frazer's *The Golden Bough* came embossed with an Arts and Crafts-style mistletoe logo, a device laden with a 'smoky second nature' echoing the access that photography also gives us to the faces of the dead.

On Not Wanting To Be Photographed

The enchanted native is one of the strategies through which the longing for escape from disenchantment is articulated. This has been astutely diagnosed by Michael Taussig in his reading of Robert Flaherty's 1922 film about Inuit life *Nanook of the North*, which features a celebrated scene with a phonograph. He describes Nanook's 'look of wild disbelief on hearing sound emerge from the white man's phonograph' and his subsequent attempt to eat it. The audience is invited to read this as Nanook's perform-ance – his actions, his response. Taussig, however, rightly insists that this is a contrivance not of the 'primitive' Nanook, but of the primitivist film-maker Flaherty: it is 'a set-up job. Mimesis of mimesis'.[24]

Undoubtedly this scene attempts to stage the superior technical rationalism of the viewing audience, but Nanook also stages an enchant-ment no longer honestly accessible to the filmmaker, just as 'primitives' endlessly staged for nineteenth-century anthropologists an enchantment

with techniques that nineteenth-century technologies appeared to have superseded. But enchantment could be phrased negatively as well as positively. The anthropological literature abounds with accounts of suspicion and hostility towards the presence of the camera and a related set of narratives about the inability to read or comprehend properly photographs as documents. While these may superficially appear to enhance evolutionary narratives of civilizational superiority, one might also see in them a backward projection of a desire for modern enchantment that Tylor and Frazer had attempted to make taboo. The native's 'difficulty' with photography provides the alibi for the modern's own desire to find in the photographer the descendants of 'augurs and haruspices'.

Nanook's sensuous and concrete response to the technics of reproduction is an example of what Tom Gunning has called cinema's 'primal scene' in which the 'absolute novelty of the moving image' reduced audiences to 'a state usually attributed to savages . . . howling and fleeing in impotent terror before the power of the machine'.[25] Anthropologists have themselves generated but also recorded as ethnographic facts numerous examples of this sensuous mimeticity. Thus Timothy Burke notes a Zimbabwean advertiser's narration of a screening during the Second World War of films in rural areas. In one instance 'the audience arose screaming in fright when footage of planes strafing the ground was shown'. The same informant told Burke a serially repeated story that on the grounds of its repetition he terms a 'genre', 'a common colonial story'. This concerned a Rhodesian health official proselytizing in the Zambezi Valley for malaria prevention. Armed with large drawings, and a two-foot papier-mâché mosquito, he found his efforts rebutted by locals who pointed out that 'Our mosquitoes are not so big'. Burke concludes that these stories were part of a larger mediation of the 'dangers and benefits of modern visual technologies . . . the tip of an iceberg, a deeply embedded and shared reaction to modern visual genres'.[26]

In a parallel manner, certain anthropologists celebrated the difficulty they experienced in taking photographs and the difficulty that being photographed posed – or appeared to pose – for certain subjects. 'Resistance' of certain kinds could certainly be productive for an emergent scientific discipline, subjects' reluctance serving as a foil to rationalist enlightenment.

Group of LAMBANI (LAMBADI = Indian Gypsy) or BRINJARI
SAKRAPATNA, W.C.MYSORE.
dd.R.Bruce Foote 1902.
[had been taken.
Taken in a _tonda_ (fixed camp) by H.K.Slater. The men were away, & on return were annoyed to hear the photograph

41 H. K. Slater, 'Group of Lambani or Brinjari, Sakrapatna', 1902.

This perhaps informs the caption to a 1902 image of Indian Lambani women photographed by H. K. Slater while 'the men were away', these men being 'annoyed' upon their return 'to hear the photograph had been taken'. Here gender is the fracture point of the ambivalence between fascination and repulsion. In a similar fashion the classicist F. Haverfield's small blurred 1905 shot captioned 'boy making the "horns" sign before the camera at Segni, southeast of Rome' in the Pitt Rivers Museum archive seems to celebrate the complex space between visibility and occlusion, revelling in the temporary victory of transparency (illus. 42).

A more muscular assertion of local resistance and bewilderment as a foil for the superiority of foreign technology and inspection is apparent in the traveller Frank Burnett's account of his use of a flash-light in Milne

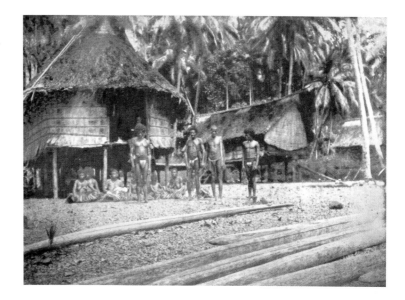

43 Frank Burnett, 'Village, Milne Bay, British Papua. The large house in which the author attempted a flash-light photograph with disastrous results', 1909,

Bay in New Guinea in 1909. The interior darkness of native dwellings necessitated the use of a combustible flashlight. Having attracted a large group with offers of tobacco, Burnett grouped them at one end of a large hut, before applying a match to his flashlight. Burnett detailed the results in a lengthy paragraph written to appeal to the cultural sensibility of a late-Edwardian audience:

> I certainly did not anticipate the panic that followed. The nervous system of one ancient savage, who was sitting on his haunches . . . received such a shock that he fell back against the matting, which, by giving way, precipitated him head over heels down the ladder to the ground. How he escaped breaking his neck was a marvel. But apparently he received no injuries from his unceremonious mode of departure. When last I saw him he was making for cover . . . as though chased by the devil, whom, no doubt, he thought was close at his heels. Then an old dame, with a child in her arms, whom I had placed near the fire, was so overcome with fright that, regardless of consequences, she seated herself upon the glowing embers. Judging by her subsequent actions, the result must have been disconcerting,

42 F. Haverfield, 'Boy making the "horns" sign before the camera, Segni, southeast of Rome', 1905.

73

as might be supposed, when it is understood that her sole covering consisted of a loin cloth . . . Upon recovering her equilibrium, with a heart-rending yell, she made for a door, and reaching the ground in a flying leap, shewed, by her 'sprinting' capabilities, that, though old in years, she retained a portion of her youthful agility . . . Under the circumstances I considered it advisable to gather together my photographic paraphernalia, and proceed as quickly as possible, to another field of operation.[27]

The Pitt Rivers Museum also holds a set of stereoscope cards of India issued *circa* 1910 by Underwood and Underwood and featuring images by the remarkable commercial photographer James Ricalton. The captions on the reverse of the cards, together with a very lengthy account published to accompany the card series, permits the detailed reconstruction of Ricalton's intentions and metaphorical world. Card number 7, titled *'There is no God but God and Mahomet is his Prophet' – prayers in Mosque, Ahmedabad*, and the text in Ricalton's book, circles around the paradoxes of visibility and invisibility:

We cannot fail to notice two on the line whose faces are turned slightly away from the Kaaba toward the photographer . . . A photograph is an image – therefore most Mahommedans are savagely opposed to being photographed; these men are apparently indifferent. A man attempting to photograph a praying group of Mohammedans in Hebron, Palestine, would be in considerable danger.[28]

Ricalton's images and texts engage the paradox of how one makes the invisible visible, and – since he has managed to photograph (and in some sense render banal) the invisible – one of the strategies through which to appropriate the symbolic (indeed ontological) value of not being visible, in the visible itself. It is worth noting the frequency of this gesture and how radically it contravenes the assumption (derived from Michel Foucault and Edward Said) that colonialism's power springs straightforwardly from visibility. Ricalton, by contrast, desires the sublime yield of obscurity ('Mere light is too common a thing to make a strong impression

on the mind', as Edmund Burke noted in classic 1757 essay on the Sublime[29]). It is *not* the fact of being made visible that allows power to play over bodies; rather, it is the act of re-inserting the possibility of invisibility in the fact of visibility. As the caption to Ricalton's card notes, 'These worshippers are more tolerant than Moslems in general. As a rule they regard a photographer's camera as an impertinence to be resented, but in this particular instance they are practically ignoring the infidel observer.' They become the visible manifestation of something much more powerful and interesting: obscurity. Burke himself had warned against 'anything light and riant [*sic*]; as nothing so effectually deadens the whole taste of the sublime'.[30]

There is no doubt, then, that the resistance to photography was a genre, and a colonial genre at that. As Patricia Spyer put it there was a 'pervasive European desire to go to all extremes to expose the allegedly primitive refusal to be photographed'.[31] Rodney Needham described the idea that 'primitives' fear that their souls would be captured in 'the little black box' as a 'literary stereotype', one arising from travellers' poor language skills and reliance on their own literary conventions and super-stitions. Whereas travellers such as Jørgen Bisch reported having to flee in his canoe for his life (from aggrieved photographic subjects) in northern Borneo,[32] Needham himself (who had conducted fieldwork in the same area) reported the Penan people's ease with photographs, being able to decode them regardless of the pose of the subject, but generally holding prints 'some thirty degrees from the vertical'.[33]

However, it would be foolish not to concede that many photographic subjects did also experience genuine perturbation and discomfort when confronted with the camera.[34] Many of these are responses to the armature that surrounded the camera (structures of authority, colonialism, prisons and so on), but some are also anxieties that emerge from the contempla-tion of the technical procedures of photography. Early examples include the Dutch army physician Dr A. W. Nieuwenhuis travelling in Borneo in the 1890s with a Javanese photographer Jean Demmeni. Among the Kajans 'The fear prevailed . . . that the soul of a person photographed would be taken away by the picture', and Demmeni was only able to start photographing after four months' residence.[35] In Bali the anthropologist

Margaret Weiner was told that the early twentieth-century ruler Déwa Agung of Klungkung was un-photographable: the Dutch had made repeated attempts to photograph him but, as a priest told Weiner, he could not be 'caught' by the camera lens.[36]

Further examples are provided by Thomas Whiffen, writing about the north-west Amazon in 1915. The Boro people, he recounted, viewed his camera as 'an infernal machine, designed to steal the souls of those who were exposed to its baleful eye'. They were especially suspicious of his photographer's cloak and assumed that he disappeared under it in order to 'read their minds'. The fear of soul stealing, Whiffen argues, was a rationalization of their response to the prints that he was printing in the field: 'The Indian was brought face to face with his naked soul, represented by the miniature of himself in the photographic plate. One glance, and one only, could he be induced to give. Never again would he be privy to such magic.'[37]

Caution is certainly required in our response to these accounts but to read them wholly as the playing out of European fantasies would deprive those that were photographed of the possibility that they were truly apprehensive, resistant and had their own autonomous cosmological understandings of photography. It is easy to see how a technology of picturing, whose magicality was largely disavowed by those who deployed it, would fit easily within cosmologies where shadows, spirits and souls moved freely. In rural southern Africa missionaries encountered people who 'knew ghosts and skins but not Europeans' language of pictorial imagery'.[38] Magic lantern slides – 'luminous nocturnal images' – that missionaries used in their proselytizing were absorbed by the Kgalagadi of the Kalahari, for instance, into pre-existing categories of dreams and visions which provided a ready-made category 'for their digestion'.[39]

We Have Never Been Modern

Photography makes brief appearances in Frazer's 1911 *The Golden Bough* and Lucien Lévy-Bruhl's 1928 text *The 'Soul' of the Primitive* but both these

works attempt to impose a fundamental break between 'primitive' and other mentalities. For Frazer the explorer on the lower Yukon River who is confronted with 'native resistance' stages these two very different mentalities. The explorer erects his camera and while focusing is approached by the 'headman of the village' who demands that he be allowed to see under the cloth. He then 'gazed intently for a minute at the moving figures on the ground glass . . . and bawled at the top of his voice "He has all of your shades in this box".' Panic, of course, ensues.[40] The abridged 1922 edition of *The Golden Bough* expanded the material on photographic superstition: Dr Catat's travails in Madagascar, having to 'return' photographically stolen souls in baskets, are detailed, Sikhimese horror of the 'evil eye of the box' described, and the refusal of Scottish highlanders to be photographed (following the experience of those who submitted and subsequently 'never had a day's health') regretfully noted.[41] Lévy-Bruhl likewise assumes that 'primitives' will be prey to this error: their cosmologies already have the conceptual infrastructure that will necessarily misrecognize photography. His book is, however, a compendium of beliefs that make possible a commensuration between 'primitive' conceptions and photography. He observes, for instance, that 'Very often in the collective representation of the primitives, the "vital principle" or "life" of the individual is not to be distinguished from his shadow, similitude, or reflection.'[42] But here we reach a point of what Lévy-Bruhl called 'capital importance'. This revolves around whether we believe that the non-primitive mentality is indeed 'modern'.

The difference between the 'primitive' and 'modern' for Lévy-Bruhl is that the former thinks about 'identity' while the latter thinks about 'resemblance'. For the 'modern', 'My likeness – the reproduction of myself . . . has no effect upon my destiny.' Conversely, for the 'primitive', 'The picture is not a reproduction of the original distinct from it; it is itself.' If this were straightforwardly true photography would emerge as the modern technological essence of a modern sensibility, quite unlike the 'primitive' domain of shadows and souls. But is this distinction quite so easy to maintain? A closer reading than I am able to provide here would demonstrate that Lévy-Bruhl himself provides grounds to blur the stark oppositions he draws. He concedes that the 'modern' is enchanted

by relics, for instance: something of Goethe's and Victor Hugo's personalities 'seems to cling to their pens', and something of Napoleon's 'still exists in his sword'.[43] Although in theory 'we think differently', it seems that in practice there is much in common.

We have already encountered the 'modern' Balzac's 'primitive' fear of photography. But to muddy further the distinctions that Lévy-Bruhl sought to impose, we might briefly consider late nineteenth-century German juridical theorists' discussions of the legal right to one's own image (*Persönlichkeitsrecht*). They developed analogies to 'the right to one's own name' and to 'the right to one's own body'.[44] A crucial contributor to this debate was Hugo Keyssner, whose intervention was prompted by instantaneous photography and who demanded protection from 'the electrical light of publicity'.[45] Some, such as Georg Cohn, who opposed the original attempt to institute this legally (arguing in very Lévy-Bruhlian terms that such law was 'primitive'), succumbed in the face of cinema, conflating 'original and image',[46] claiming that 'the cinematograph, which listens to our actions should not be allowed to publicly ape us, like a double'.[47] In 1910 Berthold Viertel would write of the 'dreadful doubleness of representation', and Hugo Münsterberg would write in 1916 of cinema as 'magical': 'Every dream becomes real, uncanny ghosts appear from nothing and disappear into nothing.'[48]

The value of Walter Benjamin's writing in grasping this fearful attachment to the magical double has already been noted. But we might also add Bruno Latour, for he helps us understand the paradox at work here, the same paradox we have encountered in Tylor's approach to animism and photography. Latour directs our attention to an unachieved project of 'being modern' in which he gives equal weight to the desire to be modern and the impossibility of attaining that modernity. His is an account of ambivalence and contradiction that helps us understand why a figure such as Georg Cohn simultaneously was repelled by the primitivity of the fear of the double and also recognized the ineluctability of its presence.[49]

The 'Thing' Which Has Been There

We have already discussed the manner in which photography appealed to early anthropologists as a potential solution to the *problem* of observation. Recall Andrew Lang's declaration that 'Man cannot be secluded from disturbing influences, and watched, like the materials of a chemical experiment in a laboratory.'[50] Photography as a technical procedure – and one that ideally facilitated a distance between the photographer and what was photographed – seemed to resolve certain aspects of this problem, although disturbing influences could still contaminate the photograph. A fine example of this is a cabinet card produced in the 1880s by the Hudson's Gallery of Tama, Iowa, which is inscribed on the reverse 'Winter houses of woven "slough" grass and cowskins, spoiled by the white man in the foreground'. This ideal of distance as a guarantee of the

44 'Hudson's Gallery, Tama, Iowa', c. 1880, cabinet card. Inscribed on the reverse: '. . . spoiled by presence of white man in foreground'.

camera's non-interventionist nature found its most memorable idealization in *Coral Gardens and their Magic*, in which Malinowski proposed taking a 'bird's eye' view of a Trobriand's gardening cycle. This would involve the possibility of an 'Ethnographer's Eye', which would be like 'a super-cinema operating from a helicostatic aeroplane'.[51]

But photography's promise would quickly reveal itself to be a 'trouble'. Photographs are usually taken to tell a story: their 'difficulty' stems from their insistence on always telling their own story. Photography's 'enactment' – what film scholars call the profilmic[52] – produced an effect of manifestation that commonly exceeded the particularity of the event of its making. There is a precise photographic dimension to this but also, perhaps, a general visual dimension. Consider what Wittkower described as the visual's tendency to solidify presences and claims which in their linguistic form are always more uncertain. He notes a tactic in illustrated texts in which the appearance of an illustration can 'favour belief in what is left open to doubt in the text'.[53] Bernadette Bucher in her study of early European representations of the Americas raises intriguing questions about the specificity of visual representation, suggesting that in the visual, 'negation as a means of expression is lost'. She notes the role of negation in language and the manner in which, linguistically, Native Americans became what early modern Europeans were not. This is memorably embodied in Montaigne's observation 'Eh quoi, ils ne portent pas de hauts de chausse!' ('What! They're not wearing breeches!'). Bucher proposes that in the visual arts negation is impossible: 'it is impossible to portray a thing by what it is not: it is present or absent, and if it appears, it is always positively, in a certain shape'.[54] Bucher helps us understand the manner in which visual manifestation produces a heightened assertion and presence. This in turn points to the positivity of presence – the art of the concrete – mobilized by visual mimesis.

Photography ratcheted up this positivity, for every photograph was indisputably a document of an event, an event that could not be denied. In photography, as Roland Barthes observed, 'I can never deny that *the thing has been there*.' The event – what Barthes also refers to as photography's 'sovereign Contingency' – is marked by the particularity and specificity of what he called the 'body' (*corps*), whose singularity he

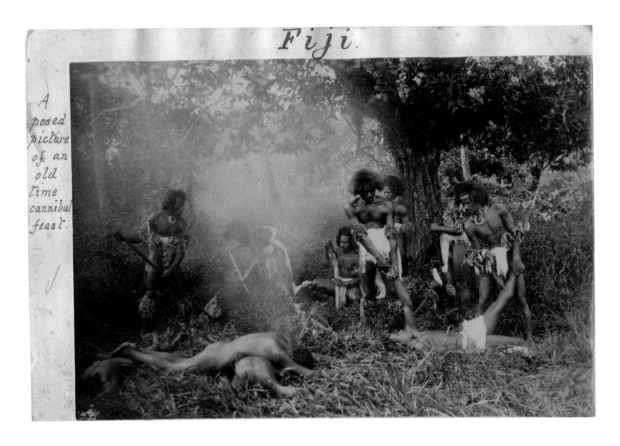

Within the image, handwritten text reads:

Fiji.

A posed picture of an old time cannibal feast.

45 Thomas Andrew's 'old time cannibal feast', c. 1890.

contrasted with the generality of the '*corpus*'.[55] The camera records what is placed in front of it and on its own is incapable of making distinctions about the relationship of its visual trace to psychic, social or historical normativity. It never knows and can never judge whether what it records is 'typical', 'normal' or 'true'. This would make photography very useful, but also very troublesome, to anthropology.

T. Andrew's *circa* 1890 photograph of a Fijian 'cannibal feast' bears a marginal note: 'a posed picture of an old time cannibal feast'. The 'posed' nature of image – its artifice – is knowledge from the domain of the *corpus*. It is a form of extraneous knowledge generated outside the frame of the photograph, perhaps helped by our scepticism about the existence of anthropophagy.[56] If we assume that cannibalism was not practised,

46 Charles Carpenter, 'First Nation's Man Demonstrating Articulated Whale Mask, St Louis', 1904,

and especially was not practised in such visually stereotypical forms, we are likely to concur that this photograph must indeed be 'posed'. But this is not a knowledge derived from the *corps* of the photograph. We have no way of declaring – on the basis of the visual evidence of the photograph – that these bodies have not been slain, and no way of declaring that they are not about to be devoured. They have not and will not, of course, but that, as I suggest, is a knowledge derived from the *corpus*.

Posing, and specifically posing as a cannibal, has a venerable history in anthropology. A celebrated instance involves the young Franz Boas, soon to become the founding father of North American cultural anthropology. Shortly after 1894, following his observation of the Kwakiutl Hamatsa dance in British Columbia, Boas posed as a cannibal spirit so that photographs could be made that would assist the sculptor of the US National Museum's Kwakiutl diorama. Boas's performance was a restaging of a ceremony witnessed in British Columbia that he had been propelled to investigate following his earlier witnessing of a performance by Kwakiutl at the Chicago World's Columbian Exposition of 1893.[57] The 'real' is almost submerged in this precession of simulacra.

Simulation was also in demand at the St Louis World's Fair (a.k.a. Louisiana Purchase Exhibition) of 1904, at which more than two thousand native peoples were made to perform their culture with the encouragement of W. J. McGee, the first President of the American Anthropological Association (illus. 46). These included a Congolese Mbuti man, Ota Benga, whose biography entangled the barbarity of Belgian colonialism and American scientific racism: his family was murdered by Force Publique prior to his being brought to perform at St Louis before his subsequent departure for the Bronx Zoo.[58] Also on display were Ainus from Japan and the Apache leader Geronimo, who sold photographs of himself. Competitive War Dances were held in the Aeronautic Concourse but the poor gate money – very hot weather resulted in disappointing attendance – reduced the prizes available and participants danced with little enthusiasm.[59] Kwakiutl performers staged a Hamatsa ceremony while Frederick Starr of the University of Chicago gave a running commentary. The *St Louis Examiner* reported that no 'human flesh was actually eaten, but the dancers went through the motions so vividly that several ladies in the class

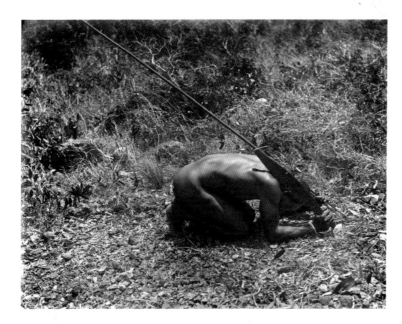

were obliged to turn their heads away. Savage and blood curdling yells, horrible expressions of fear on the faces of the dancers, fastening of the teeth in the flesh and smacking of lips were the climax of the wild dance.'[60]

Re-enactment also played a central role in A. C. Haddon's photographic ethnography. This was driven by an anxiety that 'the natives are fast dying out' and his conclusion that 'it is our bounden duty to record the . . . ceremonial observances and religious beliefs of vanishing peoples'.[61] In Haddon's re-enactment, as Elizabeth Edwards has argued, the 'appearance' of the 'primitive' is 'played out for the camera' in order to 'inscribe the reality of these remnants of Torres Strait society . . . on the photographic plate'.[62] This is fully revealed in a series of images directed by Haddon in Mabuiag in 1898 that engage the myth of Kwoiam whose life and death animates the sacred geography of the Torres Strait. Edwards details how the landscape bears this impress: his footprint can still be seen, boulders are the heads of his victims and his spear thrust is marked by an ever-flowing stream. Ambushed by his enemies, he retreated to a hilltop, crouched and died.

Haddon's popular 1901 account, *Head-Hunters: Black, White and Brown*, textually conflates topography with this sacred geography, temporarily positing the historical veracity of this local cosmology: bushes on the side of the hill are red 'due to the blood that spurted from Kwoiam's neck'. This bracketing out of qualifiers such as 'I was told', and 'locals believe' is of course the central tactic of fiction's suspension of disbelief, which some anthropological writing of this period happily appropriated. But there are also re-enchanting captions in the Torres Strait Reports, such as 'Leaves from the ubu bush (*Melaleuca leucodendron*) on Kwoiam's Hill, Mabuiag, that still bears spots of his blood',[63] and most memorably a re-enactment of the death of Kwoiam himself. A photograph that Edwards captions 'Man imitating the death of culture hero Kwoiam, Mabuiag, 1898', depicts a kneeling figure, his knees pulled up towards his body and his hands placed in front of his head (illus. 47). One of his hands grasps a large spear whose shaft cuts a diagonal swathe across the picture plane. A sketch in one of Haddon's notebooks reveals the degree of forethought that preceded the making of the photograph.[64]

Edwards perceptively notes that Haddon's re-enactment photographs involved a 'total collapse of temporalities' of 'the distinction between mythic, historical and contemporary time' and that the 'past becomes present through photography'.[65] We can draw on Roland Barthes' insights to explain this, before returning to a consideration of the problems this posed for an anthropology concerned with 'observation'. Barthes brilliantly illuminated the *double temporality* of photography: all photographs (not only those that are 're-enacted') bring the 'there-then' of the making of the photograph into the 'here-now' of our viewing of the photograph. All photographs embody that powerful paradox that Barthes explored through a memorable discussion of Alexander Gardner's 1865 portrait of the thwarted assassin Lewis Payne. Payne is shown in his cell, awaiting execution, his wrists shackled; Barthes captions this 'he is dead and he is going to die'.[66] Dead *and* going to die locates this extraordinary double time: the present of the viewing of the photograph in which we know that Payne has already been executed and the present of the making of the photograph when we know he is going to die. The impossible and paradoxical *and* elides these two states.

This double temporality can be united with Barthes' insights concerning the 'sovereign Contingency' of the photograph: photography's 'micro-event'. Barthes contrasted this contingency and the *corps* it produced with that 'something else' (the 'corpus' or the real). A parallel distinction was clearly understood by T. Rangachari, the chair of the 1927–8 Indian Cinematograph Committee, who, commenting on the potential effect on Indian audiences of seeing naked actresses on the screen, argued that the 'question of [the] representation or misrepresentation of western life on the screen' was not the relevant issue. The only question of importance he concluded was what he described as '*the fact*' (in the final Report of the Committee this phrase is underlined) that Western actresses were prepared to act in this manner in front of the camera, which was 'bound to create a deservedly bad impression about western morals in the country'. Rangachari's '*fact*' was what Barthes referred to as the 'absolute Particular', 'the *This* (this photograph and not Photography)', what I have referred to above as the 'micro-event' and what film scholars refer to as the 'profilmic'.

Suddenly Flashing Upon Us

The profilmic is a clumsy cinematic allusion to what lies in front of the camera at the moment of exposure. It is that 'reality' with which, as Walter Benjamin pointed out, every photograph is 'seared'. We will shortly explore the excess guaranteed by this contingency but first let us note that for some anthropologists the singularity of the photographic image embodied a deficiency of information. Some photographic images presented multiple photographic images as parts of their projects of generalization. In a curious image which separates 'high class' and 'low class' Maoris, a grid of eighteen single portraits are deployed as building blocks for sociological generalization (illus. 48). That image distributes photographs spatially: Francis Galton's composite photography sought similar kinds of conclusions but through a superimposition that produced a 'thickening' of a problematic singularity, a thickening that might also facilitate a new practice of divination (illus. 49).

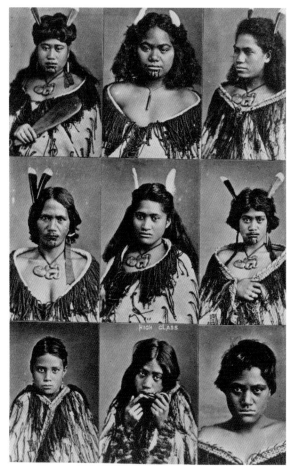

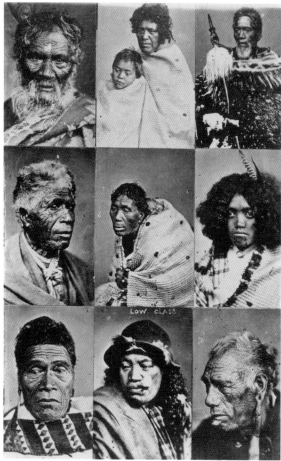

48 Unknown photographer, 'high-class' and 'low-class' Maoris, date unknown.

Galton's 'generalized' portraiture, about which he reported to the Anthropological Institute in London in 1879, was produced through the re-photography of quarter-length portraits that had been aligned through registration marks positioned in their eyes with the exposure time divided by the number of prints to be incorporated in the final image. A technique for producing similar images of skulls was discussed at the Institute a few years later.[67] Galton's 'photographic composite' portrayed 'an imaginary figure' but had the virtue of 'its mechanical precision, being subject to no errors beyond those incidental to all

photographic productions'.[68] But alongside this appeal to technology and science, there is a strong venatic or divinatory theme in Galton's argument. The technique compressed many different profilmic events and he suggests that it might liberate photography from its imprisonment within the temporality of its making. This would be useful in portraiture: 'If many photographs of a person were taken at different times, perhaps even years apart, their composite would possess that in which a single photograph is deficient.'[69] But it also opened up interpretive possibilities that the study of actual – singular – faces closed down. In a striking passage, Galton entangles the 'analytical tendency of the mind' with more poetic formulations such as 'fancy' and 'suggestiveness'. The mind's 'analytical tendency' is so strong that when confronted with 'a tangle of superimposed outlines' it will focus on one of them. But there is a fluidity and unpredictability to this work of interpretation which prompts Galton to adduce the following parallel: 'Looking at patterns of the papered walls of our room, we see, whenever our fancy is active, all kinds of forms and features. We often catch some strange combination that we are unable to recall on a subsequent occasion, while later still *it may suddenly flash upon us*'. Composite portraits, he concludes, would share much of this 'varied suggestiveness'.[70]

Evidence of this is perhaps provided by the woodcut illustration based on one of Galton's composite photographs and that illustrates the article. Although anthropological journals occasionally tipped in original albumen photographs (as for instance that which accompanied J. H. Lamprey's 1869 article), it was not until 1883 that photogravure images made an appearance in the *Anthropological Journal*. Prior to that date, photographs were routinely reproduced through woodcuts and steel engravings. In a very long caption to his illustration, Galton notes that the wood engraver has seen in the composite photograph – which combined three original images – only one 'line'. The engraver had 'made it exactly like one of its components, which it must be borne in mind *he had never seen*'.[71]

For Benjamin the collision of the camera with the event of the making of the photograph deposited a 'tiny spark of contingency'. Elsewhere, the present author has formulated a derivative proposition: 'however

49 Francis Galton's 'Composite Portraits' article (1879). The original caption reads: 'The accompanying woodcut is as fair a representation of one of the composites as is practicable in ordinary printing. It was photographically transferred to the wood, and the engraver has used his best endeavour to translate the shades into line engraving. This composite is made out of only three components, and its three-fold origin is to be traced in the ears, and in the buttons to the vest. To the best of my judgment the original photograph is a very exact average of its components: not one feature in it appears identical with that of any one of them, but it contains a resemblance to all, and is not more like to one of them than to another. However the judgment of the wood engraver is different. His rendering of the composite has made it exactly like one of its components, which it must be borne in mind he has never seen. It is just as though as artist drawing a child had produced a portrait closely resembling its deceased father, having overlooked an equally strong likeness to its deceased mother, which was apparent to its relatives. This is to me a striking proof that the composite is a true combination.'

hard the photographer tries to *exclude*, the camera lens always *includes*'.[72] Photographs, necessarily seared with reality, always have to contend with this excessive inclusion. They are, as Barthes observed, 'crammed' and 'exorbitant'.[73] For a Malinowskian practice of functionalist encompassment this was ideal: the photograph could never contain *too much* information, but for other photographers this was one source of photography's trouble.

Benjamin's wonderful observations on the excess guaranteed by contingency helps us understand all photography, but they seem to have a very special relationship to certain images in the anthropological archive. They encourage an overdue attention to the complexities of images in the wake of simplistic readings that assumed photographs could be read as transparent objectifications of ideology. Recall Benjamin's suggestion in his 'Little History of Photography' essay that

> No matter how artful the photographer, no matter how carefully posed his subject, the beholder feels an irresistible urge to search such a picture for the tiny spark of contingency, of the here and now, with which reality has (so to speak) seared the subject, to find the inconspicuous spot where in the immediacy of that long-forgotten moment the future nests so eloquently we, looking back, may rediscover it.[74]

Consider this in relation to a large albumen print in which five Sudanese males face the camera (illus. 50). Made by the commercial photographer Hippolyte Arnoux, it is titled *Tiralleurs Soudanienes*, Sudanese 'sharpshooters' or light infantry. The photographer has created a redoubt from various cork logs and placed his sharpshooters in front of various studio backdrops; he appears to have instructed them to perform the sort of ferocity that would appeal to the colonial expectations of the day. Two of the figures perform enthusiastically but three appear diffident, quizzical and perhaps straightforwardly resistant. The moment of exposure captures these 'sparks of contingency': the right-hand figure's uncertainty, the central standing figure's inquisitiveness at the actions of the photographer, and the left-hand figure's disengagement. We might read a similar contingency

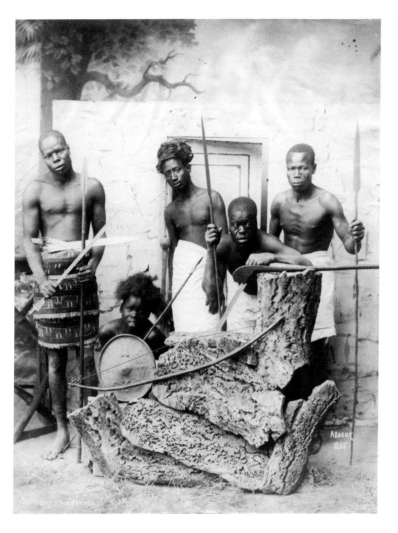

into Lévi-Strauss's paradoxical account of deceitful photographs hat
claim to present the 'untouched savage' but are undercut by 'small details
in the illustrations, since the photographer has not always been able to
avoid including the rusty petrol-cans in which this virgin people do
their cooking'.[75]

Edward S. Curtis spent a great deal of energy fighting this troubling
excess. Much of his romantic sepia vision of a dying Native American

51 Thomas Whiffen. 'Masked negative
of Amazonians', 1908–9, half-plate
glass negative.

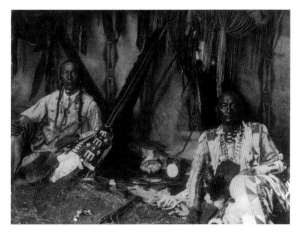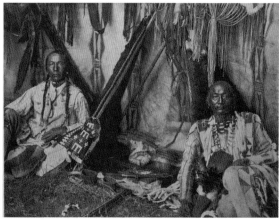

culture depended upon attempts to stage-manage the profilmic, and when that failed, to reframe and delete. As Vine Deloria wittily notes, the 'browning of America' – its reformulation through the aesthetic of Pictorialism – seemed to unite sepia colour and ancient wisdom.[76] Wherever possible Curtis tried to control the profilmic so as to minimize the need for post-exposure intervention. When confronted with refusals to perform in ritual clothes (as for instance by Navajo Yebachai dancers), he commonly made his own costumes for the purposes of the photograph. Faced with images that contained 'too much information', often of a 'hybrid' nature, selective enlargement permitted the elimination of unwanted elements. This was the case with an image depicting Chief Joseph, Edmund Meany and an unidentified Nez Perce Indian. Professor Meany, who taught Curtis history at the University of Washington, stands between the two seated ornately dressed Indians wearing a coat and tie. However, Curtis wanted only Chief Joseph for his masterwork *The North American Indian* and accordingly rescued his noble visage from the contaminated reality that had seared the original image. Thomas Whiffen, working in the north-west Amazon at about the same time, deployed similar selectivity in favour of the 'authentic'. A vignetted negative in the Haddon Collection in Cambridge reveals a group, mostly clad in European-influenced dress, from which a boy wearing a headdress has been abstracted as the pure depository of indigeneity (illus. 51).[77]

52 Edward S. Curtis, *In a Piegan Lodge*, c. 1910, print from an untouched negative.

53 Sepia and 'ancient wisdom' united in the 'browning of America'. Edward S. Curtis, photograph from *In a Piegan Lodge*, c. 1910, photogravure.

In a similar manner the lone heroic figure who would subsequently appear in Curtis's image titled *Crying to the Spirits* appears against a light sky in the original negative. The published print burned in a darker, brooding sky, and increased the contrast around the figure's face, enhancing the elegiac quality of the image. These interventions in an 'inadequate' profilmic are common and translate prosaic images of Native Americans photographed in their contemporaneity into emotionally heightened forms. In other instances Curtis engages in a deliberate falsification worthy of later Stalinist photographic disappearances.[78] The original negative of *In a Piegan Lodge* depicted two ornately dressed men seated either side of a mysterious object that may be a medal or clock. Incarnated as a gravure in *The North American Indian*, the object has disappeared (illus. 52, 53).

A concern about the possible misreading of the profilmic is clear in Charles Gabriel Seligman's treatment of photographs of the Veddas of Ceylon in his monograph of 1911. Seligman, a veteran of the second Torres Strait expedition and a crucial member of the 'intermediate generation', worked among the Veddas between 1907 and 1908 and expected to find a hunter-gatherer society of the kind extensively photographed by commercial Ceylonese studios such as W.H.L. Skeen, Scowen, Plâté and

54 Charles Gabriel Seligman, 'Vedda cooking in a rock shelter at Bandiyagalge', 1907–8.

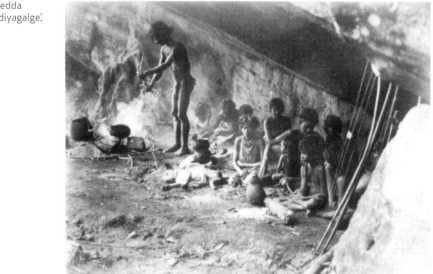

the Colombo Apothecaries. Their beautiful albumen prints, produced in profusion from the 1880s onwards, depicted the Veddas in the depths of the jungle clutching hunting weapons.

Seligman soon discovered the gap between the commercial photographic image and their ethnographic reality. He was only able to meet four families who had never practised cultivation. The rest had 'assumed the role of professional primitive men' and were 'commonly fetched to be interviewed by travellers . . . where they appear clad only in the traditional scanty Vedda garment, whereas, when not on show they dress very much as the neighbouring peasant Singhalese'.[79] The acute awareness of the difference between the dominant photographic image of the Veddas and Seligman's own observations doubtless informed the predicament he then faced in relation to the publication of a series of images taken 'in the depths of the jungle'. These had to be retouched to increase contrast, a fairly routine procedure in its day. But Seligman, having staged the veracity of his observations against the mendacity of commercial photography, found himself anxiously disavowing his own photographs. He explains that despite the use of rapid plates the darkness of the jungle was insurmountable and retouching was unavoidable. Consequently, he declares that his plates are 'more or less faked' and, lest anyone confuse them with real photographs, the questionable images are all marked with an asterisk after the caption. Seligman here underlines the faith invested in the profilmic and strives to make explicit the manner in which his photographs are no longer strictly the trace of a singular event.

Fig. 1. Itale Yaka ceremony (Bandaraduwa)*

55 The skeptical asterisk: Charles Gabriel Seligman, 'Itale Yaka Ceremony (Banaraduwa)', 1911.

More Vividly Than Can Be Described in Words

The sovereignty of the profilmic in performance or re-enactment narratives such as Curtis's was relatively unproblematic: he was interested in the suspension of disbelief and the generation of commercial income. In the

context of professionalizing anthropology this sovereignty created a good deal more trouble. Consider for instance the vein of sovereign contingency that runs through what many consider one of the crown jewels of the British tradition: Edward Evans-Pritchard's *Witchcraft, Oracles and Magic among the Azande*, first published in 1937. This magnificent study of the philosophy of causation in Zandeland in the Anglo-Egyptian Sudan delivers a mass of complex ethnographic observation clustered around a series of rationalizing explanations. It is the richness and attentiveness of Evans-Pritchard's data that have made the work endure, for it remains a model example of alertness to a seemingly alien life-world. As Geertz has observed, its strategy of 'disenstrangement' of the seemingly bizarre renders its subjects not 'others' but 'otherwise'.[80] The book is a double text: seen from one point of view it is a remarkable piece of what would later come to be called ethnomethodology, or ethnosociology (getting inside and inhabiting the categories of Zande thought), shadowed by a rationalist exegesis. From another angle it appears as a colonial work of documentation infected to its very core with an empathy for Zande epistemology.

Evans-Pritchard's writing, Clifford Geertz has noted, is exceptionally 'optical', 'his "being there" signature passionately visual'.[81] He quotes a striking passage from *Nuer Religion*:

> When I think of the sacrifices I have witnessed in Nuerland there are two objects I see most vividly and which sum up for me the sacrificial rite: the spear brandished in the right hand of the officiant as he walks up and down past the victim delivering his invocation, and the beast awaiting its death. It is not the figure of the officiant or what he says which evokes the most vivid impression, but the brandished spear in his right hand.[82]

This is all part of what Geertz terms Evans-Pritchard's 'magic lantern ethnography'.

Either way, it can be usefully considered as a 'transparency', to extend the metaphor suggested by Clifford Geertz: it has the quality of an intensely coloured positive enframed by a sturdy mount. This quality is also apparent in Evans-Pritchard's other work – for instance, an image, 'August shower',

56 Edward E. Evans-Pritchard, *Nuer Rain in Homestead*. Reproduced as 'August Shower' in *The Nuer* (1940), plate 46, ethnographic transparency.

which appeared in his 1940 book *The Nuer* (illus. 56).[83] A tent flap and pole frame our view of a line of distant cattle and huts and unwittingly incarnate the photographer in a rain-sodden phenomenology. Suddenly we are profoundly aware of the camera as a physical object, held by an ethnographer sheltering from the rain. There is an immediacy, a sense of presence, but also a qualification: a sense of literal and metaphorical framing: the ethnographer is a foreigner in his tent, not a Nuer sheltering in one of the distant huts.

There is an anxious inversion – often signalled in Evans-Pritchard's text by the use of 'nevertheless'[84] – manifest in his published account through the different evidential properties of, on the one hand, his writing and, on the other, the photographs, 34 of which illustrate his book. Evans-Pritchard's writing elucidates in a masterly and empathetic manner Zande 'natural philosophy', revealing among much else that Zande witchcraft is used to explain 'unfortunate events'. 'Witchcraft has its own logic, its own rules of thought and . . . these do not exclude natural causation.'[85] In a famous passage, Evans-Pritchard expresses what Kierkegaard rendered as the 'double-edged little dagger'[86] of 'either/or', that seemingly radical choice that dissolves before our very eyes. Evans-Pritchard begins his fourth chapter with a decisive resolve, a resolve that will quickly become more complex. He seeks a material and rationalist explanation of a phenomenon (witchcraft) whose subjective reality for the Zande he needs simultaneously to uphold: 'The physiological condition which is said to be the seat of witchcraft, and which I believe to be nothing more than the food passing through the small intestine, is an objective condition, but the qualities they attribute to it, and the rest of their beliefs about it, are mystical'. Evans-Pritchard then follows this with the famous declaration: 'Witches, as the Azande conceive them, *cannot exist*.'[87]

Zande witches cannot exist and yet Evans-Pritchard's book contains several photographs of singular and collective witch-doctors, figures whose existence is predicated on the presence of witches ('A witch-doctor'; 'Witch-doctors dancing round a hole in which Kamanga is to be buried', illus. 57). Linguistically, Evans-Pritchard presents several qualifications of the 'look, they have no breeches' variety, despite his admirable desire to understand Zande practices. He describes at one point exposing the witch-doctors: 'I caught them out and compelled them through force of

97

awkward circumstances to divulge their exact mode of trickery';[88] elsewhere he catalogues a 'variety' of tricks.[89]

Evans-Pritchard's text expresses his rationalist framing: witches cannot exist but the job of the anthropologist is to try and make sense of them. The logic of photography, however, is subtly different: it presents as he says things 'more vividly than . . . can be described in words'.[90] Text seems capable of a certain vignetting whereas photography always comes 'bled' to edges, without the framing and distancing that text more easily allows. Photographs present a regime of evidence which Evans-Pritchard's text constantly strives to negate: witch-doctors and perhaps witches, as the Azande conceive them, *do exist*, it seems, at least in their photographs.

The Trouble with Writing

Earlier we encountered – via Tylor – a magical piece of South Sea writing, able to speak at a distance, prefiguring Edison's phonograph and also (I suggested) photography, whose magical qualities Tylor was unable honestly to grasp. This image of the chief, wearing the magical wooden chip inscribed with writing to augment his authority among fellow Islanders, resonates powerfully with an 'extraordinary incident' in Claude Lévi-Strauss's celebrated 1955 travel narrative *Tristes Tropiques*. Perhaps the most accessible of all his writings, *Tristes Tropiques* entwines photography with a problematic form of writing under the sign of a mournful self-loathing. Ethnography, photography and writing are all allied as unwitting agents of the destruction of the primitive.

This was not a new trope: Malinowski had written in *Argonauts* about what we might label (in the spirit of Lévi-Strauss) that 'extraordinary paradox'. Ethnology, he bemoaned in the first words of that book's Foreword, is

> in the sadly ludicrous, not to say tragic position, that at the very moment when it begins to put its workshop in order, to forge its proper tools, to start ready for work . . . the material of its study melts away with hopeless rapidity.

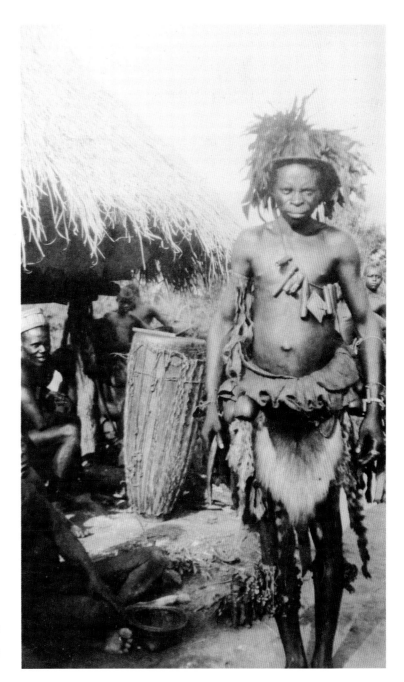

57 Edward E. Evans-Pritchard, *Zande Binza (Witchdoctor)*, 1927–30. Reproduced as *'A Witch Doctor'* in *Witchcraft, Oracles and Magic Among the Azande* (1937), plate 14.

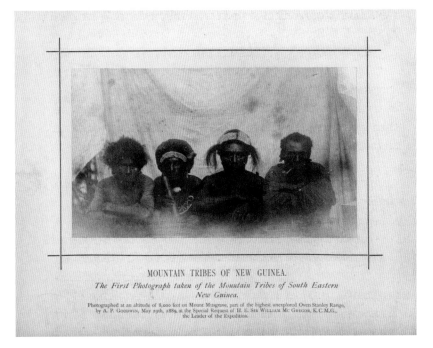

MOUNTAIN TRIBES OF NEW GUINEA.
*The First Photograph taken of the Mountain Tribes of South Eastern
New Guinea.*

Photographed at an altitude of 8,000 feet on Mount Musgrave, part of the highest unexplored Owen Stanley Range,
by A. P. GOODWIN, May 29th, 1889, at the Special Request of H. E. SIR WILLIAM MC GREGOR, K.C.M.G.,
the Leader of the Expedition.

58 A. P. Goodwin, 'The First Photograph taken of the Mountain Tribes of South Eastern New Guinea, Photographed at an altitude of 8,000 feet on Mount Musgrave, part of the highest unexplored Owen Stanley Range, by A. P. Goodwin, May 29th, 1889, at the special request of H. E. Sir William McGregor, K.C.M.G., the Leader of the Expedition', 1889.

The inhabitants of 'savage countries', he continued, 'die away under our very eyes'.[91] We might also place a genre of 'first contact' images within this interpretive frame: 'firstness' gestures to an inevitable decay inaugurated by the event of having been represented. A. P. Goodwin, a lengthy caption reveals, photographed a group of 'Mountain Tribes of South Eastern New Guinea' at an altitude of 2,440 metres (8,000 feet) on Mount Musgrave on 29 May 1889. This was the 'first photograph' taken of them, a notation that helps create a sense of their impending transformation, and perhaps 'melting away' in the face of future encounters with the camera. A symmetrical 'lastness' fulfils a similar function. C. A. Woolley's 1866 series of the 'last of the Tasmanians' included a defiant portrait of Trucaninni, who seems to communicate her self-knowledge that the camera hopes she will perform her own demise (illus. 12).

Tristes Tropiques opens with a powerful disparagement of photography as an anthropological tool. Exploring has become a trade, no longer dedicated to discovering 'hitherto unknown facts after years of study',

but instead dedicated to 'assembling lantern-slides or motion pictures, preferably in colour, so as to fill a hall with an audience'.[92] The information these images are capable of communicating is of a degraded kind (including 'the misdemeanours of the ship's dog'), and the images themselves seem to merge into the decrepitude of the institutions that contain them: Lévi-Strauss recalls a 'gloomy' amphitheatre at the end of the Jardin des Plantes where a 'projector, which was fitted with inadequate bulbs threw faint images on to an over-large screen, and the lecturer, however closely he peered, could hardly discern their outlines, while for the public they were scarcely distinguishable from the damp stains on the walls'.[93]

Photography repeatedly emerges as an inadequate mechanized shadow of a former completeness. It is firmly allied with the 'prodigious mass of noxious by-products which now contaminate the globe'[94] and has displaced substances such as red dye for which formerly people 'risk[ed] their lives in India or in the Americas'. Those earlier travellers' trophies were sensorially rich, providing 'visual and olfactory surprises', and added 'a new range of sense experience to a civilization'. Modern 'moral spices' that, by contrast, help us sink 'further into boredom' are 'photographs, books and traveller's tales'.[95]

Given the despair that photography evokes in Lévi-Strauss, it is hardly a surprise that it should become narratively yoked to another tragic form: 'bad' writing. 'The Writing Lesson' – a much-discussed chapter[96] – describes Lévi-Strauss's experience among the Nambikwara, and specifically a Nambikwara chief's public display of the technology of writing. Lévi-Strauss handed out paper and pencils with which initially the Nambikwara did nothing, but then some began to write, or rather to produce lines across their pages in imitation of the ethnographer with his notebook. A chief had 'further ambitions' and joined the ethnographer with a writing pad producing 'wavy lines on his paper' in response to Lévi-Strauss's questions. 'Each time he completed a line, he examined it anxiously, as if expecting the meaning to leap from the page . . . there was a tacit understanding . . . that this unintelligible scribbling had a meaning which I pretended to decipher [illus. 59].'[97] Subsequently, the chief attempted to read to fellow Nambikwara, a 'farce' that went on for

two hours and which Lévi-Strauss interprets as an attempt to demonstrate his alliance with the white man and that he 'shared his secrets'.[98]

That it might be useful to draw a parallel between Lévi-Strauss's hostility to this appropriation of writing and his hostility to photography is suggested by the manner in which his photographic equipment and the broader question of vision appear in the 'writing lesson' text. Lévi-Strauss narrates a 'dangerous expedition', albeit one that appeared to him at the time of writing as simply 'grotesque', from Juruena into Nambikwara country. Finally, Lévi-Strauss's expedition reaches the rendezvous and 75 Nambikwara appear together with their extremely nervous leader. Wary of each other, none of two groups sleeps that night. The next day dawns and with it 'the extraordinary incident' described above, which will preoccupy commentators for many decades.

59 Claude Lévi-Strauss, 'A page of "writing" by a Nambikwara Indian', from *The Raw and the Cooked* (1970), p. 325.

Lévi-Strauss's party is in a hurry to depart, disconcerted by the 'mystifications of which I had just been the unknowing instrument'. However, his mule is ill, stops dead in its tracks and Lévi-Strauss suddenly finds himself alone, 'lost, in the middle of the bush'. He dismounts and fires several shots from his rifle, scaring his mule, who runs off into the distance. Lévi-Strauss puts his 'weapons and photographic equipment neatly at the foot of a tree', memorizing its position. A comic pantomime of the anthropologist in pursuit of his wily mule then ensues, which intensifies when he finally manages to mount it. Wandering confusedly, the sun going down and expecting at any moment to 'be the target of a volley of arrows', he is rescued by two Nambikwara. The recovery of Lévi-Strauss's equipment (rifle and camera) that he had found so difficult was for the Nambikwara 'child's play'.

That night Lévi-Strauss sleeps badly, tormented by the 'extraordinary incident'. 'The Nambikwara had learnt what it meant to write! But not at all, as one might have supposed, as the result of a laborious apprenticeship. The symbol had been borrowed but the reality remained quite foreign to them.'[99] Lévi-Strauss's disquisition upon the civilizational consequences

of writing (which extends over several pages) is directly followed by another passage that links visuality and pain. While at Utiarity, an epidemic of 'purulent opthalma broke out among the natives'. Extremely painful, it also presaged, for some, 'permanent blindness'. For some days the whole group was paralysed and Lévi-Strauss reluctantly departs, leaving the expedition's doctor behind to help, and presses on to Campos Novos.

This narrative has a mythic quality to it and, if subjected to a Lévi-Straussian structural analysis, might reveal the following juxtapositions and alignments: the extraordinary incident is announced; Lévi-Strauss loses his photographic equipment; he sleeps badly thinking about the extraordinary incident; the Nambikwara are blighted with eye disease.

60 Claude Lévi-Strauss: 'An epidemic of very painful, suppurating eye inflammation struck the Indians while we were there . . . We witnessed some distressing scenes'. Photograph of the Nambikwara, Brazil.

The anthropologist's loss of his photographic equipment and the Nambikwara's immediate ability to locate it suggest an echo – there is an equal ability to locate technologies that require no 'laborious apprenticeship'. The purulent opthalma appears as a mythic punishment for the transgression of a natural order of speech.

Writing in the mid-1990s in a prologue to a collection of his photographs from Brazil from 1935–9, Lévi-Strauss consolidates this trope of disruption, and makes explicit his anxiety about the tension between the lived practice of life and how that practice is captured in the photographic image, revealing in several of his photographic images the contours of a broader 'technology lesson'. Lévi-Strauss documents his immersion as a child in photographic technology and process: his father was a portrait painter who routinely photographed his subjects 'to guide him in the placement of their principal features'. His father, along with his mother, would visit Lévi-Strauss in São Paulo in 1935 and father and son shopped for photographic supplies there, acquiring a twin-lens reflex Voigtlander and a Hugo-Meyer F1.5 with a 75 mm lens. This turned out to be 'practically unusable because of its weight'. An 'oval shaped miniature 8 mm [film] camera' was similarly neglected: 'I hardly ever used it, feeling guilty if I kept my eye glued on the viewfinder instead of observing and trying to understand what was going on around me.'[100] Two Leicas, by contrast, never ceased to make him 'marvel how such a small format . . . could produce very precise details'.

In 1994, looking back 60 years later at a selection of images of São Paulo, and of Amerindian peoples such as the Caduveo, the Bororo and the Nambikwara, Lévi-Strauss records his numbness when confronted with these photographs. By contrast, his notebooks for the period, treated with creosote to repel termites and mildew, still retain an almost undetectable 'perfume', which 'instantly brings back to me the savannas and forests of Central Brazil, inseparably bound with other smells . . . as well as with sounds and colours'. They are 'the thing itself, still a real part of what I have experienced'.[101] Photography, however, brings back nothing of this; photographs are 'silent' images. They are proofs of something having existed or happened, but not perfumed emissaries of experience. They are merely 'indices' that leave Lévi-Strauss

with 'the impression of a void, a lack of something the lens is inherently unable to capture'.

The most succinct statement of Lévi-Strauss's response to photography appeared in a much later essay, 'To A Young Painter'.[102] Here he contrasted the 'coherence' which the artist imposes on the outer world by 'omitting some data, by amplifying or reducing other data, by modulating the data he keeps' with the photographer's impoverished options. 'The physical and mechanical constraints of the camera', Lévi-Strauss continues, together with 'the chemical constraints of sensitive film, the subjects possible, the angle of view, and the lighting, allow the photographer only a very restricted freedom compared with the artist's practically unlimited freedom of eye and hand'.[103] For Lévi-Strauss, photography is too closely bound to 'the profuse information that the outer world is constantly sending out to assail the sensory organs'. It is imprisoned in that crude world of uncoded surfaces and objects: its analogue modality and unavoidable capture of contingency made it too vast ('crammed' and 'exorbitant' to recall Barthes) and too blank an object for a structuralism wedded to a linguistic binarism – a kind of digitalism *avant la lettre*.

Tristes Tropiques brings us full circle from a nineteenth-century anthropology, uncertain about the reliability of speech and seeking in photography the stability and fixity of writing. In the nineteenth century the photographic image offered 'facts about which there could be no question'. By the mid-twentieth century (*Tristes Tropiques* was published in 1955), many viewed these 'facts' as dead external manifestations of a cultural complexity that demanded different modes of engagement. They were, as Gregory Bateson put it, 'bored with the conventional study of the more formal details'.[104] Edmund Leach – in a prefiguration of the impact that structuralism (the paradigm invented, in anthropology, by Lévi-Strauss) would have on British anthropology – suggested that most anthropological description was no better than 'butterfly collecting', seduced by external appearance. Anthropologists were preoccupied with categories akin to 'blue butterflies', classes arrived at by the study of surfaces that were 'irrelevant for the understanding of lepidoptera'.[105] The new modes of engagement and analysis, which often involved a reframing and repositioning of photography, are the subject of the next chapter.

three
The Problem with Anthropology

Anthropologists, as we have seen, were also showing the photographs they made to the subjects who appeared within them. Occasionally, they noted viewers' difficulty in seeing their content: many reports describe an inability to decipher the contents of images. Perhaps the most resonant account of this difficulty was provided by the anthropologist Anthony Forge, who juxtaposed this 'resistance' with Abelam ritual painting. Forge had worked among the Abelam in Papua New Guinea and documented a male painting cult in which complex iconographic elements were taught to initiates. He was concerned to demonstrate that the images Abelam men produced might look 'abstract' when shown to viewers who had not been inculcated into the local visual language. Those who possessed that language could easily understand the work of 'reference' undertaken by the images. What appeared to be an Abelam inability to read photographs introduced a symmetry that was of great use to Forge: he hoped to suggest that photographic reference was *also* dependent on a code that had to be learned. There was nothing 'natural' about *either* system.

Forge noted that Abelam exposure to photography went back – intermittently – as far as 1937 and the first contact with Europeans, and that young Abelam men who spent several years labouring on the coast usually returned with photographs of themselves 'in all their modern finery', taken by Chinese photographers. These tended to be full-body rigid poses shot against a plain backdrop. *These* photographs, Forge notes, could be easily 'read'. However, when shown any image that confounds this learned aesthetic (action images, not full face, or full figure), 'they cease to be able to "see" the photograph at all'. Forge provides

poignant evidence of desire thwarted by perceptual innocence: travellers from distant villages who came to see Forge because they knew he had a photograph of a deceased relative 'were often pathetically keen to see him at all, turning the photograph in all directions'. Photographs in which figures dominated were also opaque: Forge 'had to draw a thick line round [a figure] before it could be identified' and even then Forge concluded that viewers 'willed themselves to see it rather than actually saw it'.

The Shock of Convention

The conclusion drawn by Forge is that Abelam vision had been socialized 'in a way that makes photographs especially incomprehensible, just as ours is socialized to see photographs and indeed to regard them as in some sense more truthful than what the eye sees'.[1] The sense of representational relativity that lies at the heart of Forge's account had been intimated earlier in the Africanist anthropologist Melville Herskovits's linking of the 'common finding' of a failure to 'see' photographs to a broader philosophical revision of the 'natural' quality of the photographic image. 'To those of us accustomed to the idiom of the realism of the photographic lens', he wrote, '*the degree of conventionalism* that inheres in even the clearest, most accurate photograph, *is something of a shock.*'[2]

This conversion of a photographic realism – its quality as a 'natural' sign capable of producing facts 'about which there is no question' – into a conventionalism in which intelligibility is simply the result of cultural training, prefigured the self-questioning of ethnographic 'authority' which characterized much anthropology in the 1980s. This questioning was perhaps exemplified most influentially in an edited collection of essays arising from a 1984 seminar at the School of American Research in Santa Fe, *Writing Culture*, which opens with a discussion of a photograph of a scene of writing. Referring to the frontispiece, which depicted the anthropologist Stephen Tyler in India in 1963, the book draws attention to the scarcity of images like this that show anthropologists in the field, performing that activity upon which their professional evaluation ultimately rests: writing. *Writing Culture* then notes familiar images of

Malinowski's tent which appear in *Argonauts* (see illus. 32), but which deny us access to the scene of writing and contrasts these with an image first published by the historian of anthropology George Stocking in 1983. This striking image, shot from inside the tent, reveals Malinowski in profile, apparently writing, and various Trobrianders outside, peering in. Although taken some time during the second decade of the twentieth century, the image, Clifford and Marcus (the editors of *Writing Culture*) argue, is a 'sign of our times, not [Malinowski's]'.[3]

In a weak echo of Derrida's critique of the possibility of 'self-presence', and informed as much perhaps by Brechtian notions of *Verfremdungseffekt* (that alienation or distancing effect that disrupts naturalistic illusion), or possibly, indeed, by the *Wizard of Oz*, *Writing Culture* demanded that the fragile and multiple dependencies of 'ethnographic authority' be rendered visible. It set itself in opposition to an anthropology that claimed 'transparency of representation and immediacy of experience'. In developing its critique – one that was taken up by very significant numbers of anthropologists around the globe – *Writing Culture* built upon critiques of visualism and gave many of them specifically photographic metaphorical form.

The critique of the visual per se has been identified by Martin Jay as a profound preoccupation of twentieth-century French critical theory.[4] Within anthropology the lineage of critique would include work by Anne Salmond, who traced the infiltration of visualist metaphors to the very core of anthropology,[5] and Johannes Fabian, who presented a historical critique documenting anthropology's reliance on a moral spatiality.[6] As part of the 'shift away from the observing eye',[7] *Writing Culture* urged a 'discursive' rather than 'visual' approach and one that attended to differently positioned voices rather than a disembodied eye of God. The metaphors quickly become highly photographic: '"Cultures" do not hold still for their portraits. Attempts to make them do so always involve simplification and exclusion' including the 'selection of a temporal focus'.[8]

The concern with photography as a metaphor for what had gone wrong was even more apparent in James Clifford's other work. Malinowski's photography receives extensive scrutiny for the manner in which it seems to compress both the 'formation and break-up' of ethnographic authority in single images. His images – like the frontispiece to *Argonauts* – seem to

combine the desire for the authority of an observing presence delivering authoritative images in which the maker remains invisible (along the lines of the photographer beneath his cloak), *and* the anthropologist as reflexive literary figure, appearing in his images and convincing through literary panache. The *Argonauts* frontispiece, titled 'A Ceremonial Act of the Kula', in which Trobrianders perform an exchange of a necklace, claims a documentary, observational status, but, as Clifford notes on closer inspection, the islanders 'seem to be looking at the camera'. The image thus entwines formation and rupture: 'Kula exchange has been made perfectly visible, centered in the perceptual frame, while a participant's glance redirects our attention to the observational standpoint we share, as readers, with the ethnographer and his camera.' The image embodies both the foundational claim of modern anthropological authority based on the presumption that 'you are there . . . because I was there' and a Brechtian unravelling of that authority.[9]

In a short account of the anxieties of fieldwork in Morocco, published some ten years earlier, one of the *Writing Culture* contributors had provided a detailed examination and critique of an anthropology built upon observation. Having finally received permission to live in a village to conduct fieldwork, Paul Rabinow is filled with angst about his professional motives. How would he reply to villagers when they asked why a 'rich American' wanted to live by himself in a mud-house in their village, he wonders. Perhaps he would respond: 'The furthering of anthropology', an anthropology, Rabinow observes, defined in the oxymoronic space of 'participant-observation'. 'However much one moves in the direction of participation, it is always the case that . . . the context is still ultimately dictated by "observation" and externality'.[10] This 'externality' – and what appear to be hostile local responses to it – is vividly gestured in a photograph by Paul Hyman (whose work is reproduced throughout Rabinow's text). Hyman, a professional photographer, was, like Rabinow, working under the guidance of Clifford Geertz in the walled oasis market town of Sefrou with the attention of demonstrating what 'someone innocent of academic social science who approaches the world through a lens rather than a typewriter would see'.[11] Hyman's photograph (reproduced here, illus. 61) shows a Moroccan shopkeeper appearing to gesticulate furiously

at the camera (and hence we the viewers) and visually marks the anxiety of anthropology's 'oxymoronic space'. If earlier approaches to the gaze in its colonial incarnation assumed that the viewer of the photograph was able to partake vicariously in the power of surveillance, this image renders the viewer as vulnerable as the photographer to the anger of his putative subject.

Hyman's photograph crystallizes changes that had happened in the decades since H. K. Slater had sanguinely recorded the Lambani husband's displeasure at discovering that their wives had been photographed (illus. 41). The sixth edition of *Notes and Queries* (published in 1951) decreed that 'it cannot be too strongly emphasized' that photographs of sacred places and ceremonies must not be taken 'unless the permission of the people concerned has been obtained'. Much better, it continued, 'to do without such pictures than to run the risk of incurring ill-will or even hostility by [the] tactless disregard of local feeling'.[12]

In retrospect, it is possible to provide a much longer history (some of which has already been alluded to) of this questioning of the naturalizing claims of its own representations and of the nature of a 'monological' anthropological knowledge. We might push this as far back as the 1880s, the period during which an anonymous Nicobarese artist sketched the anthropologist E. H. Man at work with his camera on these remote islands in the Bay of Bengal. Julius Lips's archive of 'savages hitting back' demonstrates the explosive nature of 'dialogical' images and knowledges. We might also draw attention to two books, published in 1941 and 1942, that help frame a debate that would only be fully explored within anthropology in the mid-1980s. The two books form a striking pair, one a classic of modernist anxiety and self-loathing, the other the cold application of a scientistic gaze.

The latter book, Margaret Mead's and Gregory Bateson's *Balinese Character* (1942), was an encyclopedic attempt to document the impact of child-rearing practices on the bodily disposition of Balinese society. Sections cover motifs such as 'Awayness', 'Visual and Kinaesthetic Learning' and 'Hand Postures in Daily Life'. Bateson – one of the most original and inventive of twentieth-century anthropologists – enumerated four factors that he believed had helped 'diminish camera consciousness'. The first of

61 Paul Hyman, untitled photograph from the 'Sefrou' series. The shopkeeper's gesticulations appear to be aimed at the camera but were in fact directed at the *drari*, the crowd of young boys, gathered behind Hyman.

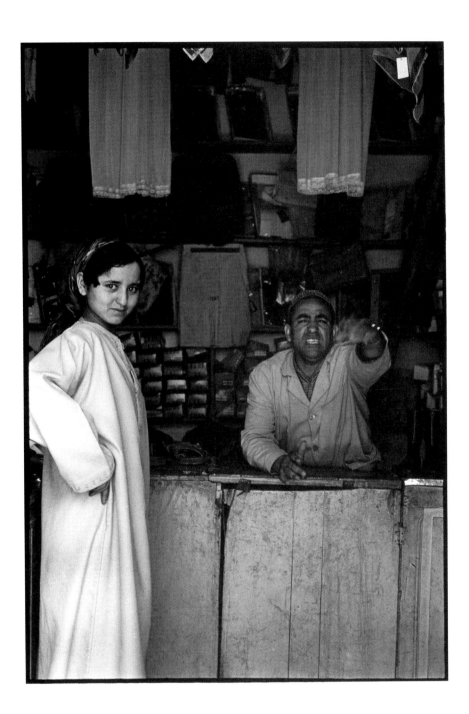

these was the 'very large number of photographs taken' – 25,000 Leica stills. Then there was the routinization of photography as part of the research – Bateson and Mead wore their two cameras every day and used them continuously without requesting permission from subjects. Further, they foregrounded 'small babies' as the ostensible focus of their photographs, managing to acquire candid shots of their parents in the process. And finally, they occasionally used an angular viewfinder to record their subjects unaware.[13]

This panopticon-like amassment of images, driven by a fear of the contamination of 'consciousness', contrasts starkly with that monument of photographic and literary modernism, *Let Us Now Praise Famous Men*, published in the United States the previous year. Whereas Bateson matter-of-factly described a series of techniques intended to extract likenesses from subjects that might wish not to be photographed, Agee's text is an agonistic stream of consciousness, endlessly tussling with the moral peril of representation. 'It seems to me curious, not to say obscene and thoroughly terrifying, that it could occur to an association of human beings drawn together through need and chance and for profit into a company, an organ of journalism, to pry intimately into the lives of an undefended and appallingly damaged group of human beings, an ignorant and helpless rural family', begins a typical Agee paragraph, before continuing: 'for the purpose of parading the nakedness, disadvantage and humiliation of these lives before another group of human beings, in the name of science, of "honest journalism" . . . and in the virtual certitude of almost unanimous public approval'.[14]

The Trouble with Documentary

By the 1980s Bateson's and Mead's anthropological agenda appeared positively archaic. At the beginning of that decade an innovative ethnography of poetics and song among the Kaluli of Papua New Guinea had used different photographic aesthetics to define the choices that faced a post-modern anthropology. Steven Feld, the ethnographer, conducted detailed ethnography on the auditory world of a forest-

dwelling people, aiming to show how sound 'codes' related to cultural 'ethos'. This involved a complex task of translation, not only between Kaluli linguistic concepts and standard English, but also between constructs such as 'feelingful experience' and academic social science. Feld addressed a divide between what he (after Allan Sekula) termed 'realist' and 'symbolist' approaches and exemplified these through the contrast of two very different photographs. The first of these depicts a Papuan New Guinean man heavily decorated with face and body paint and cockatoo and hornbill feathers. The figure is described by Feld as 'holding a drum', but in fact this part of the picture is cropped out in the original publication but visible in the version reproduced here. The image says little about the experiential nature of the ritual occasion and the dance for which the man (and ethnographer) is waiting. The image is formally composed, carefully focused and conveys a large amount of detailed information which can be read against the exegesis offered in the text.

The second image ('the object of the second image is some distortion of the first, taken with the subject in motion'), by contrast, is an example of what M. V. Portman a century earlier would have referred to as a 'fuzzygraph' (Feld acknowledges that it might appear to be a sign of 'incompetence'[15]), and seems proleptically to address Clifford's observation about culture's unwillingness to stand still for its portrait. Here the camera captures it in motion, a blur of feathers producing dynamic, ghostly zones of energy. If the previous image was 'realist', this is 'symbolist', with Feld deciding to 'use a metaphoric convention' established within Euro-American photography to make a statement about a Kaluli metaphor. Feld's experiment highlights the exhaustion of a conventional descriptive photography concerned only with stable surfaces, but it also draws attention to a shift – within some anthropological practice – away from language and towards practice and embodiment as the crucial location of cultural dynamics. The object of photography changes towards 'feelingful experience' and in so doing finds itself abandoning its earlier aesthetics. It consequently arrives at the paradox articulated by Feld: 'the imaging code considered the most documentary has the least to do with my imaging behaviour as an ethnographer'.[16]

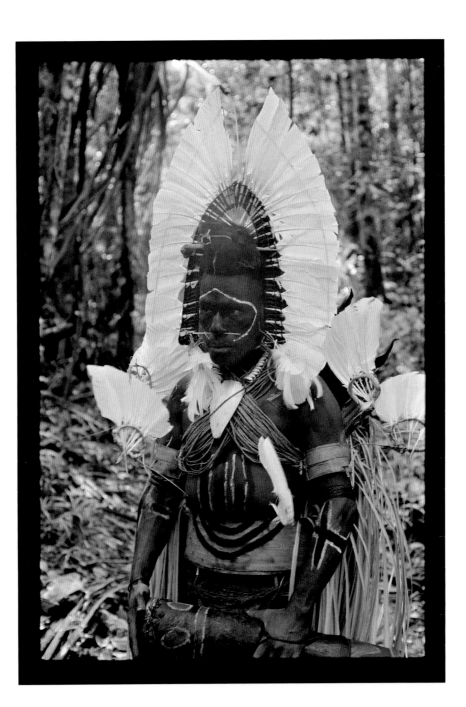

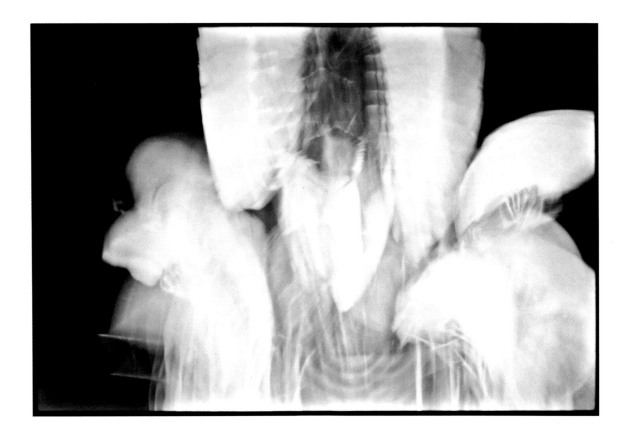

63 Steven Feld, 'Frozen in motion while dancing up and down in the dark longhouse corridor a dancer is seen as a "man in the form of a bird"', c. 1980s.

62 Steven Feld, 'Gaso of Bonɔ dressed in a kɔluba costume', c. 1980s.

One trajectory in recent anthropological engagements with photography has responded to an ambivalence about claims to ethnographic authority, and the kind of unease about 'realist' photography expressed by Feld, by focusing on what is sometimes referred to as 'indigenous media'. This interest in the camera, not as a tool of anthropologists' documentation of others, but as a tool already in the control of the communities that anthropologists were studying, was stimulated by debates about 'indigenous film' within visual anthropology, a sub-branch of anthropology that focused almost exclusively on moving images. As Faye Ginsburg noted, low-format, inexpensive video equipment was 'in the hands of people almost everywhere on the planet'.[17] This itself built upon a longer tradition that encompassed the analysis of national media.

Gregory Bateson published the preliminary results of an analysis of the Nazi film *Hitlerjunge Quex*, intended as a contribution to the war effort, as early as 1943, while still working as a film analyst attached to MOMA, New York.[18] He proposed that the film be read as a primary document of the worldview of its makers: 'The camera – and especially the motion picture camera – can lie freely about whatever passes in front of the lens, but inasmuch as the film was made by Nazis and used to make Nazis, we believe that . . . the film must tell us the truth about Nazism.'[19]

A fuller account of Bateson's research was subsequently published by his then wife, Margaret Mead, in the early 1950s and would form the basis for the later observation by the visual anthropologist Sol Worth that 'it is as silly to ask whether a film is true or false as it is to ask whether a grammar is true or false'.[20] Worth argued that photographs and films were prisms that allowed the viewer into the world of the maker of the image, an assumption he explored in detail in a collaborative project with John Adair which involved the teaching of film-making techniques to a group of Navajo as a pathway into their cognitive processes.[21]

Initially formulated as a means of directly accessing indigenous psyches, 'indigenous media' has widened via issues of political autonomy, to a reflexive engagement with local media as a means of engaging historical complexity and cultural and aesthetic hybridity. Alongside this there has been a growing acknowledgement of those colonial-era – and sometimes anthropological – interventions that have in part complexly inflected contemporary practices. Retrospectively filling in this complex collaborative history in relation to still photography quickly produces a rich haul: anthropologists frequently worked with local photographers and found their own 'portrait events' inflected by local aesthetics and expectations.[22] Consider an image from Ghana in the Pitt Rivers Museum. Captioned on the verso 'Chief of Obomen and Suite, Gold Coast', and possibly photographed by F. W. Ensor *circa* 1900, the photograph captures a senior Akan chief and his entourage formally grouped beneath a large state umbrella (illus. 64). There are anomalous elements in this image (such as the chief's headdress and the gold disks – usually worn by men – adorning the females[23]), but it seems overwhelmingly likely that the image records this Akan chief's organization of the photographic event, rather

64 F. W. Ensor(?), 'Chief of Obomen and Suite, Gold Coast', c. 1900.

M. OLU. OLUSOGA
Artistic Photographer & Enlarger

PHOTO HOUSE
Idepo Street, Ijebu-Ode.

than anything as disembodied as a 'colonial gaze'. Other images – often lacking any provenance or contextualizing information – bearing equal testimony to local photographic practices also inhabit the anthropological archive. In the Haddon Collection, for instance, there is an image of 'Alese the Chief of Ilese' in Nigeria, pasted on an ornate local mount whose verso records that it was a gift from the chief in January 1929 to Ethel Sophia Fegan. The mount reveals that the photograph is the work

of M. Olu Olusoaga, 'Artistic Photographer and Enlarger' of the PhotoHouse in Ijebu-Ode in south-west Nigeria.

The Gold Coast image could very well illustrate the West African photographic attention to symbolic hierarchy upon which Stephen Sprague commented in the late 1970s: 'The most important person is seated . . . in the centre of the first row, with the next most important seated to his left. Persons of least status stand further towards the back and edges of the frame.'[24] The Ijebu-Ode image would equally well illustrate the observation, which Sprague cites, that 'very much like other African chiefs [the *Oba*] thought he could hand on his image to posterity more beautifully by means of an enlarged photograph than by a wooden statue'.[25] Yoruba, Sprague suggests, may have been substituting photographs for traditional sculpture since at least the 1930s.

Sprague was writing specifically about Yoruba photography in the provincial town of Ila-Orangun, which he researched in collaboration with the anthropologist Marilyn Houlberg during 1975 (illus. 66). The importance of his brief study deserves to be underlined, not least because it would serve as a provocation to a host of later studies in other parts of the world. Sprague focused on the 'cultural values' revealed within Yoruba photography, which he argued were 'coded in Yoruba'.[26] He drew attention to the retention of formal poses within photography, and photography's seepage into pre-existing ritual practices. Most striking among the latter was photography's use in ritual practices associated with twins. In the past, in the event of the death of one twin, parents would commission a wooden twin *ibeji* figure that then participated in ritual protocols with the extant twin. Photography displaced these wooden signifiers and Sprague records several instances where – because no photograph had been made of a twin before their death – the surviving twin was dressed as the deceased and a photographic image of the two siblings produced (illus. 67).[27]

Sprague also had important observations to make about photography's transformative potential, arguing that it was caught up in fluid patterns of status: certain practices of photography were associated with the modern and progressive and the production of photographs was one means of displaying wealth.[28] Sprague gestures here towards a diluted

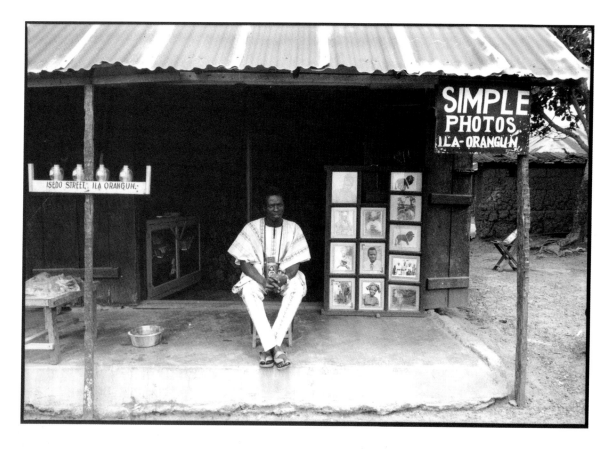

66 Stephen Sprague, 'Simple' photograph studio, c. 1975.

form of that photographic 'disturbance' about which Roland Barthes had written. This also directs our attention to a question that has simmered underneath the 'indigenous media debate': are cameras simply a translucent window through which we can view pre-existing cultural practices? Or is the camera itself a complex agent of cultural transformation?[29] Although Bateson advances some tentative conclusions about the 'propagandic effectiveness' of covert themes within the film,[30] we can contrast his approach to *Hitlerjunge Quex* with Walter Benjamin's arguments about the 'aestheticization' of politics. For Bateson film was a vehicle of ideology, and he was interested in film as a means of better understanding that ideology. For Benjamin film was crucial to that ideology in the first place: Nazism was in part a cinematic project for the Nuremberg

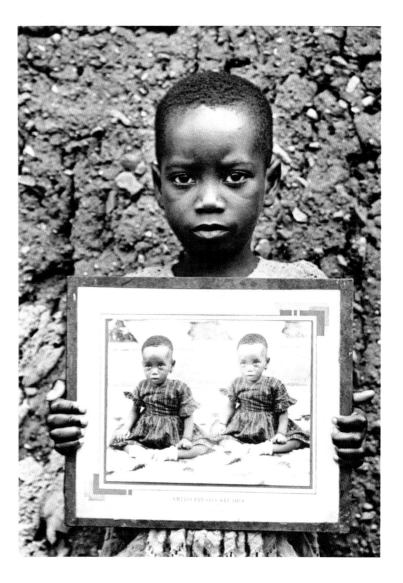

rallies and Riefenstahl's *Triumph of the Will* could not be easily disentan-
gled from these as a new form of excessively performative politics. Within
anthropology this issue was focused by the claim made by Mokuka, a
Brazilian Amerindian Kayapo film-maker (attending an anthropological
film conference in Manchester in 1992), that 'Just because I hold a white

man's camera, that doesn't mean I'm not a Kayapo . . . if you were to hold one of our head-dresses would that make you an Indian?'[31]

68 Philip Kwame Apagya, *Chief Photographer: Self Portrait*, 1996.

Observers are Worried!

West Africa has generated other insightful studies of vernacular photography. The anthropologist Tobias Wendl has directed attention to Ghanaian photographers' exploitation of the possibilities of the profilmic.[32] Mobilizing sharply styled clothing and fantastic painted backdrops of 'an idealized society of mass consumption', Ghanaian studios celebrate that fact that it is impossible to deny (to recall Roland Barthes) that 'the thing has been there'. Studio backdrops depict luxurious bourgeois domestic interiors, well-stocked fridges, international airports and dramatic cityscapes. One Kumasi photographer, Alfred Six, described himself as a 'king-maker' and he possessed 'all the accessories necessary for transforming ordinary citizens into traditional chiefs of kings, and women into *ohemmaa* (queen-mothers)'.[33] Another photographer, Philip Kwame Apagya, offers a studio backdrop with the 'traditional royal umbrella of the Ashanti kings' (illus. 68).

The 'thing that has been there' produces unstable effects. On the one hand it is utterly compelling: Apagya narrates how his successful career ('like a jet taking off') was indebted to his realistic and highly coloured backgrounds. People saw the resulting photographs and gasped 'How beautiful! A roomful of precious items. Whose house is it?'[34] Having reluctantly been persuaded that it was taken in a photographic studio, they too flocked to have their portraits taken. Stories circulate of angry husbands who refuse to believe that a studio-posed photograph was not taken in the commodious home of a wealthy lover (illus. 69). On the other hand photographs are valued precisely because of their phantasmatic character. Wendl positions them within an Akan culture of semiotic ambivalence. He notes a popular motto to be found on Ghanaian buses and taxis: 'Observers are Worried!' Photography enables Ghanaians to wander through 'the frontiers between illusion, desire and reality'. Akan notions of 'reality' invoke a domain that is not visible to the human eye, and it is

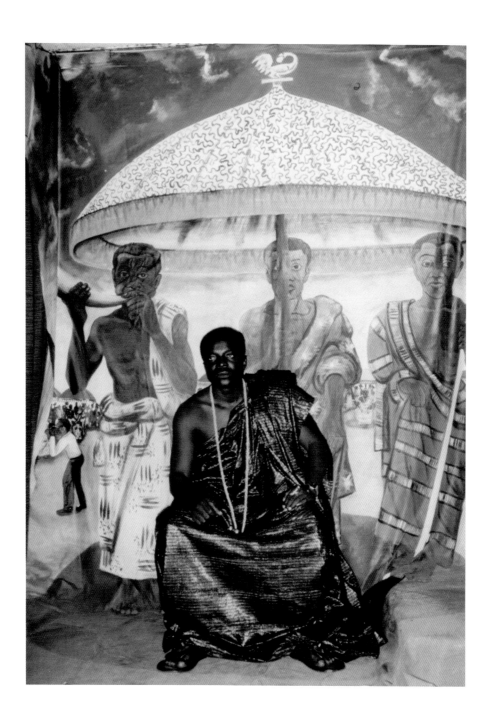

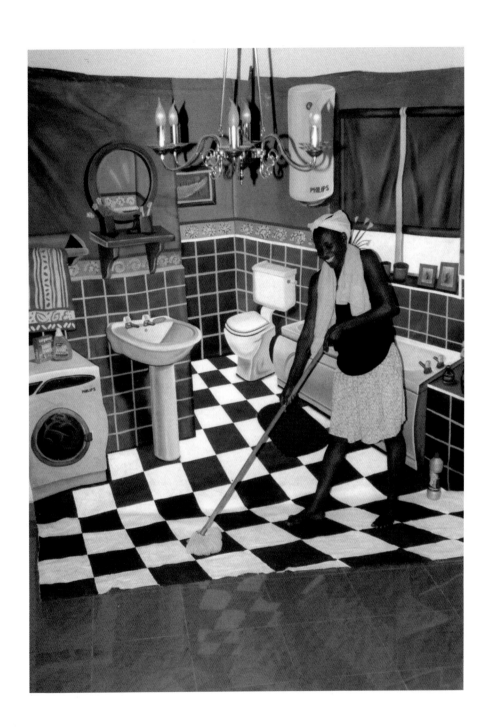

69 Philip Kwame Apagya, *Auntie Monica's Bathroom*, 2000.

precisely through 'lines of fracture with "normal" reality that the universe of Ghanaian photography reveals all its richness and multiplicity'.[35]

Wendl provides an illuminating frame through which to view the vernacular central Indian practices that this author has been observing, intermittently, since the early 1980s.[36] In rural and small-town central India (as in much of West Africa), the studio retains a central place in most people's encounters with photography. Increasingly cheap and easy to use, cameras have yet to sustain serious practices of self-photography: consumers still opt to surrender themselves to their local studio impresarios in the hope that under their skilled direction they will 'come out better'. Wanting to 'come out better' in their photographs (*is se bhi zyada acchha mera photo ana chahie*) is the aspiration of every visitor to the studio, and they denote by this the desire not to replicate some pre-existing 'something else' (for instance, that impossible subjectivity of who they 'really' are), but to submit themselves to masterly profilmic technicians who are able, through the use of costume, backgrounds, lighting and camera angles, to produce the desired pose, 'look', *mise-en-scène* or expression. One such technician is Vijay Vyas of Sagar Studios, who noted that 'everyone wants to look their best' and then proceeded to catalogue the activities and interventions that fed into the transformative zone of the profilmic:

> They hope they will look their best in photos. They don't want to wear their everyday clothes. Just like you – if you want your photo taken, you'll brush your hair, wear your best shirt . . . They don't want *vastavik* [realistic] photos. They always say I want to look good . . . everyone says I am like this but I want to come out better than this in my photo. So we try.[37]

Coming out better occurs in the space of the profilmic: it is the 'reality' of the studio space that matters for it is that which is deposited for the future in the photographic image. As in Ghana, images explore the lines that criss-cross the 'real' and the 'profilmic'. Consider for instance the only photograph that Ramachandra, a village carpenter, could afford to mark the wedding of his eldest son (illus. 70). The group were ushered into the backroom of a photographic studio in the nearby town and

asked to choose a backdrop. Ramachandra opted for a position between
two backdrops – one depicting Dal Lake in Kashmir, the other a blue wall
against which identity photographs were usually taken. The photograph
– the result of a quick decision in the face of economic hardship – provided
two backdrops for the price of one but also deliberately shattered any
'realist' pretence. The photograph became a record of a profilmic ambiva-
lence, positioning its subjects between two possible worlds.

 In this regard Ramachandra's choice connected him with a long
Indic tradition of philosophizing about the nature of the real that the
Sanskritist W. Norman Brown encapsulated as 'a generally accepted
theory that no one knows the ultimate truth'.[38] The *Markandeya Purana*,
for instance, adumbrates an indeterminate relationship between a

70 Prakash Jha Ramchandra and family
in Venus Studio, Nagda, 1988.

71 Unknown photographer, *Inside and
Outside the Mouth of God*, c. 1985,
photomontage.

72 Unknown photographer, *Jain couple at the Taj, Babulal Bohra.*

dream existence and the real that continually switch in a manner akin to the surfaces of a Möbius Strip. Markandeya is swallowed by the god Vishnu and roams his belly for thousands of years unable to determine whether he is 'inside' or 'outside'. Vernacular photography adopts this conceit, positioning portrait images of subjects inside the mouths of mythical beasts (illus. 71), but also extends an un-decidability about the final status of an image which can be the cause of real pleasure. A photograph of a Jain couple at the Taj Mahal (illus. 72), who were distant relatives of the person who showed me the image, produced such a response. Unable to recall whether the relatives had indeed visited Agra (the location of the *Ur*-Taj Mahal), it was impossible to determine the status of *this particular Taj*, which might easily have been a large photographic backdrop in a photographic studio. This profilmic Taj, and its resistance to classification, was the source of much

73 Karen Strassler, photographic studio backdrop with radio, painted in the late 1950s by A. Ngarobi (Gesang), City Photo Studio, Yogyakarta.

amusement among a small group who were gathered to give an opinion of its status.

The Taj Mahal is obviously a crucial signifier of Indian heritage, and in the Indonesian practices studied by Karen Strassler, studio backdrops depicting cultural landmarks are deployed in the creation of a virtual national space. The former President Sukarno's ultramodern Hotel Indonesia jostles alongside volcanoes and rice fields in a virtual *tour d'horizon*. Described as *ramai* ('lively, busy, colo[u]rful and full of life'[39]), these vividly coloured *mises-en-scène* attracted customers to competing photographic studios. Backdrops of domestic interiors featuring glass windows, staircases and occasionally swimming pools allowed visitors to photographic studios to 'physically enter the space of these fantasies and bring them home as tangible *kenang-kenangan* (memories/souvenirs)' (illus. 73).[40]

This concern with localized photographic practices was one way of responding to the *Writing Culture* engagement with the trouble with anthropology. It appeared to annul the problematic nature of an observational 'externality': the camera was no longer a tool of surveillance held by the anthropologist but an intimate prosthesis of a local cultural practice. Another way of responding to anthropology's problems was through an engagement with its history, and the use of photography to re-enact crucial elements of that history. This has involved archival projects by professional anthropologists, and an embodied response in artwork produced by photographic practitioners.

Anthropologists' critical engagement with their disciplinary past included significant work that foregrounded photography as an ethical prism through which to visualize a broader history.[41] A concern has also emerged with the ethics and politics of the continued visibility of the colonial archive. For reasons that in part reflect Aboriginal regimes of visibility and occlusion, this concern has been most apparent in discussions about Australian material. Nicolas Peterson has recently written of the 'changing photographic contract' in Australia in which images that previously circulated freely are increasingly subject to new protocols of control.

Peterson looks at different 'contractual' moments, contrasting the earlier coercive and cavalier production of images with a later regime of

74 Nicolas Peterson, the film unit of the Australian Institute of Aboriginal Studies documenting a restricted men's ceremony image has been overlain with a 21st-century sensibility.

deference to Aboriginal sensibility. He comments on an early twentieth-century Kerry postcard of a secret *bora* ceremony from central northern New South Wales (which was also listed as an albumen print in the catalogue issued by Kerry discussed in chapter One). The photographer Charles Kerry subsequently wrote of the 'enormous difficulties' experienced in accessing the rite and the 'prejudice against a white man [seeing] this secret ceremony'.[42] Kerry's image circulated widely as a postcard, and in a similar fashion photographs taken later by anthropologists such as Donald Thomson and Charles Mountford, although primarily intended for scholarly outlets, were also published in mass-circulation magazines

such as *The Illustrated London News* and *National Geographic*. Recent
changes are epitomized by the treatment in a 2003 publication of a mid-
1960s photograph by Peterson. Labelled 'The scientific gaze', the image
shows on the left the film unit of what was then called the Australian
Institute of Aboriginal Studies, consisting of two cameramen and two
sound recordists who are pointing their equipment at an event that
Peterson has blocked out. The black oblong marks the presence of a
new consensus about what can and cannot be shown.

From I-witnessing to Body-witnessing

Parallel ethical and political issues have been explored in the Australian
Aboriginal artist Leah King-Smith's elegiac *Patterns of Connection*.[43]

75 Leah King-Smith, photograph from the
Patterns of Connection series, 1995.

76 George Trager, 'Big Foot Lying Dead in the Snow at Wounded Knee', 1891.

The works overprint archival images of Aboriginal people with King-Smith's original fish-eye landscapes in large Cibachrome prints. The series was a response to her work in the archives of the State Library of Victoria in 1989 and 1990, where she worked with collections of early photography of Aboriginal people whose fragility and substitutability profoundly disturbed her. The smallness and disposability of the original archival prints have been banished by the imposing prints of *Patterns of Connection*, whose glossy surfaces confront the viewer with their own mirrored presence. The sheen of the images produces a shadow of the beholder, who becomes part of the image in the act of viewing. In addition to the sepia and black, when exhibited the prints also assume the complex shimmer of their surroundings. If the archive prints were one sign of the 'world as picture' – of a realm over which 'man' had power

(structured through alien taxonomies and endlessly substitutable[44])
– King-Smith's photocompositions might be seen as a reassertion of
the power of that world over a colonizing eye. The power relations are
reversed: it is no longer the viewer who structures the world in his/her
own image, but the (Aboriginal) world that 'impresses' the viewer.
A similar refusal of the 'absolute eye that cadavarizes'[45] and its photog-
raphic conventions is also apparent in the South African photographer
Zwelethu Mthethwa's portraits of Cape Town's informal settlement
residents (self-)posing in fabulously coloured domestic interiors. These
backdrops (often the product of recycled advertising posters and com-
mercial packaging) produce a surreal vibrancy, and a sense of heroic
tenacity by the subjects of the portraits in the face of an increasingly
commoditized world. The 'drama of colour' also facilitates – as Michael
Godby has argued – the assertion of individual human values through
its negation of a 'sociological' practice of black and white photography.[46]

The 'negation' of the broader anthropological archive has taken
many forms. Some have been narrational interventions, such as the
Seminole/Muskogee/Diné artist Hulleah J. Tsinhnahjinnie's re-telling of
George Trager's mournful 1891 photograph (illus. 76) of Big Foot lying
dead in the snow after the massacre of Wounded Knee in South Dakota.
The massacre was the US Government's response to the messianic Ghost
Dance movement, whose photographic documentation by James Mooney
was recorded in chapter One. Tsinhanhjinnie describes a 'vivid dream'
in which a small girl, wearing moccasins, walks into this photograph,
searching for someone. She walks over to Big Foot, 'shakes his shoulders,
takes his frozen hand . . . and helps him to his feet. He then brushes the
snow off of his clothes . . . and they walk out of the photograph.'[47]

Recoding takes a more fully figural form in the work of Gordon
Bennett, an Australian artist who perhaps more than anyone else has
explored the possibilities of visual 'translation' between media, and
between culturally essentialized aesthetics through what we might think
of as the grain of visualization.[48] Bennett's Aboriginal mother was raised
on a reserve and prohibited knowledge of her own people's belief and
customs. Bennett's own upbringing, which he has written about with
searing insight and poignancy, involved a complete invisibility of his

77 Gordon Bennett. *Australian Aborigines (Notes on Perception No. 4)* 1989, acrylic on paper.

Aboriginality and his work engages this legacy in complex and rewarding ways. Bennett's triptych of 1989, *Requiem, Of Grandeur, Empire*, demonstrates his concern with cultural technologies of rule and colonial technologies of representation. Aboriginal figures (based on early photographic images by Charles Woolley of Trucanini and by J. W. Lindt from the 1860s and '70s) are positioned at the vanishing-point of perspectively depicted cubes. Labelled A, B and C, these conflate colonial literacy and abbreviated racist calumnies (which Bennett references explicitly in many other works) as dual technologies of domination. Linear perspective and European technologies of writing, together with civilizational rhetorics (two of the triptych reference European classical archways), are diagnosed as central devices in the construction of Aboriginal identities by a colonial 'world picture'. His chief interest is the arbitrary nature of identifications and the ways in which technologies that claim a natural status might be overturned by radically different world views. *Empire* endows Emperor Augustus at the summit of the archway with an Aboriginal 'halo' referenced through the 'dot' style that became such a characteristic feature of Western Desert acrylic paintings from the 1970s onwards, which is also simultaneously the pixilation of the massreproduced stereotype. This style is deployed more systematically in a series *Notes on Perception/Australian Icons*, the fourth image of which subjects another J. W. Lindt image to the acrylic dot treatment (see illus. 10). 'Everyone could, and still can, "picture" an Aborigine', Bennett writes: early photographs become 'internalized icons against which contemporary Aborigines are measured'.[49] Bennett's images dissolve the photographic surface into the aesthetics of a competing system.

Part of King-Smith's response to the colonial archive involved a strategy of embodiment. The exponential re-sizing of images gave them a necessary permanence and presence. But redress was also possible through a literal embodiment, often through what bell hooks termed

strategies of 'perverse re-enactment'. The black British photographer
Dave Lewis, for instance, saturates his images with the enfleshed bodies
of those subjects whom the archive desiccated as comparative data.
Lewis references Lamprey's grid in an image of his own face emerging
from a focusing plate (illus. 79): here is the disavowed face beginning to
reassert its own presence. The same photographer pursued this theme in
other images: a ghostly body re-emerges from the anonymous space of
the archive (that of the Haddon Photographic Collection in Cambridge
University's Museum of Archaeology and Anthropology). For Lewis, the

78 David Lewis, photograph from
the *Impossible Science of Being*
commission, 1995.

drawers of the archive's card catalogue serves as a distantiated metaphor of the distantiating project of colonial photography: the grid of the grid, we might say.

Pushpamala N., an Indian artist who has worked in collaboration with the British photographer Clare Arni, has developed a re-enactment strategy that is even more explicit in its visual reference to the colonial archive but subjects it to deliberate and perverse slippage and *métissage*. In their series *Native Women of South India: Manners and Customs*, their critical

81 Pushpamala N. and Clare Arni, 'Toda H-26', from *Ethnographic Series, Native Women of South India: Manners and Customs*, Bangalore, 2000–2004, sepia-toned silver gelatin print.

80 Pushpamala N. and Clare Arni, 'Toda, after late 19th-century British anthropometric photograph', from *Native Types Series, Native Women of South India: Manners and Customs*, Bangalore 2000–2004, sepia-toned silver gelatin print.

re-enactment of anthropological objectification focuses initially on M. V. Portman's anthropometric studies of the Andamanese from 1894 (illus. 80). This is signalled by the use of Portman's unmistakable customization of the Lamprey grid (which he converted into a painted chequerboard black and white backdrop). However, this is quickly subverted in *The Ethnographic Series: An Exhaustive Scientific Analysis and Anthropometry of the Female Inhabitants* by the diversity of Pushpamala incarnations that appear against this backdrop: she appears in numerous different guises, none of them 'Andamanese'. She appears, anomalously, as a Toda woman from South India (rather than that of a Bay of Bengal Andamanese), and later as Nadia, the whip woman of Hindi film, and as iconic figures from Ravi Varma's late nineteenth-century paintings. The photographic aesthetic – indebted to Portman (and explicitly signalled as such in her accompanying documenta-tion) – is tested to destruction by a superfluity of perverse enactments (illus. 81). This directs our attention to the tension between the classifica-tory frame established by Portman's colonial aesthetic and what Barthes called photographic 'sovereign Contingency'. A Toda woman standing where we expect to see an Andamanese person forces us to contemplate

photography's inability to transcend the 'body' in favour of the '*corpus*'.[50] 'The event is never transcended', Barthes wrote, 'for the sake of something else'.[51]

Divination Redux

The contingency of the event returns us to photography's divinatory potential. Benjamin's vision of the photographer as a modern-day augur or haruspice can find much support from recent anthropological commentaries on vernacular imaging practices that stress the dangerous liminality of the moment of exposure of the negative. Tobias Wendl, whose Ghanaian study we have already invoked, notes the use of photography as a mode of exorcism, a kind of 'photo-therapy', and that negatives were referred to as *saman* or 'ghosts of the dead'. Pregnant women commonly avoided the camera for fear of exposing their unborn child to various dangers.[52]

82 Unknown photographer, Sheikh Ahmadou Bamba photographed while under house arrest by the French in Djourbel, Senegal, 1913.

 A *particularly fascinating example of the power of the photographic 'event' emerges from Senegal, where photography's 'tiny spark of contingency' pre-* cipitated a large cult around Sheikh Ahmadou Bamba. Bamba was photographed 'on a sultry, sunny day' sometime in 1913. Bamba was under house arrest by the French (as an alleged political agitator) and the photographer posed him against a slatted wooden mosque in the town of Djourbel. The bright sunlight, Allen and Mary Nooter Roberts record, produced various visual effects: his face breaks up into patches of light and dark, his eyes are hard to discern, his white robes glow and at the bottom of the image 'his right foot is obscured and appears to be missing'. The photograph, the Roberts record, has 'taken on a life of its own' and served as a 'visual catalyst for an explosion of visual imagery during the past twenty years'.[53]

83 Unknown photographer, *Noorman with the Light of Divine Radiance*, 1979.

The stark black/white contrast (evoking a conflictual history of French colonial constructions of race and ethnicity) of the image connects readily with Mouride cosmology. The Roberts report a Mouride mystic who described the black to be found in shadows as *el-nuru* in Arabic, 'which, paradoxically enough, means "light"'. Enlightenment springs from darkness: the Kaaba at Mecca is jet black and darkness is said to be the 'mother' of light.[54] Bamba's face – split into patches of black and white by the brilliant sunlight reflected on his skin – also becomes a site for a cosmological reworking. Sufis – already sensitized to finding in the face of the Prophet a 'marvellously written manuscript of the Qur'an'[55] – find in Bamba's face a calligraphic physiognomy in which the nose becomes an *alif*, the sweeping form that instantiates the name of Allah. Blessed with iconic properties (whose parallel is Korda's image of Che Guevara), Bamba's photograph collapses the contingency of the profilmic photographic moment into the messianic time of Mouridism, 'his missing right foot, lost in the deep shadow of that hot afternoon' the Roberts write 'steps into and out of obscurity, into or out of the other world'.[56] A cult around the Shirdi Sai Baba in contemporary India – to whom the Roberts are currently turning their attention – displays a similar preoccupation with photography's 'tiny sparks of contingency'. Almost uniquely in the broader Indian pantheon, images of Sai Baba invoke the power of the index: 'This is a real photograph', many of his images declare (most other photographs actually being chromolithographs based on photographic referents). Some of these show butterflies photographed in mid-flight, in whose extended wings an apotropaic Sai Baba miraculously appears.

A similar divinatory index can be seen at work in photographs distributed by one Noorman, a retired veteran of the Sukarno revolution in Indonesia. The anthropologist Karen Strassler narrates how Noorman, now living in poverty and obscurity in Yogyakarta, drew upon images in which a divine radiance (*wahyu*) appears to anoint him as Sukarno's true successor as part of a messianic revelatory history that 'collapses the

distance between past and future, promising through portents and miracles – return and recovery'.[57]

Working in Roviana in the Solomon Islands, Christopher Wright presents a compelling complementary account of photography as the *engin blong debil*, the 'engine which belongs to the devil' (illus. 84, 85).[58] Photographs are 'electric', one Solomon Islander related: 'they take things from the air . . . the spirit can make things in the photograph. The spirit can stay in the photograph like it stays in a skull. You can see the shadow of the spirits.'[59]

Such insights resonate with an earlier Melanesian history and suggest a possible re-interpretation of an early twentieth-century 'cargo cult' known as the 'Vailala Madness'. Famously studied by the Papuan Government Anthropologist F. E. Williams, the 'madness' involved the loss of bodily control (*haro heraripe* – 'one's head is turning round'), the eruption of a new language of 'nonsense syllables' called 'Djaman' (German), the destruction of old customs and the preparation for the arrival of a ghost ship in the Gulf of Papua bearing the spirits of the dead reincarnated as white men.[60] The spirits of the dead presaged their arrival by leaving imprints of their European boots, 'and even their bicycle tracks were found on the beaches'.[61] They might appear in the night as large black and white dogs, and 'lights flashed suddenly out of the darkness . . . the same as electric torches'. The leaders of the movement were in continual contact with the dead through the papers that fluttered down from the sky[62] and through the messages received through the 'flagpoles', copies, Williams presumes, of the wireless apparatus used by the Anglo-Persian Oil Company, who was active in the region.[63] The Australian photographer Frank Hurley's aeroplane flying overhead added to the prophetic crackle in the air.[64] In this swirling conjunction of signs and transmission – of wireless, cameras, planes and ships – we can glimpse a sense of the new histories of a 'world photographic system' that are yet to be written.

Some years later, considering the nature of Orakaiva magic, Williams would draw a fascinating connection between Papuan ghost beliefs and his own photographic practices (for he was himself an energetic photographer). He recalled 'a place of the dead', a 'mysterious lake haunted by ghosts' which Orakaiva women and children tried to avoid if possible.

84 Christopher Wright, Simon Sasae holding the only photograph he has of his father, Roviana, Western Solomon Islands, 2001.

However, it lay on the way to certain gardens and they would 'scurry by with their heads averted', terrified by the possibility of being seen by ghosts. Williams was attempting to photograph in this site of charged belief and narrates how Orakaiva expectations seeped into his own photographic practice:

I was manipulating some photographic-plates in a changing bag. A changing bag in the tropics is an awkward thing, as uncomfortable as a gas-mask. You look into its collapsible interior through a slit bound tightly up to your eyes, and the only light which enters the bag should come through a red window. But while I was changing my plates I became aware of a puncture through which there shone

143

85 Christopher Wright, Faletau Leve holding a framed photograph of himself as a young man, Roviana, Western Solomon Islands 2001.

a thin shaft of devastating white light. It was my reaction which revealed to me the fact that I was as much a magician as them, for I immediately shut my eyes.[65]

Back in the Western Solomons, the anthropologist Arthur Hocart had documented the associations of ghosts with cameras as early as 1908 ('The soul is called *galagala*, which also means a shadow, a reflection; it is caught in a camera'),[66] but rather than relegating this (following, for instance, Needham) to a mere 'literary stereotype' of some form of primitivist misconception, Wright uses it as a tool to prise open parallels between 'savage' and 'modern' practices. Is this, he asks 'an aberrant primitive reading, a misreading, of photography, or a recognition of one its fundamental tasks?'[67]

Our narrative of photography has turned full circle twice: from Tylor to Lévi-Strauss (from a 'good' to a 'bad' writing), and via anthropologists' investigation of their subject's own photographic practices we have come back to photography as a form of divination, unapologetically situated at the centre of 'animist' practices about which the anthropologist no longer feels anxious.

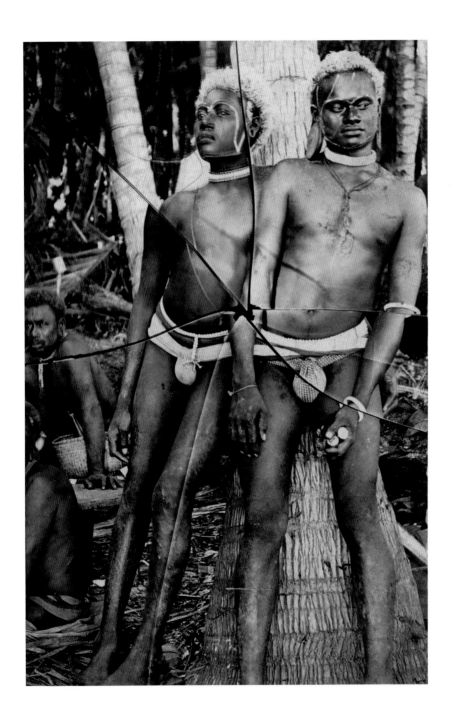

Epilogue: The Holograph

One apparent solution to the problem with anthropology was 'reflexivity'. This addressed the 'externality' of anthropology's observations (to recall Rabinow) by situating anthropologists within their ethnographies. It was intended to play a part in the destruction of anthropology's naturalistic 'illusion'. This desire for reflexivity explains a curious sub-genre of images to be found in some anthropological monographs. These images push reflexivity to the furthest possible limit. Consider, for instance, the US anthropologists Deborah Gewertz's and Frederick Errington's monograph *Twisted Histories, Altered Contexts* on the Chambri of Papua New Guinea. One image exemplifies what we might term the 'reflexive loop' and is titled: 'Still holding Deborah's dissertation, Yarapat and his clansmen performed chants to control the water level'.[1] The text describes how Gewertz's dissertation (the material embodiment of her interpretation) itself becomes an agent in new forms of social practice.

This trope recurs commonly: in the second edition of Steve Feld's seminal ethnography of acoustic concepts among the Kaluli (to which we have already had cause to refer) he describes how in 1982 he was once again in the field. Sitting in the longhouse, observing costume preparations for a forthcoming ritual: 'a young boy from another village entered the longhouse bearing a netbag of mail [including] a small box from the University of Pennsylvania Press'. As he sliced it open his partner Shari Robertson shouted to him to smile and recorded the event on film. His Kaluli hosts seem to be more impressed by the sharpness of his pocket jackknife than the book, although one male, Gaso, becomes extremely interested in the colour plate of himself adorned for a drumming prelude

86 The 'crack in the mirror'. For many anthropologists the camera has become an increasingly contested tool. Photography's naturalistic illusion and its 'thin-ness' and 'flatness' have all come under attack. This image by Henry B. T. Somerville of New Georgian men, Solomon Islands, from c. 1893 might serve as a visual metaphor of this skepticism. Vintage print from a cracked glass plate negative.

to an evening ceremony (illus. 62). Feld is concerned to avoid any accusation of narcissism: he discusses this event in the postscript to the second edition as a means of further elucidating Kaluli concepts of 'textualism'. He also provides, as a kind of talisman, an amusing epigraph from Isaac Bashevis Singer: 'When the writer becomes the centre of his attention, he becomes a nudnik. And a nudnik who believes he's profound is even worse than just a plain nudnik.'[2]

Feld inveighs against what he terms the 'cult of the author' and without doubt uses the arrival of these books to positive theoretical effect. However, he also reaps the benefit of being seen to 'talk nearby'. He demonstrates that he is not describing the Kaluli simply for the benefit of a distant anthropological audience. The arrival of the books serves simultaneously as a reciprocation, a gesture of good faith and a poetic metaphor that provides a form of closure based on circularity.

It would be disingenuous to deny that similar motivations under-lined the use of certain images in my own monograph on photography in central India.[3] I included a small number of images of myself, some labelled as such and some not. Because of the heavy overpainting, many readers may not have been aware of the author's presence in the latter, undeclared images. That was an attractive possibility to me because it helped sustain the fantasy of intersubjectively moving through a number of different positions (analyst, participant, local consumer and so on). There were also a set of practical and ethical factors: paying photographers to make images of myself facilitated a whole set of encounters under the aegis of client and the money I paid for the images seemed an equitable way of recompensing them for their time. But there was also a cruder set of imperatives at work: including images of myself, photographed in the local manner, permitted the visibility of the indexical body of the fieldworking anthropologist. The images help establish the reliability of my testimony and also helped complete the loop of ethical intersubjectivity since I am made visible in the same, broadly analogous way as other people from central India who also appear in the book.

This ethical intersubjective loop was also partly evident in the cover image that shows Ramlal, the brother of a villager called Hira with whom

I had felt very close. I had once photographed Hira holding a photograph of his deceased father, in a manner that is very common in the village: the physical cradling of an image for the purposes of making another image is an accepted way through which one can show respect and affection for deceased individuals. About a decade after I had first got to know him, Hira was tragically killed by a train as he was crossing the railway tracks in the nearby town. So subsequently I photographed his brother Ramlal in the same fashion, cradling the photograph I had earlier taken of Hira. I decided to use this image on the cover because it summed up many of the central themes in the book: the role of photography in social relations, their role as memorials, and an aspect of the materiality of images; also I knew it would mean a great deal to Hira's mother. In addition, it was attractive because of its gesture towards a Baudrillardian recursive simulacrum: the photo not of reality but only, and necessarily, a photo of another photo. But beyond this was also, of course, a declaration of my own authorial reliability: 'trust this book, from the pen of someone who was sufficiently intimate to participate in the production of the images circulating in this society'.

Implicit in this is also the claim that my own images were accepted by villagers, just as Gewertz's and Feld's own work was accepted by their hosts. This claim is at root moral and political: it asserts the dialogical and collaborative dimension to ethnography; but it is also a claim, of course, for a certain professional authority: 'they have witnessed my witnessing and affirmed it'. In this way, paradoxically (inter)subjectivity becomes the new objectivity, freighted once again with those very problems from which it sought escape.

This would not surprise those who have contemplated the representational matrix signalled by Velásquez's *Las Meninas*, a painting that was inserted in the consciousness of cultural theorists by its appearance as the frontispiece in Michel Foucault's *Le Mots et les choses* (1966).[4] This depiction of Velásquez in the act of creating the portrait of Philip IV and his second wife Mariá Anna places the viewer in the position that the sitters would have occupied (and they are shown only reflected in a distant mirror at the back of the painting). Is this reflexivity, or a Brechtian distancing effect *avant la lettre*? Or might we find ourselves

agreeing with David Carroll's reading of (one of)
Foucault's own interpretations of it:

> To represent the process of representation . . . would
> be . . . to contain within it a metarepresentation that is
> the ultimate word or the ultimate context or scene of
> representation, its end. Nothing seems to escape rep-
> resentation when representation itself is represented.[5]

Reflexivity perhaps leads up a dead end but is still
in play alongside other strategies. Within contemporary
anthropology it is easy to find those that condemn
photography as 'thin' and culturally meaningless,[6]
naive enthusiasts for photography, and sophisticated
advocates of processes of photographic 'repatriation' that
collapse photography back into the space of lived cultural
practice. In these last strategies – which emphasize the
sensory, material and embodied aspects – the problem
of observational 'externality' is resolved by re-integrating
photography into the social practice being observed (illus.
87). As Edwards, the most eloquent advocate of this approach, argues,
'We must see' photographs 'as part of ongoing social biographies of
images that remain entangled with dynamic sets of sensory and social
relations beyond and in excess of the image itself'.[7]

One recent lineage of anthropology – one that has acquired consider-
able momentum – links the US Melanesianist Roy Wagner with the
influential British Melanesianist Marilyn Strathern. Strathern has served
as Wagner's mortal representative on earth, elucidating and making
operational certain of Wagner's famously obtuse positions, including
his thinking about the nature of holography.

'Image' is a central concept in all Wagner's work, but one can imagine
him agreeing with Picasso, who – confronted with a photograph pulled
from a wallet with the claim that 'this is my wife' – famously retorted:
'she's a bit small and flat isn't she?'[8] Wagner's concept of image shares
with photography that opposition to language that has featured so

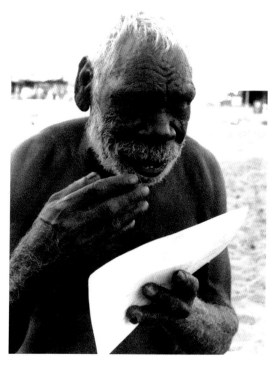

87 Roslyn Poignant, Frank Gurrmanamana,
the principal Anbarra owner of the Jambich
Rom ceremony, sings from the repetoire of
songs belonging to the ceremony, matching
the appropriate verse to each photograph
in the series taken 40 years earlier of the
ceremony by Axel Poignant. Maningrida,
Arnhem Land, Australia.

strongly in the account presented here. In *Asiwinarong*, his ethnography of the Usen Barok of New Ireland, he presents speech as a threat to the integrity of the image. 'Talk', the Barok say, 'is cheap': 'an image can and must be experienced, rather than merely described or summed up verbally'.[9] In a refusal of ekphrastic possibility, images share metaphor's 'peculiar intransigence' to exegesis recalling the literary critic I. A. Richards's observation that practical criticism was akin to 'slitting the throat of a nightingale to see what makes it sing', and the historian Carlo Ginzburg's memorable contrast of the 'divinatory' corporeal knowledge of the 'horse trader or card shark' with the 'schematic rigidity' of physiognomy treatises of the kind popularized by Johann Kaspar Lavater in the eighteenth century.[10]

The image, Wagner argues, 'must be experienced in order to be understood, and the experience of its effect is at once its meaning and power'.[11] Images elicit and contain meanings within their own complex space: 'An anthropologist who might set out to get the *real* gloss would be horribly frustrated, because the cultural convention exists at the level of the *image*, not at that of its verbalized gloss.'[12] Wagner tends to the mystical and his difficult concept of 'obviation' – explicitly linked to Zen philosophy – marks a cyclical process of unfolding and exhaustion that eventually returns to its point of origin.[13] This points to the space of the hologram as opposed to the flat space of the photograph. If the photograph's problem is that it *might* be thought capable of being translated by its caption (that is, its two-dimensional visual information might find a parallel in another informational register), the promise of the hologram as metaphor is that it contains within its own form all possible meanings. It is, to invoke the title of one of Wagner's especially inscrutable works, a 'symbol that stands for itself'.

The three-dimensional form of the holograph underlines the 'thinness' of the photograph. Capable of capturing *forms*, the anthropologist Kirsten Hastrup has argued, photography cannot 'of itself convey implicit meanings',[14] those contextual resonances that are a feature of the *thick*[15] description to which anthropology should aspire (illus. 88, 89). The photograph in Hastrup's account is a space of deficiency, of lack: it is 'reality imprisoned', a mere 'souvenir' of the real.[16]

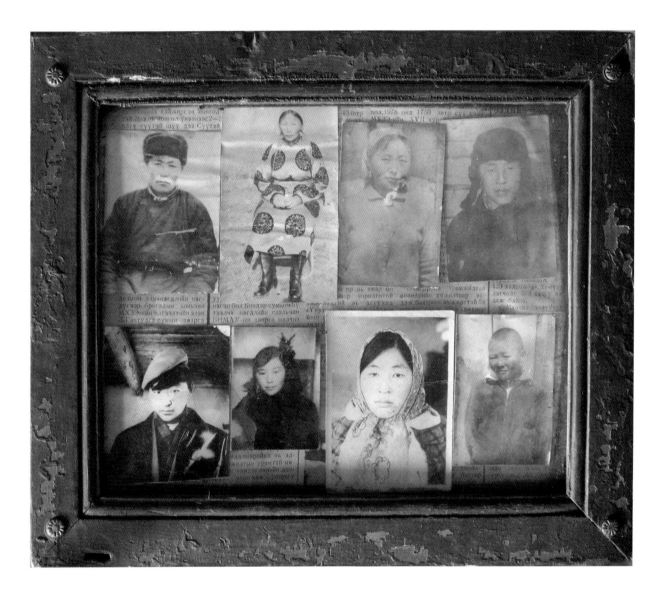

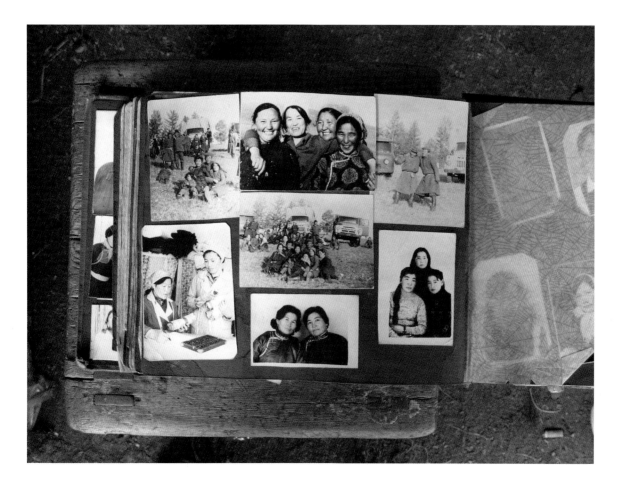

88–9 Rebecca Empson, photographic
montages, Ashinga District, Northeast
Mongolia, 2007. 'Relationality', which
emerged as a key theme in recent anthro-
pological thinking, conjures a 'depth' that
much photography seems incapable of
recording or grasping. By contrast these
frames contain assemblages, networks
of relationality.

By contrast, depth and relationality are crucial aspects of the holo-
graph's recursive murk. Photography's acuity – previously prized for its
legibility – is now seen by some to offer a false clarity, and to be heir to a
European legacy that constitutes the world as (flat) picture to be viewed as
object by human subjects. This Renaissance inheritance and the 'modern'
distinction between human and non-human are of course immensely
problematic for many anthropologists, not least those attempting to
understand Melanesian life-worlds. Strathern takes the holographic baton
from Wagner, and develops the concept of the *relation* as a way of bridg-
ing the contentious gap between observer and observed, that space of

'externality' across which conventional knowledge is generated. This is explicitly gestured to by Wagner in a later text in which he advances the utopian claim that 'an absolute or perfectly realized holography would abolish the distinction between representation and reality, between the subjective thinking or knowing of things and their objective being'.[17] The concept of relation, Strathern proposes, is '*holographic* in the sense of being an example of the field it occupies, every part containing information about the whole and information about the whole being enfolded into each part'.[18]

Ensconced in the murky complexity of the holograph,[19] we can perhaps glimpse a trajectory curving through time. At the beginning of this curve we can distantly see early anthropologists striving for a technical perfection in photographic practice that would supersede the deficiencies of speech. Further on, anthropologists seem themselves to have become cameras, being exposed to the reality that they sought to record. Alongside this, doubts about photography seem to grow: the stasis upon which acuity depended was itself increasingly seen as a betrayal of the anthropological study of a cultural praxis in motion. The fuzzygraph – disparaged in the nineteenth century as a failure – now seemed to offer the potential to capture that motion. But, imprisoned as it was within two dimensions, it was seen to lack the complexity and relationality of the worlds anthropologists studied.

This history in many ways marks a move *away* from photography – an increasing suspicion about its claims, a developing awareness of its limitations. But it is also a history ineluctably tied to the photograph as the crucial evidential paradigm of the world within which anthropology has emerged and metamorphosed. In the holograph, that complex and reticulated space of a relational modern world with which anthropology is now confronted, anthropology continues to define itself through – and against – the nature of photography.

References

Prologue: Images of a Counterscience

1 A slip accompanying the drawing, in the Photographic Collection of the Royal Anthropological Institute, is dated 24 October 1885.

2 See Christopher Pinney, 'Henta-koi', in The Raj: India and the British, 1600–1947, ed. C. A. Bayly (London, 1990), p. 284.

3 Michael Aird, Portraits of Our Elders (Brisbane, 1993), p. vii.

4 See Jane Lydon, Eye Contact: Photographing Indigenous Australians (Durham, NC, 2005).

5 Aird, Portraits, p. 60.

6 Eva Lips, Savage Symphony: A Personal Record of the Third Reich, trans. Caroline Newton (New York, 1938), p. 7.

7 Julius Lips, The Savage Hits Back (New Haven, CT, 1937), p. xxi.

8 Ibid., pp. 234–44.

9 Ibid., p. xxv.

10 Malinowski, 'Introduction', in Lips, Savage, p. viii.

11 See Karen Strassler, 'Material Witnesses: Photographs and the Making of Reformasi Memory', in Beginning to Remember: The Past in Indonesia's Present, ed. Mary Zurbuchen (Washington, DC, 2005), and her Refracted Visions: Popular Photography and National Modernity in Java (Durham, NC, 2010), pp. 207–49, for a model account of what an anthropologist can bring to the study of such movements.

12 Michel Foucault, Words and Things: An Archaeology of the Human Sciences (London, 1974), p. 379.

13 Ibid., p. 373.

14 One of Belting's central propositions is that 'Animation, as an activity, describes the use of images better than does perception': Hans Belting, 'Image, Medium, Body: A New Approach to Iconology', Critical Inquiry, XXXI/2 (Winter 2005), p. 307. See also Belting, Bild-Anthropologie: Entwürfe für eine Bildwissenschaft (Munich, 2001), English translation forthcoming from Princeton.

15 Walter Benjamin, 'Little History of Photography', in Walter Benjamin: Selected Writings, vol. 1, part 2, 1931–4, trans. Rodney Livingstone et al., ed. Michael W. Jennings et al. (Cambridge, MA, 1999), p. 514.

16 Ibid., p. 512.

17 The metaphor is Benjamin's in a letter to Adorno, 10 November 1930, in Theodor W. Adorno and Walter Benjamin, The Complete Correspondence, 1928–1940 (Cambridge, MA, 1999), p. 7.

18 Bejamin R. Smith and Richard Vokes, 'Introduction: Haunting Images', Visual Anthropology, XXI/4 (2008), p. 283.

19 Benjamin, 'Little History', p. 512, emphasis added; see also Michael Taussig, Mimesis and Alterity: A Particular History of the Senses (New York, 1993), for a parallel exposition.

20 'The propagandists, image-makers and ideologues of technological culture are its magicians . . . technology and magic, for us, are one and the same'. Alfred Gell, 'Technology and Magic', Anthropology Today, IV/2 (April 1988), p. 9.

21 Taussig, Mimesis and Alterity.

22 Benjamin, 'Little History', p. 512.

23 James G. Frazer, 'Preface' to Bronislaw Malinowski, Argonauts of the Western Pacific: An Account of Native Enterprise and Adventure in the Archipelagoes of Melanesian New Guinea [1922] (London, 1932), pp. vii–viii.

24 W. H. Flower, cited in H. H. Risley, The People of India (Calcutta, 1915), p. 6.

25 E. H. Man, 'A Brief Account of the Nicobar Islands', Journal of the Anthropological Institute, XV (1886), p. 440; cited by Alison Griffiths, 'Knowledge and Visuality in Turn of the Century Anthropology: The Early Ethnographic Cinema of Alfred Cort Haddon and Walter Baldwin Spencer', Visual Anthropology Review, XII/2 (Fall/Winter 1996–7), p. 21.

26 Benjamin, 'Little History', p. 510.

27 C. H. Read, Notes and Queries on Anthropology [1899], p. 87; cited by Roslyn Poignant, 'Surveying the Field of View: The Making of the RAI Photographic Collection', in Anthropology and Photography, 1860–1920, ed. Elizabeth Edwards (New Haven, CT, 1992), p. 62.

one: The Doubled History of Photography and Anthropology

1 G. Batchen, Burning with Desire: The Conception of Photography (Cambridge, MA, 1999).

2 George W. Stocking, Victorian Anthropology (New York, 1991), p. 324.

3 Amalie M. Kass, 'Thomas Hodgkin (1798–1866), Physician and Social Reformer', Oxford Dictionary of National Biography (Oxford, 2004).

4 Ronald Rainger, 'Philanthropy and Science in the 1830s: The British and Foreign Aborigines' Protection Society', Man, n.s. XV/4 (1980), p. 709.

5 Ibid., p. 712.

6 Jay Ruby, Picturing Culture: Explorations of Film and Anthropology (Chicago, IL, 2000), p. 48. Serres would also commission Thiesson to make more images for a proposed 'Musée Photographiques des Race Humaines'.

7 E.R.A. Serres, 'Présentation de cinq portraits représentant deux naturels de l'Amérique du Sud (Botocudes), et pris au daguerreotype par le procédé de M. Thiesson', Comptes rendus hebdomadaires des séances de l'Académie des sciences, 29 (2 September 1844), p. 490, and E.R.A. Serres, 'Observations sur l'application de la photographie à l'étude des races haumaines', Comptes rendus hebdomadaires des

séances de l'Académie des sciences, 21 (21 July 1845), pp. 242–6.

8 E.R.A. Serres. 'Photographie anthropologique', *La Lumière*, 33 (7 August 1852), p. 130.

9 Ernest Lacan, *Esquisses photographiques à propos de l'Exhibition Universelle et de la guerre de l'orient* (Paris, 1856), p. 38.

10 Barnard Davis was a member of the Anthropological Society, a polygenist and racialist society that competed with the Ethnological Society throughout much of the 1860s.

11 T. K. Penniman, *A Hundred Years of Anthropology*, 2nd edn (London, 1952), p. 66.

12 *A Manual of Ethnological Inquiry*; reprinted in *Journal of the Ethnological Society of London*, 3 (1854), pp. 194, 204 and 195. I am grateful to Arkadiusz Bentkowski for this reference.

13 George W. Stocking, 'What's in a Name? The Origins of the Royal Anthropological Institute, 1837–1871', *Man*, 6 (1971), pp. 369–90.

14 Rainger, 'Philanthropy', p. 711.

15 'On the Ethnology and Archaeology of India', *Journal of the Ethnological Society of London*, vol. II (1869), p. 89.

16 'Opening Address of the President', *Journal of the Ethnological Society of London*, vol. II (1869), p. 90.

17 Letterpress to Plate 21, 'The Korewahs', in J. Forbes Watson and John William Kaye, *The People of India: A Series of Photographic Illustrations with Descriptive Letterpress of the Races and Tribes of Hindustan*, vol. I of Hugh Rayner's transcription (Bath, 2007), p. 37.

18 A. Campbell, 'On The Lepchas', *Journal of the Ethnological Society of London*, vol. II (1869), p. 143.

19 In the 1899 edition of *Notes and Queries*, cited by Roslyn Poignant, 'Surveying the Field of View: The Making of the RAI Photographic Collection', in *Anthropology and Photography 1860–1920*, ed. Elizabeth Edwards (New Haven, CT, 1992), p. 62.

20 Andrew Lang, *The Making of Religion* [1898], p. 39; cited by A. C. Haddon, *History of Anthropology* (London, 1910), p. 128.

21 Lang, *Making of Religion*, p. 41; cited by Haddon, pp. 128–9. In the same decade Denzil Ibbetson, President of the Anthropological Society of Bombay, observed in a talk on *The Study of Anthropology in India*: 'No one who has not made the attempt can realise how difficult it is to secure a full and accurate statement on any given point by verbal enquiry from Orientals and still more, form semi-savages', *Journal of the Anthropological Society of Bombay* (1890), p. 121.

22 J. H. Lamprey, 'On a Method of Measuring the Human Form, for the Use of Students in Ethnology', *Journal of the Ethnological Society of London* (1869), pp. 84–5.

23 Martin Heidegger, 'Age of the World Picture', in *The Question Concerning Technology and Other Essays*, trans. William Lovitt (New York, 1977), p. 130.

24 See Saloni Mathur, *India By Design: Colonial History and Cultural Display* (Berkeley, CA, 2007), pp. 52–79, for background on the large number of Indians in London during this period and for a detailed narrative of one Ram Persad.

25 Elizabeth Edwards, 'Professor Huxley's "Well-considered Plan"', in *Raw Histories: Photographs, Anthropology and Museums* (Oxford, 2001), p. 135.

26 A. C. Haddon, *History of Anthropology* (London, 1910), p. 129.

27 Max Müller, cited in ibid., p. x.

28 E. B. Tylor, 'Dammann's Race-Photographs', *Nature* (6 January 1876), p. 184.

29 Poignant, 'Surveying the Field of View', p. 55.

30 Tylor, 'Dammann's Race-Photographs', p. 184.

31 Elizabeth Edwards, 'Some Problems of Photographic Archives: The Case of C. W. Dammann', *Journal of the Anthropological Society of Oxford*, XIII/3 (1982), pp. 257–61.

32 Tylor, 'Dammann's Race-Photographs', p. 184.

33 E. B. Tylor, 'Introduction', to Friedrich Ratzel, *The History of Mankind*, trans. from the second German edition by A. J. Butler (London, 1896), vol. I, p. v.

34 Ibid., vol. I, p. x.

35 Ibid.

36 E. B. Tylor, *Primitive Culture: Researches into the Development of Mythology, Philosophy, Religion, Language, Art and Custom*, 3rd edn (London, 1891), vol. I, p. 1.

37 Chris Holdsworth, 'Sir Edward Burnett Tylor', *Oxford Dictionary of National Biography* (online edition).

38 Tylor, *Primitive Culture*, vol. I, p. 112.

39 E. B. Tylor, 'The Religion of Savages', in *The Fortnightly Review* (1866), pp. 83–5; cited by George W. Stocking, 'Animism in Theory and Practice: E. B. Tylor's Unpublished "Notes on Spiritualism"', in his *Delimiting Anthropology: Occasional Essays and Reflections* (Madison, WI, 2001), p. 123.

40 Tylor, *Primitive Culture*, vol. I, p. 143.

41 Ibid., vol. I, pp. 155–6.

42 Ibid., vol. I, p. 429. See also Erhard Schüttpelz, 'Medientechniken der Trance: eine spiritistische Konstellation im Jahr 1872', in *Trancemedien und Neue Medien um 1900: ein anderer Blick auf die Moderne*, ed. Marcus Hahn and Erhard Schüttpelz (Bielefeld, 2009), pp. 275–310.

43 Stocking, 'Animism', p. 118.

44 Incidentally the father of Australian ethnographer A. W. Howitt (ibid, p. 121).

45 Ibid., p. 142.

46 Ibid, p. 140.

47 E. B. Tylor, *Delimiting Anthropology* (London, 1881), p. 343.

48 Ibid., p. vii.

49 Ibid., p. 167.

50 Edison's tinfoil sheet phonograph was patented in February 1878.

51 Tylor, *Delimiting Anthropology*, p. 181.

52 Cited by Stocking, 'Edward Burnett Taylor and the Mission of Primitive Man', in Tylor, *Delimiting Anthropology*, p. 105.

53 Roslyn Poignant, *Observers of Man: Photographs from the Royal*

Anthropological Institute (London, 1980), p. 14.

54 Rosamund Dalziell, 'The Curious Case of Sir Everard im Thurn and Sir Arthur Conan Doyle: Exploration and the Imperial Adventure Novel, *The Lost World*', *English Literature in Transition, 1880–1920*, XLV (2002), pp. 131–57.

55 E. F. im Thurn, 'Anthropological Uses of the Camera', *Journal of the Anthropological Institute*, 22 (1893), p. 186.

56 Ibid., p. 188.

57 Ibid., p. 187.

58 Poignant, *Observers of Man*, pp. 12–13; Elizabeth Edwards, 'Science Visualized: E. H. Man in the Andaman Islands', in *Anthropology and Photography*, p. 109.

59 Maurice Vidal Portman, *Report on the Administration of the Andaman and Nicobar Islands and the Penal Settlements of Port Blair and the Nicobars for 1892–93* (Calcutta, 1898), p. 129; cited by John Falconer, 'Ethnographical Photography in India, 1850–1900', *Photographic Collector*, V/1, (n.d.), pp. 16–46.

60 W. M. Flinders Petrie, 'Paper Squeezes', *Notes and Queries on Anthropology*, 4th edn (London, 1912), p. 274.

61 M. V. Portman, 'Photography for Anthropologists', *Journal of the Anthropological Institute*, 25 (1896), p. 75.

62 Ibid., p. 76.

63 Ibid., p. 77.

64 Ibid., p. 86.

65 Ibid., p. 81.

66 Ibid., p. 85.

67 Ibid., p. 86.

68 Ibid., p. 77.

69 Ibid., p. 85.

70 Ibid., p. 86.

71 Paula Richardson Fleming and Judith Luskey, *The North American Indians in Early Photographs* (Oxford, 1986), p. 143.

72 Ira Jacknis, 'George Hunt, Kwakiutl Photographer', in *Anthropology and Photography*, ed. Edwards, p. 143. Jacknis calculates that Hunt produced 90 photographs for Boas.

73 Thomas Ross Miller and Barbara Mathé, 'Drawing Shadows to Stone', in Laurel Kendall et al., *Drawing Shadows to Stone: The Photography of the Jesup North Pacific Expedition, 1897–1902* (New York, 1997), p. 22.

74 A. Hingston Quiggin, *Haddon the Headhunter: A Short Sketch of the Life of A. C. Haddon* (Cambridge, 1942), p. 82.

75 See Elizabeth Edwards, 'Performing Science: Still Photography and the Torres Strait Expedition', in *Cambridge and the Torres Strait: Centenary Essays on the 1898 Anthropological Expedition*, ed. Anita Herle and Sandra Rouse] (Cambridge, 1998), pp. 106–35.

76 Haddon, private journal, Haddon 1030, Cambridge Museum of Archaeology and Anthropology, 8 May 1898, pp. 63–4.

77 Haddon, private journal, Haddon 1030, Cambridge Museum of Archaeology and Anthropology, 23 July 1898, p. 190.

78 George W. Stocking, *After Tylor: British Social Anthropology, 1888–1951* (Madison, WI, 1995), p. 100.

79 On the cinematographic intersections of Haddon and Spencer, see Alison Griffiths, 'Knowledge and Visuality in Turn of the Century Anthropology: The Early Ethnographic Cinema of Alfred Cort Haddon and Walter Baldwin Spencer', *Visual Anthropology Review*, XII/2 (Fall/Winter 1996–7).

80 See D. J. Mulvaney, Geoffey Walker and Ron Vanderal, *The Aboriginal Photographs of Baldwin Spencer* (Melbourne, 1982), and Phillip Batty, Lindy Allen and John Morton, eds, *The Photographs of Baldwin Spencer* (Melbourne, 2007).

81 Stocking, *After Tylor*, p. 90.

82 Philip Jones, in *The Photographs of Baldwin Spencer*, ed. Batty et. al, p. 33.

83 Stocking, *After Tylor*, p. 96.

84 Michael W. Young, *Malinowski's Kiriwina: Fieldwork Photography, 1915–1918* (Chicago, IL, 1998), p. 4.

85 Ibid., pp. 3–4.

86 Bronislaw Malinowski, *A Diary in the Strict Sense of the Term* (London, 1967), p. 38; cited by Michael Taussig, *What Colour is the Sacred?* (Chicago, IL, 2009), p. 86.

87 Malinowski, *Diary*, pp. 12–13.

88 Cited by Young, *Malinowski's Kiriwina*, p. 7.

89 Ibid., p. 6.

90 Malinowski, *Diary*, p. 22,

91 Cited in Young, *Malinowski's Kiriwina*, p. 7.

92 Malinowski, *Diary*, p. 42. 'T.' appears to be Tośka, cf. p. 59.

93 Ibid., p. 64.

94 Stocking, *After Tylor*, pp. 271 and 270.

95 Bronislaw Malinwoski, *Coral Gardens and their Magic: A Study of the Methods of Tilling the Soil and of Agricultural Rites in the Trobriand Islands* (London, 1935), vol. I, p. ix.

96 Young, *Malinowski's Kiriwina*, p. 18.

97 Malinowski, *Coral Gardens*, vol. I, p. 461.

98 The recent work of Clément Chéroux on the photography of quasi-mesmeric 'vital fluids' suggests that the parallelism between the two unconsciouses was far closer than usually thought. He documents the work of individuals such as Hippolyte Baraduc, who worked closely with Charcot at La Salpêtrière (as had Freud). Louis Darget pursued a similar interest and explicitly invoked divination as a method of reading the resulting photographs: 'he deciphered his photographs in the way fortune-tellers interpret the shapes in tealeaves, troubled liquids of all kinds, animals entrails, molten lead, swirling smoke, and cloud formations'. Chéroux then suggests that Freudian psychoanalysis repositioned this self-same divinatory paradigm into an endogenous, rather than exogenous field: Chéroux, *The Perfect Medium: Photography and the Occult* (New Haven, CT, 2005), p. 121.

99 Walter Benjamin, 'Little History', in *Walter Benjamin: Selected*

Writings, vol. I, part 2: *1931–4*, trans. Rodney Livingstone et al., ed. Michael W. Jennings et al. (Cambridge, MA, 1999), p. 512.

100 Ibid., p. 512. See also Michael Taussig, *Mimesis and Alterity: A Particuclar History of the Senses* (New York, 1993) for a parallel exposition.

101 Young, *Malinowski's Kiriwina*, p. 11.

102 See the recent work of Jeremy Millar, which imagines what Witkiewicz might have produced had he visited the Trobriands.

103 Young, *Malinowski's Kiriwina*, p. 14.

104 Taussig, *What Color?*, pp. 81 and 82.

105 Ibid., pp. 120–21.

106 A variant, more symmetrical version is known as *Kiki with African Mask*.

107 Young, *Malinowski's Kiriwina*, p. 263.

108 Jane Livingston, 'Man Ray and Surrealist Photography', in Rosalind Krauss and Jane Livingston, *L'Amour Fou: Photography and Surrealism* (London, 1986), p. 135.

109 Luc de Heusch, 'The Cinema and Social Science: A Survey of Ethnographic and Sociological Films' [1962], *Visual Anthropology*, I/2 (1987), p. 107.

110 David Tomas, 'The Ritual of Photography', *Semiotica*, XL/1–2 (1982), pp. 1–25; and David Tomas, 'Toward an Anthropology of Sight: Ritual Performance and the Photographic Process', *Semiotica*, LXVIII/3–4 (1988), pp. 245–70.

111 Edwin Ardener, '"Remote Areas": Some Theoretical Considerations', in *Anthropology at Home*, ed. A. Jackson (London, 1987), pp. 38–54.

112 Cited by George W. Stocking, *The Ethnographer's Magic and Other Essays in the History of Anthropology* (Madison, WI, 1992), p. 30.

113 See Anna Grimshaw, *The Ethnographer's Eye: Ways of Seeing in Modern Anthropology* (Cambridge, 2001), pp. 53–4.

114 Christopher Pinney, 'The Parallel Histories of Anthropology and Photography', in *Anthropology and Photography*, ed. Edwards, p. 81.

two: The Trouble with Photography

1 Roland Barthes, *Camera Lucida: Reflections on Photography*, trans. Richard Howard (New York, 1981), p. 12.

2 Walter Benjamin, *One Way Street* (London, 1979), p. 90; cited by Rachel Moore, *Savage Theory: Cinema as Modern Magic* (Durham, NC, 2000), p. 137.

3 Moore, *Savage Theory*, p. 137.

4 Felix Nadar, trans. Thomas Repensek, 'My Life as a Photographer', *October*, 5 (Summer 1978), p. 8.

5 Ibid., p. 9.

6 James G. Frazer, *The Golden Bough: A Study in Magic and Religion*, 3rd edn, Part 1: *The Magic Art and The Evolution of Kings*, (London, 1911), vol. I p. 174.

7 E. B. Tylor, *Primitive Culture: Researches into the Development of Mythology, Philosophy, Religion, Language, Art and Custom*, 3rd edn (London, 1891), vol. I, p. 112.

8 Frazer, *The Magic Art*, p. 215.

9 Bruno Latour, *We Have Never Been Modern*, trans. Catherine Porter (London, 1993), p. 114.

10 Ludwig Wittgenstein, *Remarks on Frazer's Golden Bough*, p. 131, cited by Thomas de Zengotita, 'On Wittgenstein's *Remarks on Frazer's Golden Bough*', *Cultural Anthropology*, IV/4 (November 1989), p. 390.

11 Cited by Stefan Andriopoulous, 'The Terror of Reproduction: Early Cinema's Ghostly Doubles and The Right to One's Own Image', *New German Critique*, XXXIII/99 (Fall 2006), p. 157.

12 Frazer, *The Magic Art*, p. 52.

13 Ibid., p. 55.

14 Ibid., p. 68.

15 Ibid., p. 175.

16 Ibid., pp. 205–6.

17 Charles S. Peirce, 'Logic as Semiotic: The Theory of Signs', in *Philosophical Writings of Peirce*, ed. Justus Buchler (New York, 1955), p. 98.

18 Ibid., p. 106. See also James Elkins, 'What Do We Want Photography to Be? A Response to Michael Fried', *Critical Inquiry*, XXXI/4 (Summer 2005), pp. 938–56, for an argument against this somewhat reductive version of Peirce's vastly more nuanced categories.

19 Joel Snyder has recently vociferously, but mistakenly, argued the opposite of this. Indexicality is not dependent on recognition. Joel Snyder in *Photography Theory*, ed. James Elkins (London, 2007), p. 131.

20 Susan Sontag, *On Photography* (Harmondsworth, 1979), p. 154.

21 Rosalind Krauss and Jane Livingston, *L'Amour Fou: Photography and Surrealism* (London, 1986), p. 3.

22 See Michael Taussig, *Mimesis and Alterity: A Particular History of the Senses* (New York, 1993), p. 58.

23 Cited by de Zengotita, 'On Wittgenstein's *Remarks*', p. 390, italics my emphasis.

24 Taussig, *Mimesis and Alterity*, p. 200.

25 Tom Gunning, 'An Aesthetic of Astonishment: Early Film and the (In)credulous Spectator', *Art and Text*, 34 (Spring 1989), p. 31; cited in Moore, *Savage Theory*, p. 3. See also Simon During, *Modern Enchantments: The Cultural Power of Secular Magic* (Cambridge, MA, 2002).

26 Timothy Burke, '"Our Mosquitoes Are Not So Big": Images and Modernity in Zimbabwe', in *Images and Empires: Visuality in Colonial and Postcolonial Africa*, ed. Paul S. Landau and Deborah D. Kaspin (Berkeley, CA, 2002), pp. 42–3.

27 Frank Burnett, *Through Polynesia and Papua: Wanderings with a Camera in the Southern Seas* (London, 1911), pp. 188–9.

28 James Ricalton, *India through the Stereoscope: A Journey through Hindustan* (New York, n.d.), p. 45.

29 Edmund Burke, *A Philosophical Enquiry into the Origin of our Ideas of the Sublime and the Beautiful* [1757], ed. James T. Boulton (Notre Dame, IN, 1968), p. 80.

30 Ibid., p. 82.

31 Patricia Spyer, 'The Cassowary Will (Not) Be Photorgaphed: The "Primitive", the "Japanese" and the Elusive "Sacred" (Aru, South Moluccas)', in *Religion and Media*, ed. Hent de Vries and Samuel Weber (Stanford, CA, 2001), p. 306. See also Marina Warner, *Phantasmagoria: Spirit Visions. Metaphors and Media* (London, 2006), pp. 189ff.

32 Rodney Needham, 'Little Black Boxes', *Times Literary Supplement* (28 May 1976).

33 Rodney Needham, personal communication, 21 January 2005.

34 The 6th edition of *Notes and Queries* recorded that 'manipulations under the dark cloth may suggest black magic, with disastrous results, and if, as will certainly happen, onlookers wish to look in the focusing screen, they will probably be frightened by seeing people and objects upside down' (London, 1951), p. 354.

35 Spyer, 'Cassowary', p. 305.

36 Cited in ibid., p. 306.

37 Thomas Whiffen, *The North-West Amazons: Notes of Some Months Spent among Cannibal Tribes* (London, 1915), pp. 232–3.

38 Paul Landau, 'Christ in the Kalahari Desert', *Representations*, 45 (Winter 1994), p. 31.

39 Ibid., p. 34.

40 Cited by Andriopoulos, 'Terror', pp. 157–8.

41 James George Frazer, *The Golden Bough: A Study in Magic and Religion*, abridged edn (London, 1941), pp. 193–4.

42 Lucien Lévy-Bruhl, *The 'Soul' of the Primitive*, trans. Lilian A. Clare (London, 1965).

43 Ibid., p. 152.

44 Andriopoulos, 'Terror', p. 154.

45 Ibid., p. 154.

46 Ibid., p. 160.

47 Ibid., pp. 157 and 159.

48 Ibid., pp. 164 and 165.

49 Latour, *We Have Never Been Modern*.

50 Andrew Lang, *The Making of Religion* [1898], p. 39; cited by A. C. Haddon, *History of Anthropology* (London, 1910), p. 128.

51 Bronislaw Malinowski, *Coral Gardens and their Magic: A Study of the Methods of Tilling the Soil and of Agricultural Rites in the Trobriand Islands*, vol. I (London, 1935), pp. 376–7.

52 That is, the 'reality' in front of the camera.

53 Rudolf Wittkower, *Allegory and the Migration of Symbols* (London, 1987).

54 Bernadette Bucher, *Icon and Conquest* (Chicago, IL, 1981), p. 35.

55 Roland Barthes, *La Chambre claire: Note sur la photographie* (Paris, 1980), p. 15; translated as *Camera Lucida*, p. 4.

56 See William Arens, *The Man-eating Myth: Anthropology and Anthropophagy* (New York, 1980), for the debatable case against the existence of cannibalism.

57 Curtis M. Hinsley and Bill Holm, 'A Cannibal in the Museum: The Early Career of Franz Boas in America', *American Anthropologist*, LXXVIII/2 (June 1976), p. 306. This article also reproduces all the recently rediscovered photographs.

58 Nancy J. Parezo and Don D. Fowler, *Anthropology Goes to the Fair: The 1904 Louisiana Purchase Exposition* (Lincoln, NE, 2007).

59 Ibid., p. 335.

60 Cited in ibid., p. 338.

61 A. C. Haddon, 'The Saving of Vanishing Knowledge', *Nature*, 55 (1897), pp. 305–6; cited by Elizabeth Edwards, 'Performing Science: Still Photography and the Torres Strait Expedition', in *Cambridge and the Torres Strait: Centenary Essays on the 1898 Anthropological Expedition*, ed. Anita Herle and Sandra Rouse (Cambridge, 1998), p. 109.

62 Ibid., p. 113.

63 *Reports*, vol. V, cited in ibid., p. 116, n. 40.

64 Reproduced in ibid., p. 114.

65 Ibid., p. 116.

66 Barthes, *Camera Lucida*, pp. 95–6.

67 John S. Billings, 'On a New Craniophore for Use in Taking Composite Photographs of Skulls', *Journal of the Anthropological Institute*, XVI (1887), pp. 97–8.

68 Francis Galton, 'Composite Portraits, Made by Combining those of Many Different Persons into a Single Resultant Figure', *Journal of the Anthropological Institute*, VIII (1879), p. 134.

69 Ibid., p. 140.

70 Ibid., pp. 140–41, emphasis added.

71 Ibid., caption at p. 136, emphasis added.

72 Christopher Pinney, 'Introduction: How the Other Half . . . ' in *Photography's Other Histories*, ed. Christopher Pinney and Nicolas Peterson (Durham, NC, 2003), p. 7.

73 Barthes, *Camera Lucida*, p. 89

74 Water Benjamin, 'A Little History of Photography', in *Walter Benjamin: Selected Writing*s, *vol. 1, part 2, 1931–4*, trans. Rodney Livingstone et al., ed. Michael W. Jennings et al. (Cambridge, MA, 1999), p. 510.

75 Claude Lévi-Strauss, *Tristes Tropiques*, trans. John and Doreen Weightman (Harmondsworth, 1984), p. 45.

76 Vine Deloria, 'Introduction', to Christopher M. Lyman, *The Vanishing Indian and Other Illusions: Photographs of Indians by Edward S. Curtis* (Washington, DC, 1982), p. 11.

77 See Robin Boast, Sudeshna Guha and Anita Herle, *Collected Sights: Photographic Collections of the Museum of Archaeology and Anthropology, 1860s–1930s* (Cambridge, 2001), p. 6. The extracted figure appears as part of Plate xiii in Thomas Whiffen, *North-West Amazons* (London, 1915).

78 David King, *The Commissar Vanishes: The Falsification of Photographs and Art in Stalin's Russia* (New York, 1997).

79 Charles Gabriel Seligman and Benda Z. Seligman, *The Veddas* (Cambridge, 1911), p. vii.

80 Clifford Geertz, *Works and Lives: The Anthropologist as Author* (Stanford, CA, 1989), pp. 69–70.

81 Ibid., p. 65.

82 Evans-Pritchard, *Nuer Religion*; p. 231; cited in ibid., p. 65.

83 On Evans-Pritchard's Nuer photography, see Christopher Morton, 'Fieldwork and Participant-Photographer: E. E. Evans-Pritchard and the Nuer Rite of *gorot*', *Visual Anthropology*, 22 (2009), pp. 252–74.

84 As in 'The concept of witchcraft nevertheless provides them with a natural philosophy'. E. E. Evans-Pritchard, *Witchcraft, Oracles and Magic Among the Azande* (Oxford, 1937), p. 63.

85 Ibid., p. 79.

86 Cited by Alistair Hannay in Introduction to Søren Kierkegaard, *Either/Or: A Fragment of Life* (Harmondsworth, 1992), p. 2.

87 Evans-Pritchard, *Witchcraft*, p. 63; italics my emphasis.

88 Ibid., p. 153.

89 Ibid., pp. 189–90.

90 Ibid., p. 158.

91 Bronislaw Malinowski, *Argonauts of the Western Pacific: An Account of Native Enterprise and Adventure in the Archipelagoes of Melanesian New Guinea* [1922] (London, 1932), p. xv.

92 Lévi-Strauss, *Tristes Tropiques*, p. 16.

93 Ibid., p. 17.

94 Ibid., p. 43.

95 Ibid., p. 44. See also Jay Prosser, *Light in a Dark Room: Photography and Loss* (Minneapolis, MN, 2005), for an illuminating parallel reading.

96 See Jacques Derrida, *Of Grammatology*, trans. Gayatri Chakravorty Spivak (Baltimore, MD, 1976), pp. 118–40, for a brilliant account of Lévi-Strauss's 'phonocentrism'.

97 Lévi-Strauss, *Tristes Tropiques*, p. 388.

98 Ibid., p. 389.

99 Ibid., p. 290

100 Claude Lévi-Strauss, *Saudades do Brazil: A Photographic Memoir* [1994] (Seattle, WA, 1995), p. 22.

101 Ibid., p. 9

102 'To A Young Painter', in *The View From Afar*, trans. Joachim Neugroschel and Phoebe Hoss (London, 1987), p. 249.

103 *Anita Albus: Aquarelle 1970 bis 1980. Katalog zur Austellung in der Stuck-Villa München* (Frankfurt, 1980), pp. 6–28.

104 Gregory Bateson, 'Experiments in Thinking about Observed Ethnological Material', in his *Steps Towards an Ecology of the Mind* (London, 1973), p. 55.

105 E. R. Leach, *Rethinking Anthropology* (London, 1961), p. 4.

three: **The Problem with Anthropology**

1 Anthony Forge, 'Learning to See in New Guinea', in *Socialization: The View from Social Anthropology*, ed. Phillip Mayer (London, 1970), p. 287.

2 Cited in Marshall H. Segall, Donald T. Campbell and Melville J. Herskovits, *The Influence of Culture on Visual Perception* (Indianapolis, IN, 1966), p. 32, italics my emphasis.

3 James Clifford, 'Introduction: Partial Truths', in *Writing Culture: The Poetics and Politics of Ethnography*, ed. James Clifford and George E. Marcus (Berkeley, CA, 1986), p. 2.

4 Martin Jay, *Downcast Eyes* (Berkeley, CA, 1994). Surprisingly, Jay has nothing to say about Lévi-Strauss in his magisterial survey.

5 Anne Salmond, 'Theoretical Landscapes: On Cross-Cultural Conceptions of Knowledge', in *Semantic Anthropology*, ed. David Parkin (London, 1982).

6 Johannes Fabian, *Time and the Other: How Anthropology Makes its Object* (New York, 1983). Much of Fabian's material on the visual and spatial dimensions of the humanities is derived as he acknowledges from Justin Stagl's work on the history of travel manuals. See Justin Stagl, *A History of Curiosity: The Theory of Travel, 1550–1800* (London, 1995).

7 Clifford, 'Introduction', p. 12.

8 Ibid., p. 10.

9 James Clifford, 'On Ethnographic Authority', in his *The Predicament of Culture: Twentieth-Century Ethnography, Literature and Art* (Cambridge, MA, 1988), p. 22.

10 Paul Rabinow, *Observations on Fieldwork in Morocco* (Berkeley, CA, 1977), p. 79.

11 Hyman's work appears as a photographic essay in Clifford Geertz, Hildred Geertz and Lawrence Rosen, *Meaning and Order in Moroccan Society: Three Essays in Cultural Analysis* (Cambridge, 1979). The quote is from an anonymous and un-paginated text, prefacing Hyman's photo essay. See also, Hyman, P., 'A (Fashion) Photographer's Reflections on Fieldwork', *Journal of North African Studies*, XIV/3–4 (September/December 2009), pp. 431–3; Rabinow, P., 'Chicken or Glass: In the Vicinity of Clifford Geertz and Paul Hyman', *Journal of North African Studies*, XIV/3–4 (September/December 2009), pp. 467–77; Slyomovics, S., 'Perceptions, not Illustrations, of Sefrou, Morocco: Paul Hyman's Images and the Work of Ethnographic Photography', *Journal of North African Studies*, XIV/3–4 (September/December 2009), pp. 445–65.

12 *Notes and Queries*, 6th edn (London, 1951), p. 358.

13 Gregory Bateson and Margaret Mead, *Balinese Character: A Photographic Analysis* (New York, 1942), pp. 49–50.

14 James Agee and Walker Evans, *Let Us Now Praise Famous Men* (New York, 1941), p. 7.

15 Steven Feld, *Sound and Sentiment: Birds, Weeping, Poetics and Song in Kaluli Expression* [1982], 2nd edn (Philadelphia, PA, 1990), p. 234.

16 Ibid., p. 236.

17 Faye Ginsburg, 'Culture/Media: A (Mild) Polemic', *Anthropology Today*, X/2 (April 1994), p. 5. See also the debate initiated by James F. Weiner, 'Televisualist Anthropology', *Current Anthropology*, XXXVII/2 (April 1997), pp. 197–235.

18 Gregory Bateson, 'Cultural and Thematic Analysis of Fictional Films', *Transactions of the New York Academy of Sciences* (1943), pp. 72–8.

19 Gregory Bateson, 'An Analysis of the Nazi Film "Hitlerjunge Quex"', *Studies in Visual Communication*, VI/3 (Fall 1980), p. 21.

20 Sol Worth, 'Margaret Mead and the Shift from "Visual Anthropology" to the "Anthropology of Visual Communication"', *Studies in Visual Communication*, VI/1 (Spring 1980), p. 20.

21 Sol Worth and John Adair, *Through Navajo Eyes* (Bloomington, IN, 1975).

22 See Christopher Wright, 'Supple Bodies: The Papua New Guinea Photographs of Captain Francis R. Barton, 1899-1907', in *Photography's Other Histories*, ed. Christopher Pinney and Nicolas Peterson (Durham, NC, 2003).

23 Elizabeth Edwards and Lynne Williamson, *World on a Glass Plate: Early Anthropological Photographs from the Pitt Rivers Museum, Oxford* (Oxford, 1981), p. 11.

24 Stephen F. Sprague, 'Yoruba Photography: How the Yoruba See Themselves', *African Arts*, XII/1 (November 1978), p. 56.

25 Westman, *The African Today and Tomorrow* [1939], p. 102, cited in ibid., p. 52.

26 Sprague, 'Yoruba Photography', p. 59.

27 Ibid., p. 57.

28 Ibid., pp. 56–7.

29 See Weiner, 'Televisualist Anthropology', and Christopher Pinney, *The Coming of Photography in India* (London, 2008).

30 Bateson, 'An Analysis', p. 53.

31 Ginsburg, 'Culture/Media', p. 9.

32 Other valuable studies of West African vernacular photography include Hudita Nura Mustafa, 'Portraits of Modernity: Fashioning Selves in Dakarois Popular Photography', in *Images and Empires: Visuality in Colonial and Postcolonial Africa*, ed. Paul S. Landau and Deborah D. Kaspin (Berkeley, CA, 2002), pp. 172–92; the essays in Heike Behrend and J.-F. Werner, eds, 'Photographies and Modernities in Africa', *Visual Anthropology*, 14 (2001); Liam Buckley, 'Self and Accessory in Gambian Studio Photography', *Visual Anthropology Review*, XVI/2 (2001); Tobias Wendl and Heike Behrend, eds, *Snap Me One! Studiofotografen in Africka* (Munich, 1998); C. Angelo Micheli, 'Doubles and Twins: A New Approach to Contemporary Studio Photography', *African Arts* (Spring 2008), pp. 66–85; pp. 71–91 and 'Studio Photography and the Aesthetics of Citizenship in The Gambia', in *Sensible Objects: Colonialism, Museums and Material Culture*, ed. Elizabeth Edwards, Chris Gosden and Ruth B. Phillips (New York, 2006), pp. 61–85.

33 Tobias Wendl, 'Ghana: Portraits and Scenery', *Revue Noire Collection of African and Indian Ocean Photography* (Paris, 1998), p. 150.

34 Ibid., p. 154.

35 Ibid.

36 On Indian photography, see also David MacDougall, 'Photo Hierarchicus: Signs and Mirrors in Indian Photography', *Visual Anthropology*, V/2 (1992), pp. 102–29, and the superb film by Nishta Jain, *City of Photos* (2005).

37 Cited in Christopher Pinney, *Camera Indica: The Social Life of Indian Photographs* (London, 1997), p. 180.

38 W. Norman Brown, *Man in the Universe: Some Continuities in Indian Thought* (Berkeley, CA, 1970), p. 42.

39 Karen Strassler, *Refracted Visions: Popular Photography and National Modernity in Java* (Durham, NC, 2010), p. 88.

40 Ibid., p. 98.

41 See Elizabeth Edwards, ed., *Anthropology and Photography, 1860–1920* (New Haven, CT, 1992), and Elizabeth Edwards, *Raw Histories: Photographs, Anthropology and Museums* (Oxford, 2001).

42 Cited by Nicolas Peterson, 'The Changing Photographic Contract', in *Photography's Other Histories*, ed. Pinney and Peterson, p. 123. See also the important work by Ariella Azoulay, *The Civil Contract of Photography* (Boston, MA, 2008).

43 C. Williamson, 'Leah King-Smith, *Patterns of Connection*', in *Colonial Post Colonial* (Heide, 1992).

44 Heidegger, 'The Age of the World Picture', in *The Question Concerning Technology and Other Essays*, trans. William Lovitt (New York, 1977).

45 Michel Foucault, *The Birth of the Clinic: An Archaeology of Medical Perception*, (London, 1976), p. 166.

46 Michael Godby, 'The Drama of Colour: Zwekluthu Mthethwa's Portrait Photography', *NKA: Journal of Contemporary Art*, 10 (Summer 1999), pp. 46–9.

47 Hulleah J. Tsinhnahjinnie, 'When Is a Photograph Worth a Thousand Words?', in *Photography's Other Histories*, ed. Pinney and Peterson, pp. 45–6.

48 Ian McLean and Gordon Bennett, *The Art of Gordon Bennett* (Roseville East, NSW, 1996).

49 Gordon Bennett, 'Australian Icons: Notes on Perception', in *Double Vision*, ed. Nicholas Thomas and Diane Losche (Cambridge, 1999), p. 255.

50 Pushpamala N. and Clare Arni, *Native Women of South India: Manners and Customs* (Bangalore, 2004), p. 34.

51 Roland Barthes, *Camera Lucida: Reflections of Photography*, trans. Richard Howard (New York, 1981), p. 4.

52 Wendl, 'Ghana', pp. 150–51.

53 Allen F. Roberts and Mary Nooter Roberts, 'Mystical Reproductions: Photography and the Authentic Simulacrum', in *A Saint in the City: Sufi Arts of Urban Senegal* (Los Angeles, CA, 2003), p. 43.

54 Roberts and Roberts, *Saint in the City*, p. 52.

55 Anne Marie Schimmel [1975] *Mystical Dimensions of Islam* (Chapel

Hill, NC, 1975), p. 413, cited by Roberts and Roberts, *Saint in the City*, p. 56.

Roberts and Roberts, *Saint in the City*, p. 59. See also Richard Chalfen, '*Shinrei Shashin*: Ghosts in Japanese Snapshots', *Photography and Culture*, 1/1 (July 2008), pp. 59–60, for a discussion of missing limbs (marking the presence of deceased spouses) in contemporary Japanese ghost photography.

Strassler, *Refracted Visions*, p. 254.

Christopher Wright, '"A Devil's Engine": Photography and Spirits in the Western Solomon Islands', *Visual Anthropology*, XXI/4 (2008), p. 368.

Ibid., p. 370.

See F. E. Williams, '*The Vailala Madness' and Other Essays*, ed. Erik Schwimmer (St Lucia, Queensland, 1976), and 'The Vailala Madness in Retrospect', in *Essays Presented to C. G. Seligman*, ed. E. E. Evans-Pritchard et al. (London, 1934), pp. 369–79.

Williams, 'Retrospect', p. 373.

'There was much talk at first of an aeroplane which was dropping messages from the sky' (Williams, 'Vailala Madness', p. 352).

Williams, 'Retrospect', p. 377. He also reports a trader's view that the flagpoles were 'wirelesses intended for sending messages to the steamer'. Williams, 'Vailala Madness', p. 349.

F. E. Williams, 'Retrospect', p. 377: Hurley was flying en-route Delta Division for photographic work which would later be published in Frank Hurley, *Pearls and Savages: Adventures in the Air, on Land and on Sea in New Guinea* (New York, 1924).

Cited in Michael W. Young and Julia Clark, *An Anthropologist in Papua: The Photography of F. E. Williams, 1922–39* (Honolulu, HI, 2002), p. 16.

Cited by Christopher Wright, 'Material and Memory: Photography in the Western Solomon Islands', *Journal of Material Culture*, IX/1, p. 75.

Ibid., p. 75.

Epilogue: The Holograph

Deborah Gewertz and Frederick Errington, *Twisted Histories, Altered Contexts: Representing the Chambri in a World System* (Cambridge, 1991), caption to pl. 25, p. 153.

Steven Feld, *Sound and Sentiment: Birds, Weeping, Poetics and Song in Kaluli Expression* [1982], 2nd edn (Philadelphia, PA, 1990) p. 239.

Christopher Pinney, *Camera Indica: The Social Life of Indian Photographs* (London, 1997).

Michael Foucault, *Le Mots et les choses* (Paris, 1966), translated as *The Order of Things: An Archaeology of the Human Sciences* (London, 1970).

David Carroll, *Paraesthetics: Foucault, Lyotard, Derrida* (London, 1987), p. 55.

Kirsten Hastrup, 'Anthropological Visions: Some Notes on Visual and Textual Authority', in *Film as Ethnography*, ed. Peter Ian Crawford and David Turton (Manchester, 1992), p. 10.

Elizabeth Edwards, 'Photographs and the Sound of History', *Visual Anthropology Review*, XXI/1–2 (Spring/Fall 2005), p. 42. See also remarkable documents of photographic repatriation such as *John Layard long Malakula, 1914–1915* by Haidy Geismar, Anita Herle and Numa Fred Longga (Cambridge, n.d.), a Bislama publication printed for a Vanuatu audnience.

I first heard this perennially illuminating anecdote from Mark Hobart, to whom thanks.

Roy Wagner, *Asiwinarong: Ethos, Image and Social Power among the Usen Barok of New Ireland* (Princeton, NJ, 1986), p. xiv.

Carlo Ginzburg, 'Clues: Roots of an Evidential Paradigm', in his *Clues, Myths and the Historical Method*, trans. John and Anne Tedeschi (Baltimore, MD, 1989), p. 115.

Wagner, *Asiwinarong*, p. 216.

Ibid., p. xv.

Roy Wagner, *Symbols That Stand for Themselves* (Chicago, IL, 1986), p. xi.

Hastrup, 'Anthropological Visions', p. 10.

Hastrup here draws on a famous distinction made by Clifford Geertz, in 'Thick Description: Toward an Interpretive Theory of Culture', in his *The Interpretation of Culture* (New York, 1973).

Here Hastrup draws upon Sontag's puzzlingly influential work: Susan Sontag, *On Photography* (Harmondsworth, 1979).

Roy Wagner, *An Anthropology of the Subject: Holographic Worldview in New Guinea and its Meaning and Significance for the World of Anthropology* (Berkeley, CA, 2001), p. 19.

Marilyn Strathern, *The Relation: Issues in Complexity and Scale* (Cambridge, 1995), pp. 17–18.

As Jonathan Benthall perceptively noted, 'there is the same loss of sharp contrast and definition that we find in holograms as opposed to good photographs – but many find the gain worth the loss'. Jonathan Benthall, 'The Raw, the Cooked and the Marilynated', *Anthropology Today*, X/6 (December 1994), p. 15.

Select Bibliography

Adorno, Theodor W., and Walter Benjamin, *The Complete Correspondence 1928–1940* (Cambridge, MA, 1999)

Agee, James, and Walker Evans, *Let Us Now Praise Famous Men* (New York, 1941)

Aird, Michael, *Portraits of Our Elders* (Brisbane, 1993)

Andriopoulous, Stefan, 'The Terror of Reproduction: Early Cinema's Ghostly Doubles and the Right to One's Own Image', *New German Critique*, XCIX/33 (Fall 2006), pp. 151–70.

Anonymous, 'A Manual of Ethnological Inquiry'; reprinted in *Journal of the Ethnological Society of London*, III (1854), pp. 193–208

Ardener, Edwin, '"Remote Areas": Some Theoretical Considerations', in *Anthropology at Home*, ed. A. Jackson (London, 1987)

Azoulay, Ariella, *The Civil Contract of Photography* (Boston, MA, 2008)

Banta, Melissa, and Curtis M. Hinsley, *From Site to Sight: Anthropology, Photography and the Power of Imagery* (Cambridge, MA, 1986)

Barthes, Roland, *Camera Lucida: Reflections on Photography*, trans. Richard Howard (New York, 1981)

Batchen, G., *Burning with Desire: The Conception of Photography* (Cambridge, MA, 1999)

Bateson, Gregory, and Margaret Mead, *Balinese Character: A Photographic Analysis* (New York, 1942)

—, 'Cultural and Thematic Analysis of Fictional Films', *Transactions of the New York Academy of Sciences* (1943), pp. 72–8

—, 'Experiments in Thinking about Observed Ethnological Material', in his *Steps Towards an Ecology of the Mind* (London, 1973)

—, 'An Analysis of the Nazi Film "Hitlerjunge Quex"', *Studies in Visual Communication*, VI/3 (Fall 1980), pp. 20–55

Batty, Philip, Lindy Allen and John Morton, eds, *The Photographs of Baldwin Spencer* (Melbourne, 2007)

Behrend, Heike, and J.-F. Werner, eds, 'Photographies and Modernities in Africa', *Visual Anthropology*, 14 (2001)

Belting, Hans, *Bild-Anthropologie: Entwürfe für eine Bildwissenschaft* (Munich, 2001)

—, 'Image, Medium, Body: A New Approach to Iconology', *Critical Inquiry*, XXXI/2 (Winter 2005), pp. 302–19

Benjamin, Walter, 'Little History of Photography', in *Walter Benjamin: Selected Writings, vol. I, part 2, 1931–4*, trans. Rodney Livingstone et al., ed. Michael W. Jennings et al. (Cambridge, MA, 1999)

Bennett, Gordon, 'Australian Icons: Notes on Perception', in *Double Vision*, ed. Nicholas Thomas and Diane Losche (Cambridge, 1999)

Benthall, Jonathan, 'The Raw, the Cooked and the Marilynated', *Anthropology Today*, X/6 (December 1994), pp. 15–16

Billings, John S., 'On a New Craniophore for Use in Taking Composite Photographs of Skulls', *Journal of the Anthropological Institute*, XVI (1887), pp. 97–8

Boast, Robin, Sudeshna Guha and Anita Herle, *Collected Sights: Photographic Collections of the Museum of Archaeology and Anthropology, 1860s–1930s* (Cambridge, 2001)

Bourdieu, Pierre, 'La Définition sociale de la photographie', in Bourdieu et al., *Un Art Moyen: Essai sur les usages sociaux de la photographie* (Paris, 1965)

Bucher, Bernadette, *Icon and Conquest* (Chicago, IL, 1981)

Buckley, Liam 'Self and Accessory in Gambian Studio Photography', *Visual Anthropology Review*, XVI/2 (2001), pp. 71–91

—, 'Studio Photography and the Aesthetics of Citizenship in The Gambia' in *Sensible Objects: Colonialism, Museums and Material Culture*, ed. Elizabeth Edwards, Chris Gosden and Ruth B. Phillips (New York, 2006), pp. 61–85

Burke, Timothy, '"Our Mosquitoes Are Not So Big": Images and Modernity in Zimbabwe', in *Images and Empires: Visuality in Colonial and Postcolonial Africa*, ed. Paul S. Landau and Deborah D. Kaspin (Berkeley, CA, 2002)

Burnett, Frank, *Through Polynesia and Papua: Wanderings with a Camera in the Southern Seas* (London, 1911)

Carroll, David, *Paraesthetics: Foucault, Lyotard, Derrida* (London, 1987)

Chalfen, Richard, '*Shinrei Shashin*: Ghosts in Japanese Snapshots', *Photography and Culture*, I/1 (July 2008), pp. 59–60

Chéroux, Clément, *The Perfect Medium: Photography and the Occult* (New Haven, CT, 2005)

Clifford, James, and George E. Marcus, eds, *Writing Culture: The Poetics and Politics of Ethnography* (Berkeley, CA, 1986)

—, 'On Ethnographic Authority', in his *The Predicament of Culture: Twentieth-Century Ethnography, Literature and Art* (Cambridge, MA, 1988)

Dalziell, Rosamund, 'The Curious Case of Sir Everard im Thurn and Sir Arthur Conan Doyle: Exploration and the Imperial Adventure Novel, *The Lost World*', *English Literature in Transition, 1880–1920*, XLV (2002), pp. 131–57

Derrida, Jacques, *Of Grammatology*, trans. Gayatrı Chakravorty Spivak (Baltimore, MD, 1976)

During, Simon, *Modern Enchantments: The Cultural Power of Secular Magic* (Cambridge, MA, 2002)

Edwards, Elizabeth, 'Some Problems of Photographic Archives: The Case of C. W. Dammann', *Journal of the Anthropological Society of Oxford*, XIII/3 (1982), pp. 257–61

—, ed., *Anthropology and Photography, 1860–1920* (New Haven, CT, 1992)

—, 'Performing Science: Still Photography and the Torres Strait Expedition', in *Cambridge and the Torres Strait: Centenary Essays on the 1898 Anthropological Expedition*, ed. Anita Herle and Sandra Rouse, (Cambridge, 1998), pp. 106–35

—, 'Professor Huxley's "Well-considered Plan"', in *Raw Histories: Photographs, Anthropology and Museums* (Oxford, 2001)

—, 'Photographs and the Sound of History', *Visual Anthropology Review*,

xxi/1–2 (Spring/Fall 2005), pp. 27–46

—, and Lynne Williamson, *World on a Glass Plate: Early Anthropological Photographs from the Pitt Rivers Museum, Oxford* (Oxford, 1981)

Elkins, James, 'What Do We Want Photography to Be? A Response to Michael Fried', *Critical Inquiry*, xxxi/4 (Summer 2005), pp. 938–56

—, ed., *Photography Theory* (London, 2007)

Evans-Pritchard, E. E., *Witchcraft, Oracles and Magic among the Azande* (Oxford, 1937)

Fabian, Johannes, *Time and the Other: How Anthropology Makes its Object* (New York, 1983)

Falconer, John, 'Ethnographical Photography in India, 1850–1900', *Photographic Collector*, v/1 (1984), pp. 16–46

Feld, Steven, *Sound and Sentiment: Birds, Weeping, Poetics and Song in Kaluli Expression* [1982], 2nd edn (Philadelphia, PA, 1990)

Fleming, Paula Richardson, and Judith Luskey, *The North American Indians in Early Photographs* (Oxford, 1986)

Forge, Anthony, 'Learning to See in New Guinea', in *Socialization: The View from Social Anthropology*, ed. Phillip Mayer (London, 1970)

Foucault, Michel, *Words and Things: An Archaeology of the Human Sciences* (London, 1974)

—, *The Birth of the Clinic: An Archaeology of Medical Perception* (London, 1976)

Frazer, James G., *The Golden Bough: A Study in Magic and Religion*, 3rd edn, Part 1: *The Magic Art and The Evolution of Kings* (London, 1911)

Galton, Francis, 'Composite Portraits, Made by Combining Those of Many Different Persons into a Single Resultant Figure', *Journal of the Anthropological Institute*, viii (1879), pp. 132–44

Geertz, Clifford, Hildred Geertz and Lawrence Rosen, *Meaning and Order in Moroccan Society: Three Essays in Cultural Analysis* (Cambridge, 1979).

—, *Works and Lives: The Anthropologist as Author* (Stanford, CA, 1989)

Geismar, Haidy, Anita Herle and Numa Fred Longga, *John Layard long Malakula, 1914–1915* (Cambridge, n.d.)

Gell, Alfred, 'Technology and Magic', *Anthropology Today*, iv/2 (April 1988)

Gewertz, Deborah, and Frederick Errington, *Twisted Histories, Altered Contexts: Representing the Chambri in a World System* (Cambridge, 1991)

Ginsburg, Faye, 'Culture/Media: A (Mild) Polemic', *Anthropology Today*, x/2 (April 1994), pp. 5–15

Ginzburg, Carlo, 'Clues: Roots of an Evidential Paradigm', in his *Clues, Myths and the Historical Method*, trans. John and Anne Tedeschi (Baltimore, MD, 1989)

Godby, Michael, 'The Drama of Colour: Zwekluthu Mthethwa's Portrait Photography', *NKA: Journal of Contemporary Art*, 10 (Summer 1999), pp. 46–9

Griffiths, Alison, 'Knowledge and Visuality in Turn of the Century Anthropology: The Early Ethnographic Cinema of Alfred Cort Haddon and Walter Baldwin Spencer', *Visual Anthropology Review*, xii/2 (Fall/Winter 1996/7), pp. 18–43

Grimshaw, Anna, *The Ethnographer's Eye: Ways of Seeing in Modern Anthropology* (Cambridge, 2001)

Gunning, Tom, 'An Aesthetic of Astonishment: Early Film and the (In)credulous Spectator', *Art and Text*, 34 (Spring 1989), pp. 31–45

Haddon, A. C., *History of Anthropology* (London, 1910)

Hastrup, Kirsten, 'Anthropological Visions: Some Notes on Visual and Textual Authority', in *Film as Ethnography*, ed. Peter Ian Crawford and David Turton (Manchester, 1992)

Heidegger, Martin, 'Age of the World Picture', in *The Question Concerning Technology and Other Essays*, trans. William Lovitt (New York, 1977)

Heusch, Luc de, 'The Cinema and Social Science: A Survey of Ethnographic and Sociological Films', *Visual Anthropology*, i/2 (1987), pp. 99–156

Hingston Quiggin, A., *Haddon the Headhunter: A Short Sketch of the Life of A. C. Haddon* (Cambridge, 1942)

Hinsley, Curtis M., and Bill Holm, 'A Cannibal in the Museum: The Early Career of Franz Boas in America', *American Anthropologist*, lxxviii/2 (June 1976), pp. 306–16

Holdsworth, Chris, 'Sir Edward Burnett Tylor', *Oxford Dictionary of National Biography* (online edition).

Hyman, Paul, 'A (Fashion) Photographer's Reflection on Fieldwork', *Journal of North African Studies*, xiv/3–4 (September/December 2009), pp. 431–3

im Thurn, E. F., 'Anthropological Uses of the Camera', *Journal of the Anthropological Institute*, xxii (1893), pp. 184–203

Jacknis, Ira, 'George Hunt, Kwakiutl Photographer', in *Anthropology and Photography*, ed. Elizabeth Edwards (New Haven, CT, 1992)

Kass, Amalie M., 'Thomas Hodgkin (1798–1866), Physician and Social Reformer', *Oxford Dictionary of National Biography* (online edition)

King, David, *The Commissar Vanishes: The Falsification of Photographs and Art in Stalin's Russia* (New York, 1997)

Lacan, Ernest, *Esquisses photographiques à propos de l'Exhibition Universelle et de la guerre de l'orient* (Paris, 1856)

Lamprey, J. H., 'On a Method of Measuring the Human Form, for the Use of Students in Ethnology', *Journal of the Ethnological Society of London* (1869), pp. 84–5

Landau, Paul, 'Christ in the Kalahari Desert', *Representations*, 45 (Winter 1994), pp. 26–40

Latour, Bruno, *We Have Never Been Modern*, trans. Catherine Porter (London, 1993)

Lévi-Strauss, Claude, *Tristes Tropiques*, trans. John and Doreen Weightman (Harmondsworth, 1984)

—, *Saudades do Brazil: A Photographic Memoir* [1994] (Seattle, WA, 1995)

Lévy-Bruhl, Lucien, *The 'Soul' of the Primitive*, trans. Lilian A. Clare (London, 1965)

Lips, Eva, *Savage Symphony: A Personal Record of the Third Reich*, trans. Caroline Newton (New York, 1938)

Lips, Julius, *The Savage Hits Back* (New Haven, CT, 1937)

Livingston, Jane, 'Man Ray and Surrealist Photography', in Rosalind

Krauss and Jane Livingston, *L'Amour Fou: Photography and Surrealism* (London, 1986)

Lydon, Jane, *Eye Contact: Photographing Indigenous Australians* (Durham, NC, 2005)

Lyman, Christopher M., *The Vanishing Indian and Other Illusions: Photographs of Indians by Edwards S. Curtis* (Washington, DC, 1982)

MacDougall, David, 'Photo Hierarchicus: Signs and Mirrors in Indian Photography', *Visual Anthropology*, V/2 (1992), pp. 102–29

McLean, Ian, and Gordon Bennett, *The Art of Gordon Bennett* (Roseville East, NSW, 1996)

Malinowski, Bronislaw, *Argonuats of the Western Pacific: An Account of Native Enterprise and Adventure in the Archipelagoes of Melanesian New Guinea* [1922] (London, 1932)

—, *Coral Gardens and their Magic: A Study of the Methods of Tilling the Soil and of Agricultural Rites in the Trobriand Islands* (London, 1935)

—, *A Diary in the Strict Sense of the Term* (London, 1967)

Mathur, Saloni, *India by Design: Colonial History and Cultural Display* (Berkeley, CA, 2007)

Micheli, C. Angelo, 'Doubles and Twins: A New Approach to Contemporary Studio Photography', *African Arts* (Spring 2008), pp. 66–85

Miller, Thomas Ross, and Barbara Mathé, 'Drawing Shadows to Stone', in Laurel Kendall et al., *Drawing Shadows to Stone: The Photography of the Jesup North Pacific Expedition, 1897–1902* (New York, 1997)

Moore, Rachel, *Savage Theory: Cinema as Modern Magic* (Durham, NC, 2000)

Morton, Christopher, 'Fieldwork and Participant-Photographer: E. E. Evans-Pritchard and the Nuer Rite of *Gorot*,' *Visual Anthropology*, 22 (2009), pp. 252–74

Mulvaney, D. J., Geoffey Walker and Ron Vanderal, *The Aboriginal Photographs of Baldwin Spencer* (Melbourne, 1982)

Mustafa, Hudita Nura, 'Portraits of Modernity: Fashioning Selves in Dakarois Popular Photography', in *Images and Empires: Visuality in Colonial and Postcolonial Africa*, ed. Paul S. Landau and Deborah D. Kaspin (Berkeley, CA, 2002)

Nadar, Felix, 'My Life as a Photographer', trans. Thomas Repensek, *October*, 5 (Summer 1978), pp. 6–28

Needham, Rodney, 'Little Black Boxes', *Times Literary Supplement*, 28 May 1976

Parezo, Nancy J., and Don D. Fowler, *Anthropology Goes to the Fair: The 1904 Louisiana Purchase Exposition* (Lincoln, NE, 2007)

Peirce, Charles S., 'Logic as Semiotic: The Theory of Signs', in *Philosophical Writings of Peirce*, ed. Justus Buchler (New York, 1955)

Penniman, T. K., *A Hundred Years of Anthropology*, 2nd edn (London, 1952)

Peterson, Nicolas, 'The Changing Photographic Contract', in *Photography's Other Histories*, ed. Christopher Pinney and Nicolas Peterson (Durham, NC, 2003)

Petrie, W. M. Flinders, 'Paper Squeezes', *Notes and Queries on Anthropology*, 4th edn (London, 1912)

Pinney, Christopher, '*Henta-koi*', in *The Raj: India and the British, 1600–1947*, ed. C. A. Bayly (London, 1990)

—, 'The Parallel Histories of Anthropology and Photography' in *Anthropology and Photography, 1860–1920*, ed. Elizabeth Edwards (New Haven, CT, 1992)

—, *Camera Indica: The Social Life of Indian Photographs* (London, 1997)

—, 'Introduction: How the Other Half . . .' in *Photography's Other Histories*, ed. Christopher Pinney and Nicolas Peterson (Durham, NC, 2003)

—, *The Coming of Photography in India* (London, 2008)

Poignant, Roslyn, *Observers of Man: Photographs from the Royal Anthropological Institute* (London, 1980)

—, and Axel Poignant, *Encounter at Nagalarramba* (Canberra, 1996)

—, 'Surveying the Field of View: The Making of the RAI Photographic Collection', in *Anthropology and Photography, 1860–1920*, ed. Elizabeth Edwards (New Haven, CT, 1992)

Portman, M. V., 'Photography for Anthropologists', *Journal of the Anthropological Institute*, 25 (1896), pp. 75–87

Prosser, Jay, *Light in a Dark Room: Photography and Loss* (Minneapolis, MN, 2005)

Pushpamala N., and Clare Arni, *Native Women of South India: Manners and Customs* (Bangalore, 2004)

Rabinow, Paul, *Observations on Fieldwork in Morocco* (Berkeley, CA, 1977)

—, 'Chicken or Glass: In the Vicinity of Clifford Geertz and Paul Hyman', *Journal of North African Studies*, XIV/3–4 (September/December 2009), pp. 467–77

Rainger, Ronald, 'Philanthropy and Science in the 1830s: The British and Foreign Aborigines' Protection Society', *Man*, n.s. XV/4 (. . .), pp. 702–17

Ratzel, Friedrich, *The History of Mankind*, trans. from the second German edition by A. J. Butler (London, 1896)

Ricalton, James, *India Through the Stereoscope: A Journey Through Hindustan* (New York, n.d.),

Risley, H. H., *The People of India* (Calcutta, 1915)

Roberts, Allen F., and Mary Nooter Roberts, 'Mystical Reproductions: Photography and the Authentic Simulacrum', in *A Saint in the City: Sufi Arts of Urban Senegal* (Los Angeles, CA, 2003)

Ruby, Jay, *Picturing Culture: Explorations of Film and Anthropology* (Chicago, IL, 2000)

Salmond, Anne, 'Theoretical Landscapes: On Cross-Cultural Conceptions of Knowledge', in *Semantic Anthropology*, ed. David Parkin (London, 1982)

Schüttpelz, Erhard, '*Medientechniken der Trance: eine spiritistische Konstellation im Jahr 1872*' in *Trancemedien und Neue Medien um 1900: ein anderer Blick auf die Moderne*, ed. Marcus Hahn and Erhard Schüttpel (Bielefeld, 2009)

Segall, Marshall H., Donald T. Campbell and Melville J. Herskovits, *The Influence of Culture on Visual Perception* (Indianapolis, IN, 1966)

Seligmann, Charles Gabriel, and Benda Z. Seligman, *The Veddas* (Cambridge, 1911)

Serres, E.R.A., 'Présentation de cinq portraits représentant deux naturels de l'Amérique du Sud (Botocudes), et pris au daguerreotype par le procédé de M. Thiesson', *Comptes rendus hebdomadaires des séances de l'Académie des sciences*, 29 (2 September 1844), p. 490

—, 'Observations sur l'application de la photographie à l'étude des races haumaines', *Comptes rendus hebdomadaires des séances de l'Académie des sciences*, 21 (21 July 1845), pp. 242–6

—, 'Photographie anthropologique', *La Lumière*, 33 (7 August 1852), p. 130.

Slymovics, Susan, 'Perceptions, Not Illustrations, of Sefrou, Morocco: Paul Hyman's Images and the Work of Ethnographic Photography', *Journal of North African Studies*, xiv/3–4 (September/December 2009), pp. 445–65

Smith, Bejamin R., and Richard Vokes, 'Introduction: Haunting Images', *Visual Anthropology*, xxi/4 (2008), pp. 283–91

Sontag, Susan, *On Photography* (Harmondsworth, 1979)

Sprague, Stephen F., 'Yoruba Photography: How the Yoruba See Themselves', *African Arts*, xii/1 (November 1978), pp. 52–9

Spyer, Patricia, 'The Cassowary Will (Not) Be Photographed: The "Primitive", the "Japanese", and the Elusive "Sacred" (Aru, South Moluccas)', in *Religion and Media*, ed. Hent de Vries and Samuel Weber (Stanford, ca, 2001)

Stagl, Justin, *A History of Curiosity: The Theory of Travel, 1550–1800* (London, 1995)

Stocking, George W., 'What's in a Name? The Origins of the Royal Anthropological Institute, 1837–1871', *Man*, 6 (1971), pp. 369–90

—, *Victorian Anthropology* (New York, 1991)

—, *The Ethnographer's Magic and Other Essays in the History of Anthropology* (Madison, wi, 1992)

—, *After Tylor: British Social Anthropology, 1888–1951* (Madison, wi, 1995)

—, 'Animism in Theory and Practice: E. B. Tylor's Unpublished "Notes on Spiritualism"', in his *Delimiting Anthropology: Occasional Essays and Reflections* (Madison, wi, 2001)

Strassler, Karen, 'Material Witnesses: Photographs and the Making of Reformasi Memory', in *Beginning to Remember: The Past in Indonesia's Present*, ed. Mary Zurbuchen (Washington, dc, 2005)

—, *Refracted Visions: Popular Photography and National Modernity in Java* (Durham, nc, 2010)

Strathern, Marilyn, *The Relation: Issues in Complexity and Scale* (Cambridge, 1995)

Taussig, Michael, *Mimesis and Alterity: A Particular History of the Senses* (New York, 1993)

—, *What Colour is the Sacred* (Chicago, il, 2009)

Tomas, David, 'The Ritual of Photography', *Semiotica*, xl/1–2 (1982), pp. 1–25

—, 'Toward an Anthropology of Sight: Ritual Performance and the Photographic Process', *Semiotica*, lxviii/3–4 (1988), pp. 245–70

Tsinhnahjinnie, Hulleah J., 'When is a Photograph Worth a Thousand Words?', in *Photography's Other Histories*, ed. Christopher Pinney and Nicolas Peterson (Durham, nc, 2003)

Tylor, E. B., 'Dammann's Race-Photographs', *Nature*, 13 (1876), pp. 184–5

—, *Anthropology* (London, 1881)

—, *Primitive Culture: Researches into the Development of Mythology, Philosophy, Religion, Language, Art and Custom*, 3rd edn (London, 1891)

Wagner, Roy, *Asiwinarong: Ethos, Image and Social Power among the Usen Barok of New Ireland* (Princeton, nj, 1986)

—, *Symbols That Stand for Themselves* (Chicago, il, 1986)

—, *An Anthropology of the Subject: Holographic Worldview in New Guinea and Its Meaning and Significance for the World of Anthropology* (Berkeley, ca, 2001)

Warner, Marina, *Phantasmagoria: Spirit Visions. Metaphors and Media* (London, 2006)

Watson, J. Forbes, and John William Kaye, *The People of India: A Series of Photographic Illustrations with Descriptive Letterpress of the Races and Tribes of Hindustan*, 8 vols (1868–75)

Weiner, James F., 'Televisualist Anthropology: Representation, Aesthetics, Politics', *Current Anthropology*, xxxviii/2 (April 1997), pp. 197–235

Wendl, Tobias, 'Ghana: Portraits and Scenery', *Revue Noire Collection of African and Indian Ocean Photography* (Paris, 1998)

—, and Behrend Heike, *Snap Me One! Studiofotografen in Afrika* (Munich, 1999)

Whiffen, Thomas, *The North-West Amazons: Notes of Some Months Spent among Cannibal Tribes* (London, 1915)

Williams, F. E., 'The Vailala Madness in Retrospect', in *Essays Presented to C. G. Seligman*, ed. E. E. Evans-Pritchard et al. (London, 1934), pp. 369–79

—, 'The Vailala Madness' and Other Essays, ed. Erik Schwimmer (St Lucia, Queensland, 1976)

Wittkower, Rudolf, *Allegory and the Migration of Symbols* (London, 1987)

Worth, Sol, 'Margaret Mead and the Shift from "Visual Anthropology" to the "Anthropology of Visual Communication"', *Studies in Visual Communication*, vi/1 (Spring 1980), pp. 15–22

—, and John Adair, *Through Navajo Eyes* (Bloomington, in, 1975)

Wright, Christopher, 'Supple Bodies: The Papua New Guinea Photographs of Captain Francis R. Barton, 1899–1907', in *Photography's Other Histories*, ed. Christopher Pinney and Nicolas Peterson (Durham, nc, 2003)

—, 'Material and Memory: Photography in the Western Solomon Islands', *Journal of Material Culture*, ix/1 (2004), pp. 73–85

—, '"A Devil's Engine": Photography and Spirits in the Western Solomon Islands', *Visual Anthropology*, xxi/4 (2008), pp. 364–80

Young, Michael W., *Malinowski's Kiriwina: Fieldwork Photography, 1915–1918* (Chicago, il, 1998)

—, and Julia Clark, *An Anthropologist in Papua: The Photography of F. E. Williams, 1922–39* (Honolulu, hi, 2002),

Zengotita, Thomas de, 'On Wittgenstein's *Remarks on Frazer's Golden Bough*', *Cultural Anthropology*, iv/4 (November 1989), pp. 390–98

Acknowledgements

This work builds upon several decades of intermittent research on how anthropologists have used photography in the past and how they might use it in the future. The origin of my engagement with the history of photography lies in my work as Photographic Librarian at the Royal Anthropological Institute, which laid the foundations for a Smuts Fellowship at the Centre of South Asian Studies in Cambridge. In these two locations I was much indebted to Roslyn Poignant, Jonathan Benthall and Lionel Carter.

Over the years I have benefited from the intellectual generosity of Roslyn Poignant, Elizabeth Edwards, Chris Wright, Arkadiusz Bentkowski, Pushpamala N., Mike Rowlands, Konstantinos Kalantzis, Nicholas Thomas, Karen Strassler, John Falconer, Akshaya Tankha, Anita Herle, Haidy Geismar, Sudeshna Guha, Mick Taussig, Simon Schaffer, Stephen Eisenman, Zirwat Chowdhury, Clare Harris and the late Rodney Needham.

The more Benjaminian parts of this book were presented as talks at Northwestern University (thanks to Claudia Swan and Stephen Eisenman), UCL (thanks to Mike Rowlands) and LSE (thanks to Matthew Engelke) and the more Barthesian parts in papers at St Johns, Oxford (thanks to Lucie Ryzova), the Getty Research Institute (thanks to Ali Behdad) and the London College of Communication (thanks to Elizabeth Edwards and Paul Lowe). I'm grateful to the audience at these various venues whose questions helped me sharpen and clarify aspects of the argument presented here.

Archival research on the Haddon papers at Cambridge was undertaken by Elizabeth Benjamin of Northwestern University and I'm grateful to her and to Claudia Swan who made this possible.

It was a pleasure to work with the following: at the RAI, Arkadiusz Bentkowski and Sarah Walpole, at the Pitt Rivers Museum Oxford, Chris Morton, at the Cambridge Museum of Archaeology and Anthropology, Nicholas Thomas, Anita Herle and Jocelyne Dudding, at the LSE, Silvia Gallotti and Sue Donnelly, at AMNH, Kelli Anderson, at the Alkazi Collection of Photography, Akshaya Tankha, at Northwestern, Scott Krafft, and at Museum Victoria, Kirsty Lewis.

For help in tracing and help securing permissions for images I am grateful to Pushpamala N., Dave Lewis, Philip Kwame Apagya, Paul Hyman, Steve Feld, Michael Aird, Gordon and Leanne Bennett, Leah King-Smith, Karen Strassler, Rebecca Empson, Matthew Witkovsky, Devorah Romanek, Paul Rabinow, Tobias Wendl, Allen Roberts, Cecilia Valsted, Nicolas Peterson, Philip Batty, Eduardo Viveiros de Castro, Ludovic Coupaye, Christine Barthe, Jay Prosser, Bhaskar Mukhopadhyay, Maurice Bloch and Michael Young. I'm especially grateful to those artists who so generously allowed me to reproduce their work.

At Reaktion I would like to thank Michael Leaman for his encouragement and Blanche Craig for the care she has taken with the manuscript

This book is dedicated to Roslyn Poignant. All students of anthropological photography are deeply indebted to her pioneering efforts to make the RAI archive physically accessible and the provocative object of scholarly engagement. Beyond this she has consistently highlighted the crucial role that visual representation has played in world history and consistently exemplified in her own work the need for its ongoing politically engaged theorization.

Photo Acknowledgements

The author and publishers wish to express their thanks to the following sources of illustrative material and/or permission to reproduce it:

Alkazi Collection of Photography: 9; American Museum of National History: 25–6; Babulal Bohra: 72; Gordon and Leanne Bennett: 77; British Museum 14, 37; Buxton Family Collection: 2; Cambridge University Library: 28; Center for Creative Photography, Arizona: 66–7; Charles Deering McCormick Library of Special Collections, Northwestern University Library: 53; Rebecca Empson 88–9; Steve Feld: 62–3; Ewa Franczak and Stefan Okolwicz: 33; Paul Hyman: 61; Prakash Jha: 70; Leah King-Smith: 75; Philip Kwame Apagya: 68–9; David Lewis: 78–9; Library of Congress: 52; London School of Economics: 32, 34–6; Magic Hour Films/Co-operative Campaigns: 4; © 2011 Musée du Quai Branly/ Scala, Florence: 6; Museum of Archaeology and Anthropology, University of Cambridge: 11, 27, 30, 38, 41, 46, 47–8, 50–51, 58, 65; Museum Victoria: 31; National Anthropological Archives: 24, 76; Nicolas Peterson: 74; Pitt Rivers Museum: 15–16, 18–19, 42, 44, 55, 57, 64; Roslyn Poignant 87; Pushpamala N.: 80–81; Private Collection 3, 17, 29, 39– 40, 43, 55, 71, 82; Royal Anthropological Institute: 1, 5, 7, 8, 10, 12–13, 19–23, 45, 49, 54, 86; Karen Strassler: 73, 83; Christopher Wright: 84–5.

Index